MARIETTA COLLEGE Baseball

THE STORY OF THE 'ETTA EXPRESS

GARY CARUSO

Charleston London

THE
History
PRESS

Published by The History Press
Charleston, SC 29403
www.historypress.net

Front cover, left to right and top to bottom: Don Schaly (back row, far left) as a Marietta College player in the late '50s and talking to players as coach; the five national championship rings won by the 'Etta Express; and the entire 2006 team after winning Coach Brian Brewer's first national title.

Back cover, clockwise from top left: Five members of the '06 team hoist the NCAA Division III trophy; the glitzy 2011 ring; and part of the large crowd watching a World Series game at Pioneer Park.

Facing page: Marietta College's unique baseball heritage is illustrated by the program's unprecedented five NCAA Division III national championship rings. The 2011 ring (center) is flanked by 1981 and '86 on the left and 2006 and '83 on the right. *Marietta College.*

First published 2012

Manufactured in the United States

ISBN 978.1.60949.464.3

Library of Congress CIP data applied for.

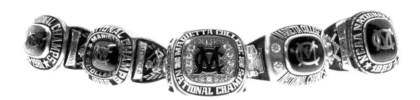

CONTENTS

Foreword, Jim "J.J." Tracy 9
Introduction 13

1. Hail to the Champions! 17
2. The Legend 25
3. Don't Encourage the Rain 41
4. A Family Affair 58
5. Dawn of a New Era 69
6. Asterisk, Anyone? 79
7. The First Time 86
8. Two Plus Two 96
9. Force of Nature 107
10. High Drama 117
11. The Successor 128
12. The Ambassador 143
13. The Tekulves 154
14. Some First Impression 160
15. "Doctor" DeSalvo 173
16. The Next Level 185
17. Passing the Torch 194
18. Extra Innings 204

Appendix 217
About the Author 240

FOREWORD

Have you ever wondered how you got to where you are in life? What were the one or two critical decisions that you made that put you on the path that soon became your life plan?

Think about how much these decisions impacted your personality, your friends, your career, your happiness and, in many cases, your destiny in life. Where would you be today if you had chosen a different school, different friends, mentors and all the people of influence who helped create and be part of your future? A different choice potentially could have completely changed your life. It may very well have led to a similar outcome, but it is likely that it would have been materially different.

The choices we make in life have significant impact, especially the choices we make about the people in our lives, the values they bestow on us and the environments we choose to live in. There are a multitude of outcomes that develop, but it is the people in your life and the evolution of your environment that ultimately help position you for success and happiness. Most often, these choices are not clear at the time you make them. You just do what you think feels right at the time and hope for the best.

One of the early decisions I made in my life was to choose to attend Marietta College and play baseball for what is now known as the 'Etta Express. I was not much different than most high school seniors. I had a dream of playing Division I baseball and then, of course, moving on after college to play professional baseball…naturally with the Yankees.

Jim "J.J." Tracy posted a career batting average of .330 at Marietta College (1976–79) and was an all-America outfielder in 1977. *Morgan Stanley Smith Barney.*

I had no doubt this would be my path in life, my destiny, mostly because it was what I wanted and what I thought I was capable of at the time. As I approached my senior year, all seemed to be falling into place. I received dozens of letters from excellent Division I schools and, of course, a few from some Division III schools, including quite a few handwritten notes from Marietta College and this persistent and intriguing coach by the name of Don Schaly.

I was very impressionable at the time. Like most my age, I was growing as a person and didn't quite understand the magnitude of what college was really all about. To me, it was mostly about sports. The education was ancillary. Not that I was a dumb guy. I attended St. Charles Prep, a very high-quality all-boys Catholic high school in Columbus, Ohio, and managed to make my way through without any major setbacks. The background here is important because there was soon to be a series of events in my life that would materially change the pursuit of my dream.

My father died suddenly of a heart attack. At the time, I had three beautiful sisters, a great brother and an unbelievable mother. As a family, we were not prepared emotionally or financially to deal with this massive change in our life. We all chipped in where we could—jobs before and after school—to help Mom make ends meet.

Baseball and college were all of a sudden less important to me. I started to drift. I missed my dad, and my lack of focus impacted me. Although I continued to succeed in baseball my senior year, my passion and enthusiasm for the game waned. During these tough times, my mom received a call from the Marietta College baseball coach, Don Schaly.

He did not ask her a word about me, my season or where I was leaning toward as a college choice. He simply asked questions about how the family was doing, all the kids, and offered his best wishes and support. I was impressed, and a life lesson was learned, but I was still going Division I.

My college choices were narrowed as I was halfway through my senior baseball season. The University of Kentucky, Harvard and Ohio State University were the final three schools that I was considering, and yes, this persistent coach Don Schaly was still in the picture.

Life was difficult for me. I really had no perspective on where I should go to college, and nothing seemed to connect. The thought of leaving my family in Ohio and attending Harvard felt like I was bailing on my family, so that didn't appeal to me. The University of Kentucky started recruiting another outfielder and seemed to lose interest in me. Ohio State began the year in hot pursuit, but at the very end, discussions softened, and they started talking a quarter scholarship or walking on.

At the same time, my mom was struggling with five kids, two jobs and a tremendous amount of responsibility. I remember talking with her one night, and she advised me that I should talk to Don Schaly because he really seemed to care about me as a person. I agreed to a phone call.

That call lasted close to an hour. Not once did we discuss baseball. We discussed my family, talked about the future, but most importantly talked about life. I remember hanging up the phone and telling my mom, "I'm going to Marietta College," and that's what happened.

Let's go back to where we started. Most often your destiny is defined by the choices you make in life. I don't really know how it happened, but I chose to play ball at Marietta College, and I wouldn't trade that experience for the world. At Marietta, I learned about leadership, respect, winning the right way, hard work, discipline, loyalty, teamwork, integrity and friendship. At Marietta, I learned to respect education and realized that the body of your successes in life will overpower your athletic achievements. At Marietta, I learned that there is no difference between Division I and Division III baseball. What matters are the friends, teammates and experiences you share through the seasons.

I went to Marietta College because of Don Schaly. He saw something in me that I didn't see in myself. Because of the success of the program and the greatness of the man, the school attracted both great athletes and great people. When you are surrounded each day by incredible character, it, fortunately, rubs off on you. You take small pieces of your life experiences, and as you mature, you figure out how to grow as a person and ultimately shape your future.

I wouldn't trade playing baseball at Marietta College for any other choice. I can't think of a different life. I have a wonderful daughter, Lauren, who is a big part of my sense of purpose in life, and she is on

earth today because I met her mother at Marietta College. I have a best friend of thirty-plus years, Bill Mosca, who has been there for me during a lifetime of experiences, and our relationship began while playing baseball at Marietta College. And I have enough memories to realize that I am who I am today in good part because of those memories.

In this book, you will read about many people who make up the history of Marietta College and its stellar baseball program. Some of these stories may seem unbelievable to you. Trust me, they all happened! Read on and enjoy. Thank you for the opportunity to share just one of the many stories that is part of the "Long Blue Line" of Marietta College baseball players and former players.

J.J. Tracy (the "other" Jim Tracy)
Marietta College Class of 1979
Director, National Sales and Business Development
Morgan Stanley Smith Barney
Marietta College Board of Trustees

INTRODUCTION

In the fall of 2010, I returned to the Marietta College campus (enrollment roughly 1,400) for the first time since I graduated in 1971. It's not that I was avoiding it, just that I always lived quite a distance away, mainly in Atlanta and more recently in San Diego.

Fortunately, President Jean Scott, Vice-president of Advancement Lori Lewis and Director of Advancement Angela Anderson encouraged me to return to speak to students with interest in the mass communications and sports administration majors. It was a great experience, at least for me, and I was amazed at not only the excellent physical state of the campus but also with the dedicated people—which is what it's all about.

Among the things packed into my two-day agenda was lunch with baseball coach Brian Brewer and Sue Schaly, the matriarch of Marietta College baseball. After lunch, I continued to visit with Brian, who showed me the impressive facilities, including Don Schaly Stadium, where I told him I used to pick up rocks when Pioneer Park, as it was known at the time, was barely past Coach Don Schaly's dream stage.

While we walked around the ball field, Brian told me about the strength of his returning pitching staff for the 2011 season and how he hoped it would prove particularly beneficial to the Pioneers in light of new rules that toned down the liveliness of aluminum bats.

Did he know what he was talking about or what?

Roughly eight months later, Marietta won its unprecedented fifth NCAA Division III National Championship, capping a remarkable 47-4 season

(.922). Anyone for a repeat? At this writing, the 2012 team is a strong No. 1 in the pre-season polls.

During and shortly after my visit, I began thinking that I should write a book about the 'Etta Express. I discussed it with several people at the college and at The History Press but didn't move forward at that time for various reasons. However, when the Pioneers won the national championship, I realized the timing was perfect and I should continue to try to make the book happen.

Putting together what you're reading was a bit of an all-night cram session—for four months—but it definitely was a labor of love. The story of Marietta College baseball is a compelling one, and I hope I've been able to do it justice for all those who've been involved in it, whether players, families or fans, as well as for those who hold Marietta College near and dear to their hearts and recognize what a remarkable piece of school history the baseball program represents.

I certainly had no idea what I was part of when I attended Marietta. It was the greatest four years of my life and prepared me for my career better than I ever could have imagined. At various times, I was sports director of the college radio station (WCMO-FM), sports director of the college TV station (WCMO-TV) and sports editor of the student newspaper (*Marcolian*). To top it off, I served Coach Schaly as a student assistant coach my last two years.

Maybe I should have known how special the baseball program was becoming when I took the JV team to Columbus in the spring of 1971 for a double-header against the Ohio State JV. We—and I use that loosely, because my role was strictly running the game and making sure the team got to Columbus and back—whipped the Buckeyes, 3–0 and 25–12. I'd like to say I remembered the scores, but in truth, I had to ask Assistant Athletic Director Jeff Schaly to find them for me.

Of course, when we got back to Marietta, Coach Schaly was as proud as could be when he heard the report of our conquest. He knew where the baseball program was headed, even if I didn't, and I'm sure he regarded that sweep as a significant step in that direction.

About a month later, Ohio State sent its JV to Marietta for another double-header. Funny thing is that we only recognized about two of the players we had seen in Columbus! Realizing what they were up against, they loaded up for the trip, and they swept the double-header, 4–3 and 4–1. It still was a pretty good showing for a Division III team facing the big, bad Buckeyes.

Ah, yes. Division III. It's the way college athletics began and the way college athletics was meant to be. No athletic scholarships. The "true student-athlete" experience. It's a long way from the scandals that seem to crop up in Division I every week. And thank goodness for that!

The fact that Marietta College baseball hasn't had a losing season since 1961 is particularly impressive in light of the school's Division III status. Until fairly recently, the Pioneers played some Division I and II competition, too. That ended, for the most part, because those schools got tired of losing to the 'Etta Express and also due to the fact that the NCAA changed post-season criteria so that out-of-classification competition isn't considered—win or lose.

Another big factor that makes Marietta's success over the last half century remarkable is that the Pioneers have to do much of their preparation for the season indoors. Even when they get outside, the climate is often less than ideal. Nevertheless, the 2011 national championship was won against Chapman University, which is located in sunny Southern California, where baseball can be played—outdoors—year-round.

Until a few months ago, I never would have guessed I'd be writing this book, but I'm certainly glad that I did. The 'Etta Express definitely deserves to have its story told. No longer will Marietta College baseball be the greatest untold sports story in America.

Many people were supportive of this project and made significant contributions to the finished product. I'd like to thank all of them, especially those who gave their time to be interviewed.

Thanks to longtime friend Pat Willis, a member of the college's board of trustees, for guidance and support. Hub Burton, associate vice-president for alumni and college relations, served as my primary contact at the college and could not have been more helpful. Tom Perry, executive director of college relations, did yeoman's work in tracking down most of the photos in the book. All-America pitcher Brian Gasser not only helped the "Pios" win the 2011 national championship, but he also chipped in to work with Burton on developing a marketing plan for the book. And Mike Eisenberg, ace of the 2006 national champs, pitched in to create an amazing video "trailer" that really helped stir up interest.

Former all-America outfielder Jim "J.J." Tracy took time from his hectic schedule as director of national sales and business development of Morgan Stanley Smith Barney to write the foreword. And former Pittsburgh Pirates relief ace Kent Tekulve and Colorado Rockies

manager Jim E. Tracy enthusiastically agreed to autograph many copies of the book to make them more special for readers.

Then, of course, there's current baseball coach Brian Brewer and the family of the legendary Don Schaly, especially his wife, Sue. It's the vision and hard work of Schaly and Brewer that built the program and maintain it as the best college baseball program in the nation—regardless of division. Without them and the hundreds of people who have contributed to the program over the years—whether players, assistant coaches, equipment managers, grounds crew workers or those who served the program in any number of other ways—there would be no story and thus no book. So, thanks to all of you who did—and continue to do—so much to "write" this story before it was put into words.

As Coach Schaly would have said, it was a team effort all the way. Sincere thanks to everyone, including the folks at The History Press, who helped make this book a reality.

Chapter I

HAIL TO THE CHAMPIONS!

The four seniors on Marietta College's 2011 baseball team were presented with a challenge. To say they took it to heart would be a major understatement.

"Before fall practice began in 2010, Coach [Brian] Brewer sat down with the four seniors and told us that as of that time, we were the only senior class not to make it to a World Series since the 1975 team [was national runner-up]," said right-handed starter Mark Williams, one member of that foursome.

Marietta attracts a lot of top-level players for the simple reason that they want to go to a school that will be competing for championships—preferably the national championship. Most of them get that chance at least once, if not two, three or even four times in some instances.

Williams, center fielder John Snyder, first baseman Casey Levens and outfielder Britt Meador were not about to make the sort of school history that none of them wanted to be associated with making. By accepting Brewer's challenge, they led the 'Etta Express to one of the greatest seasons in school history that culminated with Marietta's record fifth NCAA Division III national championship and a stunning 47-4 record (.922).

"It really started right there with the senior class," said Williams of the fall meeting with Brewer. "We looked good in February practice, and when the season started, we were like a well-oiled machine. We won the first game, and it was like a domino effect from there.

"From the senior class down to the freshman class, anyone that was put in a situation did a great job. From the beginning of the season, there was only one goal. Coach Brewer always says there's this step and this step and this step to get to the World Series. But I think the senior class took it upon ourselves to say it's not step by step—we're going to the World Series this year. It was a team effort, and it was really something to watch."

Was it ever!

Perhaps the 'Etta Express nickname that the baseball team has carried for forty years was never more appropriate than it was in 2011. Winning 47 of 51 baseball games is pretty much unheard of at any level. The team's winning percentage fell just a hair shy of being a school record. The 1981 national championship team finished 59-5 for a .9218 percentage, compared to the .9215 percentage of the 2011 team.

Entering the season, Coach Brian Brewer had high hopes, based in large part on what he felt would be a very strong pitching staff. That was indeed the case, because the Pioneers posted a staff earned run average of 1.74, tops in the nation. How good is that? The next-best team ERA in the country was 2.56 by Adrian College (Michigan). That's an extraordinary differential of 0.82 earned runs per game.

Marietta scored 427 runs for the season, an average of 8.4 per game. Opponents scored 125 runs, or 2.5 per game. It was a dominating season that included a twenty-two-game winning streak heading into the national championship game.

A good example of the Pioneers' method of dismantling the opposition took place on April 7 in a double-header at Baldwin-Wallace. The home team entered the day with an 11-6 record. Not only was Baldwin-Wallace 11–8 at the end of the double-header, but the Yellow Jackets scored a total of 2 runs and had only four hits in sixteen innings (OAC double-headers are seven innings in the first game and nine in the second). Marietta junior right-hander Brian Gasser, in the midst of a wondrous season that led to him being named Division III Pitcher of the Year, threw a no-hitter in the first game, the twentieth in school history and the first since Mike DeMark's in 2004 against Thiel.

The double-header win at Baldwin-Wallace was part of an eleven-game winning streak. The only games Marietta lost after that were April 17 at Heidelberg (8–6) and the 15–4 loss to Chapman University in the first national championship game that they quickly avenged with an 18–5 victory over the team from Southern California.

The 'Etta Express, ranked number one in the country most of the year, almost made the 2011 season and the school's record fifth NCAA Division III national championship look easy. Of course, that was not the case at all. Brewer puts his players through intense preparation for every season. That's been the case since Don Schaly arrived at Marietta College in 1964.

The buildup to the season is part U.S. Marine Corps boot camp and part think tank. It's a rigorous challenge, physically and mentally demanding every step of the way.

Add it all up, though, and it's why the program hasn't had a losing record in forty-eight years under Schaly and Brewer, and it's the reason Marietta has won more Division III national championships than any other school.

"Coach Brewer is really right when he says you have no idea what it takes to win it until you do what needs to be done," said center fielder John Snyder, who was the 2011 OAC and NCAA Mideast Regional Player of the Year, as well as an all-American who finished second in voting for NCAA Division III Player of the Year.

The Pioneers had an inkling they might be onto something big when they played a double-header at No. 5-ranked Heidelberg on April 17. Interestingly, it was that 8–6 loss in the second game that was an eye-opener. Even with the defeat, the Pioneers were still 24-3.

"We lost the second game, 8–6, after beating them, 12–0, in the first game," said Williams. "We spotted them six runs in the first two innings. Right then, Coach Brewer wasn't upset, which really surprised us. He said, 'The best teams have these days when they collapse.' We took that like, 'Wow—he really believes we have a shot.'

"We won twenty-two straight after that, and there really wasn't a close game other than the regional finals against Heidelberg [2-1, behind Gasser and Kyle Lindquist]."

As if this Marietta team needed any more momentum, it came anyway at the last practice session before heading to the World Series in Wisconsin, just as it had when Brewer won his first national championship in 2006.

Snyder said:

> *One thing we do in practice to make it competitive is have situational scrimmages. It's basically coach-pitch, and you say "runner on second, no one out," and you've got to move the runner. We play team against team, and we score it. The coaches get into it, and the players get real fired up.*
>
> *Coach Brewer said in '06, right before they left for the World Series, they had a situational scrimmage. He said in the very last round of the*

situational scrimmage, it came down to just a few points separating the teams. Someone hit a ball to left-center, and Devan Ward, who was playing left field, went back, jumped up over the fence and robbed someone of a home run to win the game for his team. He said the place just went nuts. Everyone was real fired up, and it carried over into the World Series.

And there's a crazy parallel with 2011. We had a tie at the end of the last situational scrimmage. The two tying teams then pick a hitter to send to the plate. One team picked Aaron Hopper, and he went up and singled to score a run and they got two points. My team picked me, and I singled to score a run for two points.

So, we're tied again and have to pick a player again. The other team picks someone that gets a hit—two points. Coach Brewer allows someone from the other team to pick our player, because by this time, he wants it to be over. The other team picks Britt Meador, a senior, and a really good pure hitter, line drive guy.

Coach Brewer tells him to come up and make the last out. Britt steps up and hits a home run to win the situational scrimmage. Obviously, we go crazy. Everyone's talking smack to Coach Brewer for calling him out. It was a really cool moment before we went away. Those two moments were like rallying points for those teams to win the World Series.

The 'Etta Express didn't let up when it got to the Series. In spite of being on an eighteen-game winning streak and carrying the No. 1 ranking, Brewer's team took care of business without showing any signs of any pressure that might be building.

Williams said:

When we got to the World Series, everybody was all about that No. 1 ranking and that maybe we were going to come in too high. As a team, we were a little nervous because we hadn't seen any of the teams in the Series. Then Gasser threw a beautiful game in Game 1 and that set the tone [six innings of three-hit, shutout ball in an 8–0 win].

We blew out Chapman the next day, 9–4 [behind Austin Blaski]. *I started the next game against Buena Vista, and they battled but we took care of business* [5–1].

Marietta beat Keystone College 11–2 for their twenty-second straight victory and then waited to see who would emerge from the losers' bracket to challenge them for the national championship. That turned out to be

Chapman University from Orange, California, whom Marietta had beaten in the second game of the Series.

Chapman not only beat Marietta but whipped the Express to the tune of 15–4, forcing the "if necessary" game of the double-elimination competition. Williams said:

> *We were all kind of down after the first game and looked like we were beat already. We thought* [starting pitcher] *Gasser would be a horse to win it, and he got shelled.*
>
> *Coach Brewer said, "I told you to enjoy the first game. Now it's time to get it done." He had that look in his eyes like it's time to cut the bull. It's time to win the championship. It was his body language more than what he said.*
>
> *We'd been doing it all year, and this team was not better than us. And we showed it. Blaski was lights out. He pitched beautiful.*

Final score: 18–5, behind six innings of two-hit, one-run ball by Blaski, who was named the MVP of the tournament.

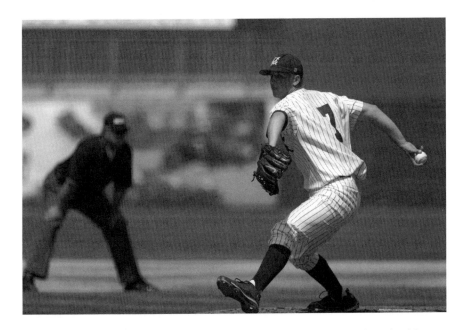

Austin Blaski pitched six innings of two-hit baseball in the 2011 national championship game, leading Marietta College to its fifth NCAA Division III title, 18–5 over Chapman, and giving him a 12-2 record for the season. *Marietta College.*

"The first championship game, I think we just gave ourselves a little breath," Williams reasoned. "Then Coach Brewer said it's not time to enjoy this anymore. We came here for a national title, and we came out and beat the crap out of them in the second game."

Referring to Marietta's superior pitching depth, Brewer said, "We talked about it in the morning, and we talked about it in between games, that the longer the day went, the bigger our advantage. We stayed patient and jumped on them pretty early in the second game [seven runs in the third inning and led, 16–1, going to the seventh]. Austin was lights out, and we played our game. I was really proud of our guys."

Hopper, Marietta's sophomore right fielder, got the Pioneers going with a two-out, two-run double in the first inning, and after Blaski gave up a run in the second, he retired twelve straight hitters while the Express built a big lead.

The eighteen-run outburst was the second-highest total in a national championship game, second only to Marietta's thirty-six runs against Otterbein in the 1983 World Series finale. Hopper led the seventeen-hit attack with four hits and four RBIs. Snyder and sophomore left fielder Jordan Grilliot each had three hits.

Snyder, Williams, Blaski, Hopper, shortstop Tim Saunders and junior pitcher Mike Mahaffey made the All-Tournament team.

Much went into Marietta's landmark season, and so much of it is shared only by the players and coaches who worked together every day to make it happen. It's a process that begins in the fall when the students report for school, and it continues through the end of the season.

Snyder said:

> One of the things we do is get together every year in the fall to lay out our goals as a team. I was talking to Coach [Cody] Castle, the pitching coach, and he said they went back and looked at that list we made for 2011, and they checked off just about every one of them. We kind of scripted it to go a certain way, and then as a group, we went out and pretty much checked off everything we wanted to do, right down to going hard from first to third on a single, little things like that.
>
> This team did those things so well that by halfway through the season, it was a forgone conclusion in our mind that we were going to get it done. As a senior, I was so proud to see it all happen, getting it done as a group and seeing the underclassmen helping us accomplish it. It was so cool to be able to watch everyone celebrate it.

A lot of that is [Associate] Coach [Mike] Deegan. He's extremely in tune with the mental aspect of the game, and he's really into goal setting. He even encourages us, before we go to bed at night, to set goals for the next morning. It's something I've carried over into my regular life now.

In baseball, it's things like you want to take fifty swings in the cage off the tee, fifty swings of soft toss, catch fifty fly balls the next day. The [big] goals never changed. It's always win the conference, win the conference tournament, win the regional, win the national championship. Those four never change. But what we got into was, "How are we going to make that happen?"

We have to do extra work in the cage, take more ground balls, have better at-bats, be more aggressive on the bases, all the little things we talked about to make it happen. The main goal never changes at Marietta—you want to win the last game of the year, the national championship—but there are a lot of things that go into that. Last year, our main goal was to get stronger, get more physical, because that's how Heidelberg beat us [in 2010]. They're more physical than us. So we put a lot of emphasis on our work in the weight room.

It was unbelievable what we were able to accomplish, and then in the spring, we went out and executed what we needed to do to get it done. You can break down things as much as you want. There probably were one hundred things on that list, down to our pitching philosophy, our hitting philosophy. It's amazing how many of them we did properly. The whole team sits down and comes up with the list. We have our playbook, and the defensive philosophy is, "Make the routine play 100 percent of the time. Don't give up extra bases. Be where you're supposed to be when you're supposed to be there." All those little things. It makes such a big difference when everyone buys into those things and executes them.

At Marietta, where winning is quite a tradition stretching back half a century, one success often connects to another, and one national championship can help lead to the next. Such was the case in 2011, when one of the year's key players, Snyder, wound up attending Marietta primarily because of Jarrod Klausman, the starting first baseman on the 2006 national champs. Snyder said:

I'm from Altoona, and so is Jarrod. It was through him that I became interested in Marietta. When they won in '06, his senior year, I was a senior in high school. I had some offers from D II schools and walk-on

shots at D I places, but when they won, he talked up Marietta to me and I went down for a visit. I fell in love with it. I wanted to go somewhere that baseball was very important, and I definitely got that vibe there. It was a really easy sell. You could tell they [Brewer and Deegan] really cared, and that's what I wanted to see—that baseball was a priority and an emphasis was put on it.

As Deegan points out, though, baseball is not the only thing that is emphasized at Marietta:

We did something in 2011 that we started four or five years ago. We wanted to be the best in everything we did, meaning academically, citizenship wise, the works. We had the top male GPA among sports teams last year on campus. Citizenship wise, we only had one or two incidents all year of anyone getting into even minor trouble. The way this team practiced and everything, it was just a special, special thing. It was such a gratifying year for everyone.

We had a pretty special year going even before the tournaments, and people were saying we were going to win it all. I said, "Who knows, but this team deserves it. They deserve a chance to play for the national championship." And they cashed it in. We were so proud of them. They put that motto of wanting to be the best in everything to fruition in all phases. From start to finish, it was a special year, and I'd say that even if we lost in the World Series. It was an amazing group of kids and an incredibly gratifying year for Brew [Brewer] and for all of us.

Inset, top: This logo says it all about a team that posted a 47-4 record, had a winning streak of 22 games heading into the national championship game and posted a nation's best 1.74 earned run average that was nearly a run better than any other team. *Marietta College.*

Inset, bottom: One for the thumb! Marietta College's fifth national championship ring is a rare gem indeed, and Paul "Doc" Spear, the baseball program's longtime athletic trainer, is the only person still with the team who has all five. *Marietta College.*

Chapter 2

THE LEGEND

Like many other men, Don Schaly went to his final resting place wearing a pinstriped suit. The difference is that Schaly's "finest" was considerably different than that of most men. He was dressed in his Marietta College baseball pinstriped uniform. Nothing could have been more fitting, because Marietta College and the baseball program were Schaly's life.

"That was a family decision [to put him in uniform]," said son Jeff Schaly, who returned to his alma mater as an assistant athletic director in 2011. "Realistically, Dad probably would have yelled at us for 'stealing' a uniform from the college!"

Well, considering that Schaly's No. 50 is permanently retired so that no one will ever wear it again, it was quite appropriate that he took it with him.

In his forty-year career as Marietta College's baseball coach from 1964 to 2003, Schaly posted a record of 1,442–329 (.814 winning percentage).

The Pioneers won three NCAA Division III national championships (1981, '83 and '86) under Schaly and were national runner-up seven times (1975, '78, '80, '84, '85, 2001 and '02). The 'Etta Express also won eighteen Mideast Regional titles and twenty-seven Ohio Athletic Conference championships in his tenure.

Schaly's stats and awards are mind-numbing. By no stretch of the imagination do they define him, but they have to be listed, because they put his greatness in perspective. For starters, he was named the NCAA Division III Coach of the Century by *Collegiate Baseball* newspaper. That pretty much says it all, but the particulars also include four National Coach of the Year

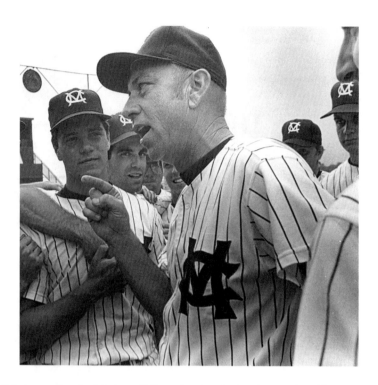

Don Schaly, wearing the Marietta College pinstripes he loved so much, addresses a group of players during his legendary forty-year career that, among other things, put him in the American Baseball Coaches Association Hall of Fame. *Marietta College Archives.*

awards, as well as twenty-one Regional and nineteen Ohio Athletic Conference Coach of the Year awards. He's enshrined in four athletic halls of fame, including the American Baseball Coaches Association and, of course, Marietta College's.

In forty years, he coached nearly 700 players, producing 101 all-Americans, 232 all-Region selections and 307 all-OAC picks. Over 40 of his players signed professional contracts.

He received two keys to the city of Marietta, and in 1984, he was recognized as the city's Outstanding Citizen. Marietta College honored him with its Distinguished Alumnus Award in 1981. He also received the MC Alumni Association Service Award, the lobby of Ban Johnson Field House was named after him and his No. 50 jersey was the first number retired in any sport in the college's history. Of course, the baseball facility, originally known as Pioneer Park, was renamed Don Schaly Stadium in 2006.

The Story of the 'Etta Express

As impressive as all of that is, perhaps the most remarkable accomplishment of his career is the fact that he never had a losing season as a head coach. That includes forty years of Marietta College baseball, as well as his three seasons as the head baseball coach at Midview High School in Grafton, Ohio, where he taught math from 1961 to 1963 after getting his master's from Penn State.

Schaly's .814 winning percentage and 1,442 career victories were the best in NCAA history, regardless of division, when he retired after the 2003 season. To this day, he still ranks first among all Division III coaches in career wins and winning percentage. With all NCAA classifications factored in, Schaly is second in percentage, though the coach ahead of him was active just twelve years, and he now ranks seventh in all-time victories.

His contribution to the Marietta College athletic department extended beyond baseball, though. He served seventeen years as an assistant football coach, the most of anyone in school history. He retired as an associate professor and also was an assistant athletic director for twenty-three years and was instrumental in the creation of the Athletic Hall of Fame.

Okay. The guy won some games and got some awards. However, that's not what his true legacy is, nor is it what he would want it to be. He was much more than a baseball coach. He was a life coach, and he taught his lessons with a zeal that may be unmatched.

That opinion comes from no less of an expert than Dennis Poppe, the NCAA's managing director for both football and baseball. He's been with the NCAA for thirty-seven years and is responsible for all issues related to football and baseball. Among other things, he is tournament director for the College World Series, the Division I version that's played annually in Omaha. However, he got his start

When Schaly retired after the 2003 season, he'd won more games (1,442) and compiled a higher winning percentage (.814) than any other baseball coach in NCAA history—regardless of classification. *Marietta College.*

with Schaly and the Division III World Series in Marietta. He's seen a few games, a few coaches and a few championships in his time.

Poppe said:

> *I don't know if I ever met anyone else that was so passionate about what he did as Don Schaly was. You're a very fortunate man to be as passionate about what you do and love what you do as much as he did. In the short time he was here [alive], he got the most out of it.*
>
> *The true test of a man or a coach—obviously, no one can contest his record was among the best, if not the best—but the true test is his reputation among his peers. I know it didn't matter if you were a Division I, II or III coach, you knew who Don Schaly was and had great respect for his coaching ability.*
>
> *I remember when he was honored at the American Baseball Coaches Association Hall of Fame banquet. He had that down-to-earth humility—"I don't deserve it." After many speeches, I think he probably was given more attention than any of the other speakers, because everyone in that room had so much respect for him. I think they understood the true passion and great love he had for the game. Although he won a lot of games, and that itself is certainly a tribute to his success, there are a lot of coaches that win a lot of games. But I don't think they have the respect from the other coaches like Don Schaly did.*

That reputation among his peers, along with his victories and awards, makes Schaly's legacy matchless. But it's what he meant—and still means—to the men who played for him that takes it much further.

Brian McKeown was an infielder at Marietta from 1975 to 1978. He calls himself a "fringe player." He didn't make all-star teams, but he was a regular contributor, and he's now vice-president of information services at U.S. Bank, and he also coaches junior high football and JV baseball in the Cincinnati area. Like a lot of the players Schaly molded, on and off the field, McKeown has an appreciation for the Ol' Man—as the coach called himself—that's grown over the years. McKeown said:

> *When we were there, we didn't understand the depth and the privilege of playing baseball at Marietta. But you knew you were part of something special. There was a chemistry that Coach built with the team. I've been around a lot of teams, coached a lot of teams and been on a lot of teams. But we [Marietta College baseball] were truly a band of brothers*

more than any of the others, because he was a very difficult task master kind of guy—by design.

As I've gotten older, I kind of figured out some things. He really wanted people to unite around a common goal, and the common goal was, "Man, this guy is crazy." He was a pretty special guy. I still talk about him. I've got a huge picture of him, probably the biggest picture in our basement. It's a picture of Coach coming off the mound with a towel around his neck. He was classic old school. He never changed.

I have never been influenced more by a single person, relative to sports, than him. He was unbelievable. I was a fringe guy, but every day— especially when I'm coaching baseball—I think of him all the time.

It's astonishing how many former players say much the same thing about Schaly. Scott McVicar was the starting shortstop and hit .303 on the 1986 national championship team. He's now associate director of admissions at Marietta. He said:

Coach was a professor. His classroom was the ball field. Many of his life lessons carried into my work life. He played no favorites. You earned what you got, both individually and as a team. We worked hard, but when I look back now, the rewards were for a lifetime.

It was his way or no way, but that was the good way. As a matter of fact, it was the first-class way. He instilled character. He wanted us to be confident, but he drew the line when it crossed over and became arrogant or cocky. He was there quickly to realign that attitude. I look back on that man, and though he's not here physically, his life lives on.

Most of Schaly's players didn't get a chance to discover how much he truly cared about them until they finished their careers. When they were in college and part of the baseball program, he was tough on them, every single one of them, day in and day out.

McVicar said:

That man loved his family, but he loved Marietta College and loved his players. It was like he did it for us. His enjoyment was not a [championship] ring, but rather watching our joy. I think back now about the love he had for us as ballplayers, as individuals.

We would joke about this in later years on alumni weekends. As a player, you'd go into his office. He'd be at his desk and you had to ask him a

question. You walked in, and he'd make you stand there while he finished what he was working on before he looked up and said, "Well, what the hell do you want?"

But as an alum, you'd walk in, and before you even got to his desk, he'd see you coming and it would be, "Scott, how are you?" Totally different, the way he treated you as a player and the total respect he showed after you made it through the program.

But there was one time after a game when I received an injury and had to leave the field. There was a collision covering second base on a stolen base, and the guy's spikes caught me on the side of the head and put me down. I had a concussion, and they had to take me to the hospital.

It was at Ohio Northern, and Jon Finke hit a walk-off home run to win the regional [beat North Park College, Illinois, 8–7, in 1984] *and get us back to Marietta for the World Series. I got back from the hospital, and I was in the locker room to take a shower. All the other guys were out in the parking lot hooting and hollering. It was just Coach and me in the locker room. He came over and gave me a hug and said, "I'm glad you're okay." I thought, "Oh, my gosh!"*

Bill Mosca had the rare opportunity not only to play for Schaly (1975–78) but also to coach under him (1986–94). He made his first varsity start in 1976 at Davidson College, when Marietta stopped in North Carolina on its way to Florida.

Mosca remembered:

I remember Jim [Tracy, the current Colorado Rockies manager] *hit third, Joe Vogt fourth and me fifth. It's my first varsity start, so I'm peeing my pants. Coach calls me over and says, "Bill, I just want you to know"…he had such a good, dry sense of humor… "Now you're batting fifth—not because you're a good hitter—but after Tracy and Vogt hit balls as far as they will, they might throw at the next guy. It won't harm us if you get hurt."*

I'll never forget that. I'm like, "He's serious, I think." I was like, "Okay, Coach, I'm just glad I'm playing." I'm playing for one of the best coaches in the nation. I'm psyched!

Schaly, probably sensing Mosca's nerves, was just trying to loosen up his inexperienced sophomore infielder. But it was the beginning of a long relationship that took many comedic turns, mainly because Mosca, as an

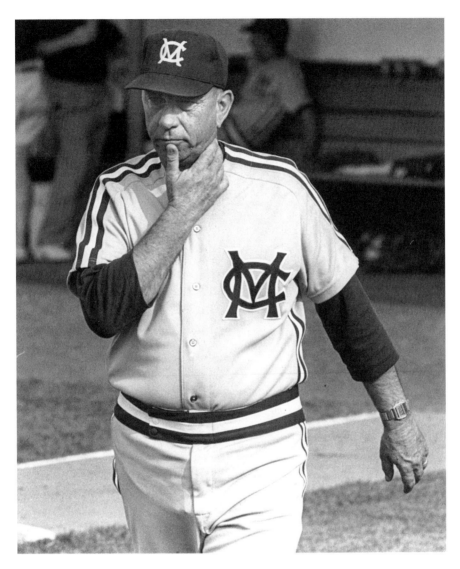

A former standout catcher at Marietta College, Schaly, shown giving signals, knew the game inside and out and displayed leadership skills even as a player that led to his unprecedented success as a coach. *Marietta College Archives.*

assistant coach, was not averse to taking his jabs at Schaly, and the coach certainly wasn't reluctant to turn the table right back on his understudy.

When Jeff Schaly introduced his dad for induction into the Marietta College Athletics Hall of Fame, he told the following story involving Mosca:

The best example of how Dad valued the opinion of his coaching staff is a conversation that took place between Dad and Bill Mosca at Centre College in Kentucky. The team had left Panama City and driven through the night, arriving at Centre College early in the morning for a double-header before returning to Marietta.

Everyone was lying around the locker room and the hallway of the gym trying to get a little sleep before the game. Dad wakes Coach Mosca up and asks him what uniform he thought we should wear. Bill says, "Grey." Dad says, "Okay, we'll wear white." Dad then asks what undershirt. Bill says, "Ones." Dad says, "Okay, we'll wear Twos." Finally, Dad asks what shoe. Bill says, "Spotbilt." Dad says, "Okay, we'll wear Converse." As you can see, Dad always valued the opinion of his staff.

That incident later led Mosca to try a little uniform trick of his own on Schaly:

We were on the spring trip the next year, and I think we were undefeated. We were having fun, but we needed to shake things up a little. So I told the captains to tell the guys, "Whatever uniforms Coach tells us to wear tomorrow, we're wearing the total opposite."

The next day, he came out and he was in his pinstripes, and we were all in our away blue uniforms. He never said a word to anybody. We just got in the vans and went to the game. We got to the ballpark, and the umpire, who we knew, walked up to Coach and said, "Coach, I don't know if you can coach today. You're out of uniform." I was behind the umpire, and I'm squirming. I knew right away, "We're dead. I don't know when it's going to happen, but it's gonna happen."

We wound up losing the double-header that day, which really made it worse. He talked to us a little after the game. All the coaches were in it together, but they blame me, which is fine, because it's ultimately my responsibility. He didn't say anything to the kids.

When we got back to Marietta from the spring trip, the next day we practiced. Then he said to the guys, "Remember that stunt you pulled in Florida with the uniforms?" "Yeah, Coach, we remember." And then he just said, "Start running." We ran around the track. I think it was five or ten miles. It might have been twenty laps. And I ran with them, because it was my idea. It was quite amusing when we thought of it, but it wasn't amusing as time went on.

He and I had really an indescribable relationship. It was just there—the working relationship. We went after each other a lot. It's not like it was all peaches and cream. We argued and fought.

That was part of working with Schaly. Even his son Joe—who played for his dad in 1985–86, was a student assistant coach for four years and a full assistant in 1987 and 1990–91—was not immune to the battles. Joe, who is now the baseball coach at Thiel College in Pennsylvania, said:

He asked me my opinion about a certain situation, and I told him. He sat there and listened and then looked at me and said, "You're a dumbass."

Then he wanted to write down what he thought the lineup could be, and he couldn't find his pencil. He was looking everywhere, lifting up everything on his desk, "Where's my pencil? Where's my pencil?"

I'm upset because he just called me a dumbass, so when he said, "Where's my pencil?" I just blurted out, "You probably smoked it!"

Mosca about fell on the floor laughing so hard.

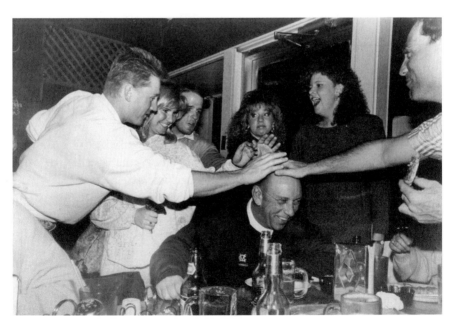

Left to right: Players Drew Witouski and Mike Kramer and assistant coach Bill Mosca, along with three unidentified female fans, rub Coach Schaly's head to see if some of his "bald luck" will stick on them. *Marietta College Archives.*

He always had to have his pencils. Not No. 2—but No. 2½! He kept a supply of them in his desk drawer, and they had to be sharp. One day, Bill [Mosca] went in there—he was mad at him about something—and he broke the tips off every one of his pencils.

We're all sitting there when he comes in and reaches in to get a pencil and found them all broken. He was fuming! We're all trying to keep a straight face, and finally Mosca broke out laughing. We were constantly antagonizing him. We had a lot of fun.

Paul Page didn't play baseball at Marietta but at Muskingum. However, he was Schaly's assistant for seven years, from 1978 to '84, a period that included two national championships (1981, '83). The native of Williamstown, West Virginia, has been the baseball coach at Ohio Dominican since 1988 and maintains a close relationship with, among others, John Schaly, whom he introduced for his induction into the Marietta College Athletic Hall of Fame. Page said:

One of the great Schaly stories is from 1982, the year after we won the national championship. We had almost everyone back, and we went down to Huntington [West Virginia] to play Marshall University. They're Division I, and they beat us bad. It was 11–1 or 11–2, and at the time, I think it was the worst loss of Schaly's career.

He got on the bus, and I mean he was yelling, just going nuts. It was unbelievable. And I mean for a long time. I said, "That pitcher was pretty good."

He says, "Bullshit!"

A few years later, that guy is throwing in the All-Star Game! It's Jeff Montgomery. He stuck it to us. He's throwing ninety [miles per hour] with a big-time slider. And Schaly's going, "Bullshit!" Looking back, Montgomery was pretty good!

In fact, he was a three-time American League All-Star for Kansas City who led the AL in saves (forty-five) in 1993 and once struck out three straight batters on a total of just nine pitches.

"But that gives you an idea of the expectations Schaly had for his players," Page said. "He wasn't going to cut them any slack, regardless of who was pitching."

Schaly probably didn't even know the meaning of "cutting some slack." He demanded everyone play by the rules and play as hard as they could every pitch of every game. That went for both teams.

Mosca recalled:

> *We were playing Tennessee Tech once, and Coach got thrown out. We're*
> *winning the game by at least ten runs, and it's the last inning. This team*
> *is up to bat, and they bat out of order. Of course, I'm running the team*
> [since Schaly was ejected]. *My head said, "Okay, you don't have*
> *to jack your socks. Have some fun here." But he calls me over and says,*
> *"Bill, they're hitting out of order." I said, "Coach, okay, but the score*
> *is..." He said, "They're hitting out of order! Go tell* [umpire] *Mike*
> *Rose right now that they're out of order. That's three outs. You've got to*
> *end the game."*
>
> *I said, "Coach, the kid coming up might not have ever...how much is*
> *he going to...?"*
>
> *"GO!"*
>
> *So I called Mike over, and I said, "Coach* [opposing], *can you come*
> *over?" I brought them both over and said, "Guys, I don't want to do this,*
> *believe me, but I gotta live with this guy behind me over here. Apparently,*
> *you batted out of order." Their coach started to say, "Bill, the guy up next*
> *hasn't batted..." I said, "Coach, I understand that, but look at that man*
> *over there and look at that piercing glare." Their coach said, "I understand!"*
>
> *So the guy was out, and the game was over. That's how into the game he*
> *was, no matter what the score was.*

Jim J. (or J.J.) Tracy, who played from 1976 to '79, recalls Schaly being physically affected by losses.

"Schaly was always fully invested," said Tracy, an all-American in 1977 who's now director of national sales and business development of Morgan Stanley Smith Barney. "After every loss, he was always emotionally drained. He was shaking. He put everything in it emotionally. He'd sit there in the same place in the dugout, the same pose, the same heavy jacket—regardless of whether it was one hundred degrees or forty—and smoking a cigarette. When you lost, he was exhausted and literally shaking when he talked to us after the game in that raspy voice."

One thing that was unacceptable was to question Schaly's authority or instructions on the field. Frank Schossler, a second baseman from 1983 to 1986 who's now on the college's board of trustees, recalls an incident in 1985 involving Monte Duncan, a first team all-America shortstop that season, as well as the conference Player of the Year. Schossler said:

Monte was a senior, a [MC Athletics] *Hall of Fame guy, the best baseball player I ever played with. He was five-foot-five, five-foot-six, 130 pounds wet. He was one of those guys that you hated if you played against him but loved if he was on your team.*

We were playing in the NCAA regional championship game in 1985 to go to the World Series. We were undefeated, and we're winning the game pretty handily. It's Monte's third time up, and he grounds out to the second baseman. Halfway down to first base, he yells some obscenities and comes in and slams his helmet down. Schaly says, "Duncan, don't do it again! It's not the helmet's fault. I don't want to hear that again."

Two innings later, Monte comes up again and pops out to second base. Same thing. He comes in and slams the helmet. We're sitting there, and all of the sudden, you see this hand go out, and Schaly grabs him, picks him up with one hand, spins him around and is holding him against the back of the dugout. His hand is shaking, and he's screaming, "I told you not to do it again. You're out of the game."

We're all thinking, "He's gonna kill him!" We'd never seen him do anything like that.

Well, Monte is a smart ass. He sits down, takes off his spikes and puts on his tennis shoes and walks down and sits right next to Schaly. He's cheering, "Come on, let's go!" At the same time, he's got a big chew of tobacco in his mouth. He could spit so that you couldn't hear anything, and he could hit a target. He's just sitting there clapping, and every so often, you'd see a spit come out of the side of his mouth. He was just pelting Schaly's shoe. Just pelting it! It was one of those things where Schaly didn't know what to do. I think he was just in disbelief.

We had a similar thing happen in '86 to John Hamborsky, a pitcher that was one of my classmates. He was a lot like Monte, pretty fiery. He was our No. 2 pitcher, and he won ten or eleven games that year. He was a little left-hander, and when he'd get in trouble, Schaly would never let him get out of it. He'd just pull him, and John would get mad about it.

After one game, John said, "The next time he does that, I'm going to say something to him." I told him not to, but sure enough, we were playing at Marietta in the second game of a double-header. He gets in trouble, and I'm standing there with him, and he says, "He always lets [Jim] *Katschke get out of trouble, but he doesn't let me. I'm saying something right now."*

Schaly's coming out, and he calls for whoever's coming in from the bullpen. He's got his hand out for the ball, and Hamborsky won't give it to him. He kept saying, "Why are you taking me out? Why are you taking

me out?" All I remember Schaly saying is, "Don't question me on the field." Hamborsky says it again, "Why are you taking me out?" He finally walked off, and when Schaly walked off, he went right for Hamborsky. The next thing we know, they're in a tangle in the dugout. Then John's picking up his bag and walking away. He kicked him out for that game.

Having a pitcher intentionally throw at a hitter is something players and coaches never talk about, but it is a practice as old as baseball itself. It takes place at nearly all levels of the game when someone on the opposing team does something that's viewed as drastically beyond the game's unwritten rules of conduct.

Schossler said:

Ron Fama was a left-handed pitcher from Beckley, West Virginia, a good kid. In 1984, my sophomore year, we were playing at home against Wittenberg. We were hitting, and there was a play at the plate. Our guy slid in, and the Wittenberg guy pounced on our guy and slammed the tag on him real hard. They called our runner out, and when he's getting up, the catcher shoves our guy away. Both benches emptied, but no punches were thrown.

Guys are getting ready to go back out, and Fama is taking off his jacket to pitch. Schaly goes over to him and says, "He's [catcher] coming up. He's the first batter. I want you to hit him on the first pitch." I'm sitting there hearing this, and I think, "Holy shit!" I'd never heard a coach say that before. You could literally see in Fama's face that he was shook up. He didn't know what to do.

He walks out and throws his warm-ups all over the place. Their catcher comes up, and Fama misses him on four pitches and walks the guy. It's early in the game, second or third inning, so no one is throwing in the bullpen. Schaly calls time out, goes out and gives Fama the hook. Fama comes in and puts on his jacket. Schaly's walking off the field, and instead of going back to his seat, he makes a beeline for Fama. He walks up to him and says, "Dammit, Fama. When I tell you to hit someone, hit 'em!" And he walks away and sits down. Fama just sat there.

Two other things Schaly had no tolerance for were being late and not following instructions. Justin Steranka, third baseman on the 2006 national championship team, was in Schaly's last freshman class in 2003. He says he got "lap club," or extra running, on two occasions.

The very first meeting as freshmen, he had everyone write their first-semester schedule, classes and times, on a card and hand it in to the coaches so they could see your classes and work the baseball stuff around your schedule. He said, for some reason, that you had to write it in pencil. Well, I showed up to the first meeting with a pen. It must have slipped my mind. I was the only guy that wrote my schedule in pen.

He called me into his office the next day: "You're going to report to lap club tomorrow at 6:00 a.m. at the field. You owe me twenty laps [players calculated that to be roughly 5.6 miles]." *I said, "Why?" He goes, "Well, I told you to write in pencil and you wrote in pen. Why did you do that when I told you not to write in pen? I'll see you at lap club."*

At first I thought he was joking, but he was dead serious. Then two weeks later, the only other time I got laps, I had to write Pittsburgh, my hometown, on some kind of form. Apparently, I forgot the "h" at the end. Schaly gave me lap club for missing the letter "h"!

It's insane, but it's teaching you to pay attention to detail. I learned that and to respect that. He was a teacher, and he made you a better person, whether you agreed with him or not, it didn't matter. He made you a better person.

A guaranteed way to get lap club was to miss "tarp duty" at the ballpark. Players were each assigned certain mornings to help a handful of teammates either take the tarp off the infield or put it on, depending on prospects for rain. Jim Katschke and Schossler both swear they still have nightmares about it.

"I still wake up in the middle of many nights thinking I missed tarp duty!" said Schossler. "And I have a dream where I'm getting in a game and I can't find my glove. He's standing there, glaring…'It's too late, you lost your chance.'"

Katschke said:

I don't think anyone prepared you more for everything in life than Coach Schaly. Even when you missed tarp duty, you disappointed him because you let down some of your teammates who had to pick up that one extra handle in the rain at 5:40 in the morning. I don't know if I can put a gauge on how that has helped me or molded me to keep your friends, love your family, love people around you and ultimately respect everything you do.

Schaly coached through major social changes in our society, especially during the late '60s and early '70s when the Vietnam War—and protests—were at a peak. Long hair was common on all campuses, including Marietta College, but not on Schaly's baseball team. He held steadfastly to operating his program the way he felt it should be run, and social changes be damned.

"When Coach retired, there was a newspaper article in the *Toledo Blade* that my manager at the time read," said Tammi (Milner) Weigand, one of Schaly's former student secretaries who still works for Marathon Oil in the Toledo area. "He asked if I knew Coach. Of course, I said I knew him very well and worked for him for four years. Then he said, 'How in the world did he conform to all the changes over those forty years and to all the players?' I looked at him and said, 'They conformed to *him!*' He didn't change for the times or for the players."

Though most of the players didn't appreciate it at the time, most of them seem to do so now.

Mike DeMark, a member of Schaly's last freshman class in 2003 who's now a rising star relief pitcher in the Arizona Diamondbacks farm system, said:

> I didn't really get the full picture about all the running until I was done. It wasn't so much the physical part. It was mentally telling yourself you could get through it. I think that was one of the key factors to Coach Schaly's method of coaching. No matter how bad you feel, you can put it out of your mind, and your mind can take over your body and get you through it. We're all stronger than we think we are. That was the biggest thing I learned from him was, "If you put your mind to it, you can do it."

Mosca said:

> He had such an influence on me. The first thing he told me when I was working for him was, "Bill, baseball is a subject, and it needs to be taught." And to this day, I tell coaches I work with as an AD at the middle school, "You are teaching a subject matter." I think he knew I had the ability to coach a sport, but he really made me teach things to a point that if someone did something wrong, he didn't say anything to them. He said to me, "You are not teaching that properly." He would always put it back on us coaches to see what more we could do with that player.
>
> He taught baseball, and he taught life. I think a lot of people just see Coach's record on the field. And to win like that in baseball is remarkable.

But if you look at most of us who went through there and graduated…most people have made an impact on the lives of their families and other people.

I think that's the message people always missed with him. He gave us something that very few people could experience. I'm very grateful for it. I was a little better baseball player, but I know I was a much better man for playing under Coach. It's one of the greatest experiences of my life, right up there with anything, with the exception of seeing my kids born. Playing for him was incredible.

Chapter 3
DON'T ENCOURAGE THE RAIN

To say Don Schaly was a little quirky would be like saying he won a few baseball games. He was an "original," if ever there was one, and it is virtually inconceivable that there could ever be another coach quite like him. He was that eccentric, but then aren't all geniuses?

Rain is a mortal enemy to baseball coaches. It can ruin their day—and sometimes days—like few other things. Perhaps no other coach took his disdain for precipitation to the length Schaly took his. He simply refused to acknowledge it whenever possible. He did this by making the windshield wipers on his vehicle "optional" equipment.

Former Marietta College all-America third baseman Mike Brandts (1984–86) said:

> One time we were driving north from Marietta, probably to Baldwin-Wallace or Ohio Northern, and it's pouring rain. Of course, that doesn't discourage him.
>
> I'm riding shotgun for whatever reason. He's got his cross and Jesus Christ statue up there [on the dashboard]. It's absolutely pouring rain, but he doesn't have on his wipers. You can't see a freaking thing, and I'm feeling a little at risk here!
>
> I said, "Coach, don't you want to use your wipers?" He said, "What the hell do you want me to do, Brandts, encourage the rain?"
>
> He drove without his wipers because he didn't want to encourage the rain! I couldn't see! I was concerned enough to ask him to turn on his wipers. That's pretty telling right there!

In more ways than one…

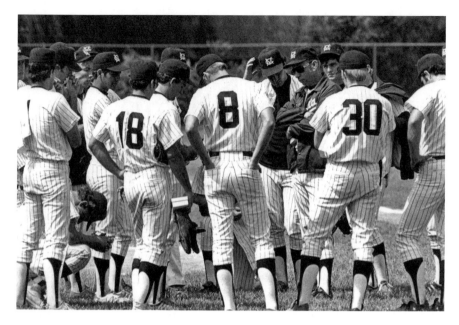

If the Pioneers weren't playing up to Schaly's expectations, he was quick to gather the players for a stern post-game lecture that might be followed by some extra running to help him get across his point. *Marietta College Archives.*

That wasn't a one-time occurrence. Schaly regularly avoided the windshield wiper switch like it would deliver an electric shock if he touched it.

Tom Galla, an all-region second baseman in 1968, said:

> *Most of the time, we walked from the field house* [where the team dressed] *to the field* [roughly a mile]. *One day, for some reason (perhaps because it was raining!), I got in his car. I was lucky enough to get a ride. And I'm sitting there thinking to myself, "Why doesn't this guy turn on his wipers? What's going on?" So I asked him, and he said, "It's not raining."*
>
> *I guess he figured if he didn't put his wipers on, it wasn't raining. He was a beauty!*

"Rainout" was a four-letter word to Schaly, and he would do anything to avoid one. As proud as he was of all the upgrades that were made to Pioneer Park, his favorite probably was the infield tarp.

The Story of the 'Etta Express

Jim Pancher, an all-America infielder who played from 1980 to 1983, said:

I remember a game we had at Wittenberg [Springfield, Ohio]. It's just pouring down rain. We shouldn't even leave Marietta, but he says, "Get in the vans. We're going." We're talking to people up there, and they say the field's not playable. But we get there, and we have to start working on the field to help them. It's pure mud.

We go inside and wait to see what's going to happen. We're thinking there's no way we'll play. We're ready to pack up and leave, but then Schaly comes in and says, "Guys, I've got some good news and some bad news. The bad news is we're going to have to wait a little longer here." We're like, "What the hell is the good news?" He says, "The good news is they allowed us to put the lights on. We're playing two!" We looked at each other, and I don't know how many f-bombs were dropped. We played a double-header in mud.

In Schaly's mind, there were two ways to do things—his way, which always was the right way, and every other way, which always was wrong. There was no gray area on anything. He never was shy about letting someone—regardless of who they were—know they were doing something that he felt was wrong.

For decades, he was the only Marietta College coach or employee with a reserved parking space. Parking was at a premium on the small campus, and he felt he needed his own spot next to the field house where the athletic offices were because the baseball facility was a mile away. He constantly had to drive recruits and their families to see the facility.

Somewhat valid logic, perhaps, but it ruffled a lot of feathers over the years, especially when someone parked in Schaly's space and was "booted" by the coach. His "boot" was to park his vehicle bumper-to-bumper against the offender's vehicle, forcing that person to track him down and ask him to move his car. He often greeted wrongdoers with some rather hostile words, and he usually wasn't quick to move his vehicle.

Debbie Lazorik, athletic director from 1991 through 2003 when Schaly retired, said:

Don had a reserved parking spot, and when someone would, by accident, park there, the manner in which he dealt with some folks…I had to tell him, "Coach, you just can't do that. You can't be like that." One time, our CFO…she didn't know…parked in his spot because over time, it

[Schaly's name] *wore off* [the field house wall], *and the college didn't want to repaint it because it was controversial. Administrators didn't even have one. I mean,* nobody *had one. There was only one person I know that ever—to this day—had their own parking spot.*

So, that day, the CFO parked there. And whenever someone did that, he would take his truck and back it in. What you had to do was find him, and then when you found him, it was not pleasant. He wouldn't cross the line with his language, but he would get right in your face. Jean Arbuckle [softball coach] *and I saw him back up against the CFO's car, and we just said, "Oh, my God!"*

Schaly's biggest vice, without question, was smoking, which took his life through lung cancer at age sixty-seven. He smoked in his office, in the dugout and everywhere else. Over the years, it cost him some secretaries who couldn't work in the cloud of smoke that permeated his office, and it also caused some administrative problems, particularly when the coaches' offices were moved into the new Dyson Baudo Recreation Center opened in 2003, the year he retired.

Paul "Doc" Spear knew Schaly longer than possibly anyone else at Marietta College. Spear, who graduated from MC in 1964, the year Schaly became coach, developed the college's sports medicine program and served as athletic trainer for a number of sports, including baseball, where he remains active.

Spear, who is the proud owner of five national championship rings, said:

When we did the baseball physicals, Coach always did the height and weight, because he didn't trust anyone else. So he stood at the scales with a chart and took the actual weights and heights. I always took his blood pressure, and he always bragged because it was better than a lot of the players, but his eating habits were terrible.

He drank coffee constantly and ate snacks out of his old office. He had that thirty-gallon canister of coffee, and he drank that every day and ate peanuts and cashews. He loved cashews and drank Pepsi, too. But he drank coffee all the time.

I'd go into his office, and it was so smoke-filled that all the pictures of players on the walls were yellow. I'd say, "Coach, you've got to quit smoking!" And he'd say, "Oh, go to hell!" That was his favorite expression—that and, "That's bullshit!"

Several people said Schaly did try to quit smoking a few times, but he couldn't stay off cigarettes very long.

The person who probably tried hardest to get him to stop smoking was his younger sister and only sibling, Joanne Schaly Warren, who lives in Cranberry Township in western Pennsylvania, not far from where they grew up in Ellwood City. When their father, John Schaly, a smoker, was diagnosed with lung cancer, she left Slippery Rock College, where she'd just finished her first semester on a full scholarship, to go home and help care for him. Joanne said:

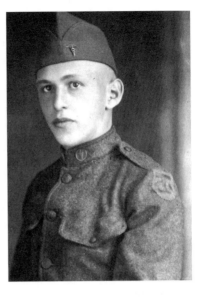

Coach Schaly's father, John Schaly, was studying to be a brain surgeon at Georgetown University when World War I broke out and he was drafted into service and trained to be a medic, a duty he carried out in combat. *Joanne S. Warren.*

Daddy was only sixty-one when he died of cigarettes, like my brother. I talked to Don about quitting, but I never got very far. I'm still angry about his smoking, and he knew it. He wouldn't tell me [about his lung cancer] *until he had to. Of course, we went to Florida and were with him when he died. In fact, on March 7* [, 2005]—*our father died on March 7—Don looked at me and said, "Joanne, I'm not going to die today," and he died two days later on the ninth.*

He didn't see my father suffer because he was at Marietta. I quit school and tried to help Daddy, but I saw him suffer, and I didn't want anyone—let alone those I loved—to smoke. I loved Don so much, and I didn't want to lose him like that.

When we were kids, Daddy smoked. I'll never forget, one day Don walked up with three or four other kids, and they'd been smoking and taunting him to smoke. He said, "I'll show you." Daddy was working in the garden, and Don went up to him and said, "Hey, Dad, how about a cigarette?" Daddy took his cigarettes out of his pocket and threw them to Don. Don said, "See. You guys have to sneak. I don't have to sneak."

He threw them back to Daddy and said, "Thanks, Dad. I don't want one right now." He was not smoking at that time. He didn't smoke in high school. He didn't smoke until he started coaching.

At Marietta, Schaly went to great inconvenience to continue smoking when times and the athletic facilities began to change. His stubbornness and his addiction became an even larger part of his legend.

Lazorik said:

> *When they made some improvements and did some remodeling to old Ban Johnson* [Field House], *we gutted the space. We all had to leave. But guess what? Only one person refused to vacate the building. He worked there throughout the summer—in all the dust and all that noise. I could not convince him to get his office remodeled.*
>
> *I look back on that, and I should have forced him to do that. But you know, there are only so many battles you can fight.*

The next step was construction of the grand Dyson Baudo Recreation Center, where the athletic offices would move.

Lazorik said:

> *We all* [athletic staff] *had to move to Timlin* [an old dorm that was vacated] *during construction. This is something that's hard to believe, but he did this. We're in Timlin. It's moldy and musty. He could smoke there, because you could only improve the air quality at Timlin! But when we're getting ready to move into the new building, he came to me and asked if he could keep his office in Timlin. He did not want to move into the new building. He got himself settled in, and he knew we were going to enforce the smoking. He knew there was no wiggle room. So he had to go outside the north end of the* [new] *building to smoke.*

To know and understand a man, it's imperative to find out just where he came from and what type of family background and environment he was exposed to during his formative years. Schaly was born and raised in Ellwood City, a small town thirty miles northwest of Pittsburgh. It was a blue-collar community, predominantly a mill and mining town, when Schaly was growing up (born October 10, 1937).

His parents, John and Mildred, were both born in the United States, but three of his four grandparents were immigrants from the Alsace region of France that bordered Germany and was under German rule at times. John was the disciplinarian, and Mildred was "just a quiet, sweet, wonderful woman. She was like an angel, really. She'd do anything for anybody," said Joanne, Schaly's younger sister.

According to Joanne, Schaly is a German name. The correct pronunciation is SHAWL-ee, "like a shawl a woman wears around her shoulders," Joanne pointed out. However, even those who knew him best and longest often mispronounce it.

"We had such a wonderful time growing up," Joanne said. "We had so much fun, and it was such a good place to be. Our parents always taught us that if a job was worth doing, it was worth doing right or to the best of our ability. They didn't expect perfection, but they did expect us to do the best we could do."

Their father actually was at Georgetown University, studying to be a brain surgeon, when World War I broke out, according to Joanne. He was drafted and trained to be a medic, a role he followed in combat. When he returned home, he held several jobs, including chiropractor, house painter and crane operator in a mill. He built the house they lived in "stick by stick," Joanne said. She remembered:

When my father was a boy, they weren't allowed to play sports because they had to work. So when Don got interested in sports, Daddy wanted him to be able to do it. He was always good at sports. He was first-string center on the high school football team and first-string catcher on the baseball team. His baseball was ruined because he played football and hurt his knees and had to have them operated on while he was going to Marietta. He used to have a couple of big-league teams interested in him, but his running wasn't fast enough after his surgeries.

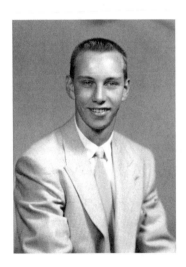

As a high school senior in Ellwood City, Pennsylvania, Schaly was a star center on the football team, as well as a standout catcher in baseball. *Joanne S. Warren.*

Once during football practice the night before our big game of the year with New Castle, Don got cleated in the face. The coaches just took him to the hospital back then and didn't call the parents. He comes home with his eye all bandaged and tried to sneak in through the dining room—like our mom's not going to see him! But she sees him with that bandage across his face and yelled, "Don, what happened to you?" He said, "Oh, nothing, Mom. Just a couple of stitches."

They went everywhere to get him a special helmet so he could play the game the next day, because they needed him. So he played, and he had this special helmet with a big star on the front of the helmet, and it had a special guard across the eyes that would protect him better.

My mother was a nervous wreck. She normally did not go to the games. She stayed at home and prayed that he would be safe. My dad was at every game. They won the big game, and the headline in the paper the next day said, "Lone star helmet helps win big game." Then it proceeded to say in the story that he had sixteen stitches in his head.

Well, my mother went to that game with her rosary beads in her pocket. She sat there praying the rosary, because she was so worried about him with a "couple" of stitches in his head. She would have been praying at home normally, but she was so afraid he was going to get hurt that night, she wanted to be there. She sat there with her hand in her pocket and praying the rosary the whole game. She had no idea he was hurt as bad as he was.

Religion was very important to Schaly, a devout Catholic. He always included the Catholic church on the tour of Marietta he gave recruits and their families, and he always made sure the players had access to church services when they were in Florida on the spring trip. Supposedly, the only Sunday he missed Mass was when the team got back to Marietta after driving all night from Florida.

Bill Mosca was Schaly's assistant coach in 1990 when he got married. It was not a Catholic service, but to appease Schaly, a Catholic priest was there. Mosca said:

When Mary and I got married twenty-one years ago, Coach was very upset that we weren't having a Catholic priest. It was a wonderful ceremony in Mary's house, and Mary knew how much it meant to me—so we had a priest stand in, and I didn't even know the guy. But Coach might not have gone if I didn't have that priest there.

Some people might say, "Why did you give in to him on that?" It was just that that's the thing you loved about him. There was no gray area. You knew exactly where you stood with him. I wanted a priest there to make sure he would come.

The rituals and customs in the Schaly home when Don and Joanne were growing up give quite a bit of insight into the type of father figure he became to many of his players.

The Story of the 'Etta Express

"We came from a family that at seven o'clock at night, you knelt down and prayed the rosary when it was on the radio," said Joanne. "If your friends were there, Daddy would invite them to kneel with us. That's just what we did. It's just the background of our family."

Don and Joanne's fraternal grandmother, Mary Schaly, lived three blocks away and was at their home much of the time. She lived to be ninety-eight, and perhaps this is part of the reason why she did, according to Joanne:

> *She would mix up carbolic acid water. She'd put ten drops of carbolic acid in a glass and put hot boiling water in it to dissolve it real good and then fill it with cold water. Before we even went to school in the morning, we'd gargle with this carbolic acid water. It didn't taste bad. You didn't swallow it. And when we came home from school, she'd have us gargle with carbolic acid water again. We never got colds! It killed the germs.*

Schaly wound up going to Marietta College at the suggestion of his high school football coach, Al Como, who graduated from Marietta. Como was the brother of famous singer and TV personality Perry Como.

This photo, circa 1957–58, shows Don Schaly (back row, far left) as he looked when playing for another Marietta College coaching legend, Don Drumm (right). *Marietta College Archives.*

Schaly majored in math at Marietta, graduating in 1959, and got his master's in physical education at Penn State the following year. He then taught math and coached baseball three years at Midview High in Grafton, Ohio, before returning to his alma mater in the fall of 1963 (1964 was his first baseball season).

As soon as he got to Marietta, he made a statement about how he was going to run his program. At that time, the Pioneers played home games at Don Drumm Stadium, a football field and track but not a baseball facility at all. Schaly considered it to pose a significant injury threat to his players, so he simply told athletic director Bill Whetsell, who hired him, that his team would not play there. Instead, he dragged his team all over the public parks and high school ball fields in the area for the next four years.

Pioneer Park opened in 1968. The college acquired what was known as the Swan Property for $75,000, and an additional $17,000 was used for the first improvements, according to Dan McGrew's "In the Various Branches of Useful Knowledge" (1994). Much work went into making the facility the showcase it has become, and Schaly did a lot of the work himself or persuaded local contractors and volunteers to do it for him and even to donate materials.

He built the concrete block dugouts himself, though they were nothing but slabs with benches when the facility originally opened. Although the Marietta baseball program's budget is certainly anything but big time, Schaly always managed to get the most out of the resources he had. The program today has come a long way since the early days when the team often traveled to Florida riding in the players' own vehicles.

Al Prish, an outfielder from 1967 to 1970 who still holds the school record for fastest average time to first base, said:

> When we went on those trips, we'd take a whole convoy of station wagons. We didn't have vans. We were in these station wagons, and the back seat faced away from the road. So if you got stuck in one of those back seats, as underclassmen usually did, you just watched the road go away and you were sick as a dog by the time we got where we were going.
>
> I remember playing a double-header at Duke, and I got bopped on the knee. I didn't think anything of it at the time, and we hopped in the station wagons, and I was in the back seat with my knees up to my chest for four hours, driving to our next game. I could hardly stand up when I finally got out of there.

Speaking of knees, Schaly's were not particularly good, thanks to playing football, but that didn't stop him from strapping on the catcher's equipment for a memorable appearance in the 1990 Alumni Game, an annual event in which former players return to campus and play a game against the JV team.

Kent Tekulve had finished his remarkable Major League career the previous year and was among the alums. Schaly, at age fifty-three, just couldn't resist a once-in-a-lifetime opportunity to play his old position for an inning and see what it was like to catch his most-famous former player and to see if he could handle Tekulve's Major League stuff—at least stuff that had been in the Majors a year earlier.

Tekulve said:

I didn't know Schaly was going to do that. There were two moments in alumni games that I will never forget. The second was when Chris [his son] was a freshman and I pitched against him. I struck him out! I'd only been retired a few years, so I still had enough that I could get him out.

But the first one was the year after I retired. I'm one year away from pitching in the big leagues. The kids on the freshman team are hitting against me. They're going, "Wow, that really moves!"

Coach is sitting there laughing. He says, "Just remember one thing. That's not good enough to pitch in the big leagues anymore."

Anyway, it's the last inning, and here he comes with the gear on. I'm thinking, "Oh, my God." I knew not to argue with him. He's going to do it. Never in my life did I put so much effort into throwing pitches that hitters would hit so the ball wouldn't get to him. I tried to take movement off it, backed off on velocity...fortunately, I could still throw it pretty much where I wanted to.

I did run into a pretty good group of freshmen hitters that if I straightened it out a little, they could get a bat on it and put it in play. I can't remember how many pitches got through to him, but every time one did, I was wincing. I was never so relieved—including the seventh game of the 1979 World Series—to see an inning end. He was still upright.

I'm saying, "What are you thinking?" Obviously it was something he thought about sometime that he wanted to do. It was probably a fifteen-pitch inning. I remember taking a deep breath and a sigh and thinking, "Thank goodness this is over." I was so relieved. Why in the world would he do that?

Ironically, one of the hitters Tekulve faced that day with Schaly catching was a freshman from Baltimore named Brian Brewer, who would replace Schaly fourteen years later.

"Teke got me out, but he managed to throw it in the strike zone, and Coach managed to catch it," Brewer recalled. "After the game, Coach introduced me to him. He said, 'Brian, this is Mr. Tekulve.' And I said, 'Mr. Tekulve, my dad doesn't like you a whole bunch.' He immediately said, 'Let me guess—you're from Baltimore.'"

Pitching for Pittsburgh in the last game of the 1979 World Series, Tekulve had retired the Orioles in Baltimore to win the Series for the Pirates.

Why was Schaly so successful? There are many reasons, probably starting and ending with his relentless work ethic. But his son Joe knows there was more to it than that. The Thiel baseball coach said:

> *I asked myself many times, for my own sake, what made him so successful. He could get the best out of his players. He had so many guys that had average talent, average skills, that would become great baseball players. He'd get everything out of them that he possibly could, and I'm not sure how he did it. I guess it was a combination of discipline, hard work. Somehow, Mosca said, he could squeeze water out of a rock.*
>
> *When I was on his staff, I wouldn't agree with some of the decisions he made, and I'd sit there and argue with him. He'd say, "So and so should play here," and I'd disagree. But 99.9 percent of the time, he was right. He'd see something in kids that no one else saw.*

Many of the things Schaly did routinely in running the Marietta College baseball program defy belief. But they are fact and not fiction. Most people believe he was in his office every day except Christmas and when the team was on an overnight trip. His days weren't short either. They often stretched into the evening hours or even later.

He was meticulous about details, especially his recruiting system, which was years ahead of its time. In fact, there probably were very few other Division III baseball coaches doing systematic recruiting like he was in the '60s and '70s. Not to mention, that was before the advent of personal computers, so he was doing everything either by hand or by pecking—using only his index fingers—on a manual typewriter that was one of his trademarks until retirement. In fact, it's now an "artifact" on display in the Schaly Lobby of Ban Johnson Field House.

Sporting his customary pencil behind his right ear, Coach Schaly makes a point to longtime assistant coach Bill Mosca during a game. *Marietta College Archives.*

His devotion to creating and maintaining a first-class playing facility at Pioneer Park was so great that a typical Schaly family outing in the summer was a trip to the field, where everyone joined in pulling weeds from the warning track.

Tekulve, who had a twenty-one-year career in professional baseball and continues working for the Pittsburgh Pirates to this day, said:

> *I've never been around anyone in the sporting world that worked like Schaly did. I wasn't around guys like* [college football coaching legends] *Woody Hayes or Bear Bryant, but I don't see how anyone could have worked longer hours than Schaly.*
>
> *The only time he was home was having dinner at eleven o'clock at night or sleeping. He was 100 percent into the program, and so were Sue* [his wife] *and their* [four] *boys. He's doing what he was doing, and she was taking care of everything else for the entire family. It was like he was on a road trip for the entire school year. He was always in that office. I don't know how anyone could have spent more time than him working on a baseball team. I can't comprehend it.*

Recruiting is drastically different now at the Division III level and requires the coaches to spend a lot of time on the road in the summer watching players. Schaly didn't do that. He did it all by asking his former players, along with high school coaches, to send him prospects. He made extensive mailings to those prospects, and once he got them and their parents on campus, he usually closed the deal, even though he had no athletic scholarship money to offer.

"Recruiting is a lot more competitive now than it was," said Mike Deegan, Marietta's associate baseball coach. "What I always say about Coach Schaly is what a pioneer he was in recruiting. I rack my brain doing a lot of recruiting, thinking, 'What would Coach Schaly be doing now?' People from the '70s and '80s still say today—and these are people from Connecticut or Chicago or wherever—that they got two recruiting letters. They got one from their local college and then one from this school in southeast Ohio.

"He was relentlessly, meticulously following up on every single lead."

That's why he was in the office every day—for as long as it took.

"He wasn't just a baseball coach—he was the chairman of the board," said Tom Galla, an all-conference and all-region infielder from 1967 to 1970. "Unfortunately, he was chairman of the board, but he did most of the work, too! He didn't mind getting his hands dirty."

Schaly never stopped coaching and managing, literally until his final hours. Some would say, "as fate would have it," he died while accompanying the baseball team on its annual spring trip to Florida. Others know better. Fate had nothing to do with it.

Tekulve recalled:

> He gets buried in his uniform, and afterward I'm thinking back…He passes away in Port Charlotte, Florida, after spending his whole life in Marietta. But he's in Port Charlotte because he was there with his baseball team. John [his son] was there with his baseball team—Ashland. Joe [his son] was there with his baseball team—Thiel. [Sons] Jim and Jeff were there. Jeff was the sports information director at Lynn [Florida] University, and Jim was umpiring.
>
> We always used to kid about Schaly—he could make it rain or he could make it not rain. He had more power than God and could get done what he wanted to get done. When you look at it, Sue was there, of course. Mike Wright [who pitched a no-hitter in Schaly's first game in 1964] was there, I was there, Spear was there, his sister, Joanne, Debbie Lazorik from the college, Jean Arbuckle came over.

The Story of the 'Etta Express

He could manage anything the way he wanted. He could make things happen the way he wanted them to happen. To have his whole family and everyone that was important to him around when he passed away, even though he's in Florida instead of Ohio, he planned it that way. He made things happen, rather than reacting to what happened, and he did it right up to the end.

Just prior to passing away in the hospital, Schaly attended one of Marietta's games, even though he was on oxygen and wheelchair bound. All-America outfielder Chris Sidick, who played two years for Schaly (2002–3) and then two for Brewer (2004–5), and pitcher Mike DeMark were the two last active players he talked to that day. Neither will ever forget the experience.

DeMark, a junior at the time who later served as one of Schaly's pallbearers, said:

He pulled me and Chris Sidick aside. He said, "You've got an opportunity to go on and play, and I hope the best for you." That was the only conversation about playing afterward I ever had with Coach Schaly, and here he was in a wheelchair still wanting to teach and motivate. He really impacted my life in that respect. I always craved his approval. I always wanted him to think I was good. To have him say that was awesome.

When they pulled up that day and he got out of the car, it was hard to see him like that. It was like our father away from our fathers. It was that tough love that showed he cared about everybody, and here he was so sick, on his deathbed, and he's out there watching Marietta baseball.

I also remember him saying to me that day, "Hey, DeMark, what inning is it?" because they didn't have a scoreboard. I said, "I don't know, Coach." And he goes, "What do you mean you don't know? That's bullshit!" I'm thinking, "This is the last time I'm going to get to talk to him, and I blew it." He was a trip! He was so old school it was awesome!

Sidick now plays professionally for the independent Washington (Pennsylvania) Wild Things, and he owns and operates a new $2 million baseball training facility in Washington. He also was a pallbearer. He said:

I remember it was really hot that day in Florida. I was out in center field in the second inning. Schaly was in our dugout in a wheelchair, looking real skinny, sitting there watching the game. I came in at the end of the inning, and Brewer grabbed me before I went to the plate and said, "After this at-bat, go talk to Schaly." I figured it was like to say goodbye.

It was in the middle of the game, and I had my mind everywhere. I remember I got a double, then someone got a hit and I scored. I walked straight over to Schaly. He grabbed me and said, "Chris I gotta go, but there are two things I want to tell you." I said, "What's that?" He grunted at me and said, "Dammit, don't throw the ball from center field to first base [behind the runner]. *It's bad baseball!" He just yelled it at me, because I used to do it all the time, and he'd always get mad at me.*

Then he looked at me again and said, "I just want you to know, you're going to do great things in baseball." I said, "I appreciate it, Coach." We had to go back out in the field, and we saw him leave. He got in the car with Sue, and they left. We finished that game and found out later that day that they were trying to take him to the hospital, but he refused to go. He sat in the car with air conditioning and watched the rest of the game from behind the outfield fence.

I have that quote from him printed with his picture and hanging on the wall in my place: "Chris, you're going to do great things in baseball." That's the last thing he said to me. I think about that all the time. I'll be out in center field in a random game, and it's six years after he passed away and I'm still playing baseball. Sometimes I gear up to throw behind the runner—but something always stops me.

The biggest thing I remember from playing for him is the respect I had for him, because I never really played for a coach like that before him. He was so involved, knew the game so well, was so committed to the team. It was nice to know you were playing for him, and in every at-bat, you were pretty much playing to gain his approval.

Many former Marietta players came back to the college for his memorial ceremony. The night before, there was a get-together at the Town House, a restaurant and bar that was a favorite hangout for baseball players. And after the ceremony, there was a large reception at Ban Johnson Field House, which is named after a former Marietta student who just happened to be the founder and first president of the American League and is a member of the National Baseball Hall of Fame.

"There were literally generations of Marietta College baseball players that came back," said Tekulve. "And over all those years he coached—forty—nothing had really changed. Very stable operation there! His opinions and what he was going to do never changed, which all of us agreed at the end was much better than if we had been able to get him to change anything."

Schaly's body is entombed in the mausoleum at East Lawn Memorial Park in Marietta. On the way to the cemetery, the immediate family stopped at Pioneer Park.

"Sue laid flowers on home plate and said, 'Don, I know you wanted to be buried here, but they won't allow me,'" recalled Schaly's sister, Joanne. "Then she went over and sat in his seat in the dugout and left flowers there, too."

"He always said he wanted to be buried at Pioneer Park, but I knew the city would never go for that," said Sue. "So I wanted to tell him, 'Even though you always wanted to be buried here, it's not possible. We just can't do it.'"

It certainly was the end of an era in many respects, but one of the most amazing parts of the story is that the program Schaly started practically from scratch not only still has life but also has the tremendous success he envisioned from the beginning.

Mosca said:

> At his funeral, I was like a baby. I cried like a baby, just like I did when my dad died. It was very emotional. There were other players that put their arms around me. It was very emotional.
>
> But I think now of the love Coach had for all of us and for Marietta, because he could have gone to a lot of other places. He could have gone to Tennessee, among others. But he loved Marietta and the type of people he turned out. When John Wooden [UCLA basketball] left or Bear Bryant [Alabama football] or any of those great coaches, people would say how hard it was to replace them. People said they were too good to replace.
>
> I always felt what Coach taught us is the sign of having something good is that it will sustain itself when you aren't even there. People don't understand what Coach built was a culture. All those other people built a great team and programs while they were there. Coach Schaly built a culture that I think has allowed Brian to do what he has done.
>
> I think what that says about Coach is it enhances his legacy even more. It's sustainable. When Brian took over, he knew what was expected of him, and he carried on the culture. Some people might think because Brian is doing it, it shows that anyone could do it. No, it enhances what Coach did.
>
> Coach is up in heaven now, maybe somewhere at Don Schaly Stadium, probably smoking a cigarette and saying, "This is what I built." He wanted it to sustain itself.

Chapter 4
A FAMILY AFFAIR

The 1956 film classic *The Ten Commandments*, starring Charlton Heston and Yul Brenner, was one of the most popular and financially successful movies of all time. It enjoyed a particularly long run around the small town in southeastern Ohio that's named after Marie Antoinette, the queen of France who helped the underdog colonists upset the Redcoats.

In the winter of 1959, John Donald Schaly, a senior at Marietta College and a BMOC, decided to ask a fetching local girl and Marietta freshman by the name of Sue Knicely on a first date.

"We went to dinner first and then to the movies to see *The Ten Commandments*," said Sue, who eight months later (on August 29, 1959) became Sue Schaly and eventually the matriarch of Marietta College baseball. "I had not seen it before, but he'd seen it *five* times!"

Perhaps Schaly's fondness for that movie was an early sign that young men who went on to play baseball for him would be subject to a set of rules and a manner of conduct that probably would have brought Moses to his knees: "Thou shalt never be late! Thou shalt run and run and run some more! Thou shalt not miss curfew! Thou shalt use a pencil—not a pen! Thou shalt be better prepared than any other team! Thou shalt make your beds before we check out of a hotel!"

You get the idea, and yes, Marietta College baseball players do indeed make their beds and take out the trash before checking out of a hotel so that they leave it in the condition in which they found it when they arrived.

But back to that date. It had as much impact on Schaly's baseball program as anything he did. Sue, married to Don for forty-five years, became the

ideal "first lady" of Marietta College baseball, and together they had four sons, all of whom were involved in Pioneer baseball in some way, graduated from Marietta (John 1982, Jim '84, Joe '86 and Jeff '90) and went on to pursue careers in athletics. Sue remains the baseball team's number one fan and even has her own reserved parking space at Don Schaly Stadium.

"Don could never have made a better choice for his wife than Sue," said Schaly's sister, Joanne Warren. "She has always been the most wonderful wife. She adopted all the kids that played ball at Marietta. I told Don that marrying Sue was the best decision he ever made in his life, and I mean that."

The way the Schalys got together is a classic Marietta College story. Don, a senior, was president of the Newman Club for Catholics, and Sue was a member of the organization.

"He needed people to work at the stadium for Homecoming," Sue recalled. "I was a lowly freshman, and he called and I agreed to do it. Back then, in the '50s, you got dressed up for something like that. I wore a brand-new pair of suede shoes to the stadium, and it rained the entire time. Those shoes were ruined. That was my first experience with Don Schaly!"

For a couple of months, that was all there was to it. Then, in January, Sue's phone rang.

> *I was from Marietta and lived at home, not on campus. He calls my house, and my mother takes the message that I'm supposed to call him back. I figured he wanted me to volunteer again, so I called him. I asked him what he wanted, and he said, "Well, I want to ask you out for a date." Just like that—out of the blue! We'd never talked before except when he asked me to volunteer at Homecoming. I said, "Okay…when do you want to do this?" He had it all figured out when and what we would do.*

Dinner and *The Ten Commandments* followed.

> *We're in Parkersburg [West Virginia], and I figure we're coming back to Marietta after the movie. But he drives to City Park in Parkersburg and parks the car. I'm thinking, "Now wait a minute!" He says, "Get out." I've got on high-heeled shoes, and it's winter, and it's slushy and slippery. He wants to go for a walk in City Park, and he wants to hear all about my life. I froze to death, and I almost fell and broke my neck! Of course, I asked him about his life, and I got a very abrupt, abbreviated version of his.*

The two dated several times after that, and Sue was expecting Don to ask her to the Sig formal (he was Alpha Sigma Phi). But she waited and waited, and it didn't happen.

> *Finally, he says, "I've got something I want to tell you. You know the Sig formal is coming up soon. Well, I already asked a girl back at Christmas vacation." It turned out she was a Marietta College girl that also was from Ellwood City. He asked her in December, and he didn't know how to get out of it. So, therefore, he's taking her to the formal, and Sue's going to sit at home. But he sent me a large bouquet of flowers, and we picked up from there!*

However, Zeke Wallis, one of Don's fraternity brothers who became a lifelong friend, actually tried to step in and put a stop to the relationship. That spring, many Marietta College students were in Fort Lauderdale during spring break, and they got together one evening for a bonfire picnic on the beach. Sue recalled:

> *Zeke Wallis comes over and sits down on the blanket I'm sitting on and proceeds to tell me why I should not date Don Schaly. He says that he's a love 'em and leave 'em guy. He went on and on, and even said he had another guy he wanted me to date. Well, I didn't listen to Zeke, and I'm glad. I didn't tell Don that for some time, but we've had a good laugh over that many times. Zeke would say, "Dammit, Schaly, I told her not to marry you."*

Wallis was two years younger than Schaly but roomed with him and two other students in an apartment on Putnam Street. Wallis, who wound up speaking on behalf of the Marietta community at Schaly's retirement celebration nearly forty-five years later, said:

> *Even then, Don showed signs of leadership. I had some academic trouble, and he set up study times when we didn't do anything but hit the books. It helped me a lot. And he also handled all the money and made sure the bills got paid. He had a great work ethic, even then, but he wasn't very socially oriented. He didn't go to parties at the fraternity house, and he didn't date that much.*
>
> *I remember that night on the beach in Florida. I'd gotten fairly well intoxicated, and we got to talking about Don. Sue was asking me what I*

thought of him. She might have even mentioned they were thinking about getting married. I said, "Sue, I really don't think you should marry him. He's not very sociable. I'm not sure this will work out." She said, "I really like Don," and I said, ""He'll probably be good to you, but I don't think you'll have many parties."

Lo and behold, before I left for the summer, Don told me he was getting married in August and asked me to be in the wedding!

The couple spent a year at Penn State, where Don got his master's, and then moved to Grafton, Ohio, for his first job at Midview High School, before they got back to Marietta in the fall of 1963. John, their first son, was born about two weeks before they left Penn State.

The Schalys first rented a place on Seventh Street but then eventually settled into a home on Harmar Hill overlooking Marietta and raised their four sons there. Actually, Sue did most of the "raising," while Don was down on campus seeing to their other seven hundred or so "sons" in the baseball program over forty years.

"Dad would say, 'Family, God, Marietta baseball,'" said Jeff. "What blurred the line so much is the way he ran Marietta baseball, because Marietta baseball was family. I don't know if my mom loves me a heckuva lot more than she loves some of those players!"

It's generally believed by people who knew Schaly that he went to the office every day he was in town except Christmas. Sue confirms that and adds quite a lot of color to the story with his Christmas Day rituals:

Our houses were real close together up on Harmar Hill, and we had privet hedges along two sides. He always waited until Christmas to trim back the hedges. He would go out and trim them, and then he'd want the kids to come out and rake it up and put it in a wagon and go across the street and through the neighbor's yard to the woods to dump the trimmings. They would be so mad at their dad. I'm sure people in the neighborhood got used to it, but the first few years, they probably thought, "That guy has a screw loose!"

But don't get the idea that there wasn't plenty of Christmas spirit in the Ol' Man, too!

He was one of those that nothing was done for Christmas until Christmas Eve—putting up the tree, putting toys together, everything. We would be up all night because of that stuff. He would go to midnight Mass, and I would

go to 7:00 o'clock or 7:30, whatever it was. He'd put all four of the boys in one bedroom and make them stay in bed, and then he would lay down on the floor, inside the bedroom, up against the door so they couldn't get out and see Christmas until I got home from church. He was a character!

The Schalys' oldest son, John, is the baseball coach at Ashland (Ohio) University. He's won 910 games in his career, through 2011, and likely will someday join his father in the very elite 1,000-victory club. Of course, he also was the MVP of his dad's first NCAA Division III World Series championship in 1981.

Second son Jim is the "black sheep" of the family. He's an umpire—and a darn good one! He works college and professional games and, in 2011, worked the College World Series in Omaha for the first time.

Joe is the baseball coach at Thiel College in Greenville, Pennsylvania. He's won 404 games in his career and, like his dad, is a member of the NCAA Baseball Rules Committee. Don, John and Joe have won a combined 2,756 games—and counting!

Jeff, the Schalys' youngest son, is Marietta College's assistant athletic director for sports information and compliance.

Joe Schaly, now the coach at Thiel College in Pennsylvania, spent plenty of time in the Marietta College dugout with his dad, and now he has his son, Colin, with him as batboy. *Thiel College.*

Coach Schaly (left) keeps an eye on the game from his usual spot next to the bat rack at Pioneer Park while his oldest son, John (right), begins his tenure as batboy, a job all four of the Schaly boys had while growing up. *Marietta College Archives.*

All four of the sons were fixtures in their dad's baseball program from the time they were youngsters. They started by chasing foul balls and then graduated to bat boy, and when the next one was ready for that job, they'd go to the old manual scoreboard in the outfield and hang numbers.

"We'd hang up the numbers out there in the cold," said Joe. "There was a metal box on the scoreboard that the numbers were in, and on a cold day, we'd just crawl inside the box, then climb out at the end of the half inning to put up the numbers. And we'd harass the outfielders."

Cold? What cold?

"They complained to their dad about how cold it was out there, and he'd say, 'It's all in your head.' He showed them no sympathy," Sue said.

Jim has the unique distinction of ejecting everyone in the family—except his mother—from a game. That includes his dad and three brothers, and you can add one of the program's greatest players to the list, because Jim Tracy, now manager of the Colorado Rockies, says Jim threw him out in a Southern League game at Chattanooga.

Among the many duties Jeff had with the baseball program through the years was serving as JV coach at times. That's when he had a run-in with Jim that resulted in a story that has taken on mythical proportions. Jeff said:

> *I really went after him. We were nose to nose at home plate, and I bumped him, too. I was a cocky, young punk, and I was extremely upset with my brother. When I got out to the parking lot, my brother's car was sitting there. I was still pretty upset. I tied the antenna on his car into a bowtie on my way out of the ballpark.*
>
> *The story doesn't end there. Obviously, Dad is mad. After the game, Jim finds Dad and shows him the car. He said, "Why are you showing me?" And Jim said, "Who do you think did it?" He said, "I don't know." He said, "Jeff did it!" Dad said, "There's no way Jeff would do that." Jim says, "I'm telling you, Jeff did it."*
>
> *We get back to the field house and we're having post-game meetings, and Dad asked me, and I said, "Yeah, I did it." He couldn't believe it. I had to pay to fix it, of course.*
>
> *Jim has thrown out everyone in the family except Mom. He got John as a player. He got Joe as a coach at Marietta, and he got Dad as a coach, and he got me as a coach. He never got Mom, but he used to threaten her. He said, "If you give me a hard time from up in the stands, one of these days I'm going to throw you out so that I've gotten everyone in the family!"*

Jim certainly had plenty of opportunities to eject his mother, because she rarely missed a game, at home or on the road, and still doesn't.

Kent Tekulve said:

> [Brian] *Brewer has kept Sue completely involved in the program. You ask about Sue and he says, "She sits down the line in her lawn chair by herself, keeping score every game." That has been consistent—she would have a blanket over her if it was cold or have an umbrella if it was raining, but she always had her scorebook keeping score. To this day, she still does that. She's down the line smoking cigarettes and keeping score.*

Not bad for someone who had never seen a baseball game of any kind until shortly before she married Don.

Sue said:

I don't remember him ever actually proposing. We talked about marriage. All I remember is one time during the summer, we'd already picked our wedding date and had everything arranged, and we were at his mother's in Ellwood City. We went into Pittsburgh to a jewelry store and picked out our rings. That's when I got my engagement ring. But as far as a proposal, I don't remember one.

I just thought he was a wonderful person. He was very down-to-earth. He was a strong Catholic, which I was, too. He was just an all-around neat person.

The same weekend we got the ring, we went to a Pirates double-header at Forbes Field. One of his buddies got us seats right behind home plate. Don told me to bring my father's binoculars, because he didn't know where our seats would be. I spent the whole afternoon with the binoculars, looking around to see what the other girls were wearing. He kept saying, "Sue, the baseball game is in front of you, and if you want to learn anything about this game, I suggest you look that way."

I'd never been to any kind of baseball game before. I went to Catholic school, and we didn't have baseball. I never had an interest in it. At first, I thought, "This is boring!"

Later, when he was at Marietta and was still coaching third base, he'd be out there giving those signs. I said, "Don, explain those signs to me." He said, "I can't explain those to you." Well, the next night, he came home with a playbook that had all the signs in it. He said, "You want to know about the signs? Look this over and see what you can learn." I looked at the first two pages, and I thought, "Forget it! I don't need to know." And I never learned any of the signals.

But she did her part—and then some. With four boys around the house, she had her hands full, especially since her husband was encamped in his office virtually every day.

"We didn't fight when he was around, but Mom got to see all of it," Jeff said. "You can imagine what it was like with four boys. I don't know how she did it. I remember if we told her one of the brothers hit us, she'd just say, 'Go hit him back.' And if it was bad enough, she'd mention Dad, and that would put an end to it."

Brewer, who saw it all in action, as a player, assistant coach and then head coach, said:

Coach ate, lived, slept Marietta College baseball. Christmas was the only day of the year he didn't step foot in the office. And I think that goes back to his motto of "You get better or worse every day. You never stay the same." He had an appetite for improvement—not just his players—but everything he did was with the intention of making Marietta College and Marietta College baseball better.

Sue raised the boys—right, wrong or indifferent. The boys got to spend time with Coach Schaly when they were at the field, when they were batboys or when they were coaching with him or coaching against him. But Sue raised them. It's just the way it was.

He loved his family. Faith and family were the two most important things to him, but not a distant third was Marietta College and Marietta College baseball. The majority of the things he did in his everyday life were to try to make this program, this college, better and allow his student/ athletes the best experience he could. It's amazing the sacrifices he made financially and in every regard for this program. And the same could be said of Sue.

She was sewing together uniforms, feeding kids and fixing kids and getting kids healthy. There was no "extended family" to it. We [baseball

Like father, like son. Coach Schaly visits with his oldest son, John, when he was at his first head coaching job at Berry College in Rome, Georgia. *Marietta College Archives.*

players] *were a part of their family. Everything they did was to make us better—better players and just better people. The effect both of them had on us is immeasurable. There's no question in my mind they made me a better baseball player and a better baseball coach, but the biggest impact they had was to make me a much better man, a much better person—spiritually, emotionally, in every regard. They made an incredible impact on me, and they know that. They were just very supportive and very parent-like figures to all of us that played here.*

Maybe you didn't always like Coach Schaly, but you always loved and respected him. Sue was the good cop, and he was kind of the bad cop. They worked famously together.

People had to wonder how and why Sue did it for all those years. And she has the answers:

I maintain that there's no greater profession for a wife to share with her husband than that of a coach. If you want to get involved—there are some that don't want anything to do with it—but I knew from the get-go that it was his life and I needed to be a part of it. And I found out that I really enjoyed it.

I knew he wanted to have a successful program, and this [constantly working] *is what he felt it took. So I went with the flow. Sure, I'd have liked to have him home a lot more, but that's the way it was. Any successful coach will tell you it's not a 9–4 job, five days a week. In retrospect, I think our four sons sort of resented the fact that their dad worked 24/7. I did, too, but I learned to accept it.*

All four sons played sports, and their dad was a big supporter. During the school year, he got to their games when his schedule permitted, and in the summer, he rarely missed a game.

Jeff said:

The biggest thing that I would get asked a lot growing up was, "Your dad must be on you all the time." And that was not the case. He basically had one rule, and that was you can't quit. If you start a season, you finish a season. You don't ever have to play again. You don't have to play any sport. But if you start a season, you finish the season. The only thing he used to give us a hard time about in baseball is if we got called out on strikes. "Swing the bat! Swing the bat!" he said.

We didn't get a lecture every time we got home. But because that's what Dad was like with his players, a lot of people assumed he was like that with us. But that was not the case. He left us alone. We could pick and choose our sports. He didn't force us into anything.

Bill Mosca, who played at Marietta (1975–78) and then spent nine years as Schaly's assistant (1986–94), knew the entire family better than most and spent a lot of time at their home. He said:

What an unbelievably remarkable woman Sue was to give her husband to all those people. She just gave her husband to all of us. There was no question of their unconditional love for each other.

You looked at little things. For instance, his car would be parked in the garage in winter, and hers would be outside, because he had to get to work every day. For anyone that would say that's disrespectful to your wife, it wasn't. It was their way, and it was Sue's way of letting us know how important we were to her.

I only learned this stuff because I was at their house regularly. I would stay here during the Christmas break some years because I was manager of the basketball team. He would invite me over, and I would eat at their house constantly. I had many dinners with Coach and his family. And when I worked here [as an assistant coach] *and didn't make much money and wasn't married. It was unique to watch their relationship and how much of herself she gave to all of us.*

She's remarkable, one of the strongest women you'll ever meet. It's funny how some people look at her. Those that are judgmental would say, "She's just so meek, and he's an ogre." That's because they didn't know them. They had no clue of their love. What I saw was one of the strongest women I've ever met in my life. She was incredible and still is.

Chapter 5

DAWN OF A NEW ERA

Marietta College had a baseball team before Don Schaly became coach in 1964. It just didn't have a baseball *program*.

Records are sketchy and statistics pretty much nonexistent for the pre-Schaly years, but the first known baseball team at Marietta was fielded in 1874—two years *before* the formation of the National League that still exists today in Major League Baseball. That team's record was 1-1.

Most years, the school played only a handful of games, and some years there were no games at all until some consistency was developed in the post–World War II years under Don Drumm, who played and later coached three sports at Marietta, including baseball through 1959. It was Drumm who was Schaly's baseball coach from 1956 to 1959.

Tom Stubbs was the baseball coach from 1960 to 1963, and though the Pioneers had a losing record in two of his four seasons, he actually turned over a good nucleus of players to Schaly for 1964. One of those players was a six-foot-two, left-handed pitcher named Mike Wright.

In Wright, Schaly inherited a workhorse pitcher who was considered a pro prospect and also was a good hitter who often played first base or the outfield when not pitching. Wright played a memorable role in getting Schaly's career going in a positive direction and eventually became a close friend of the coach and one of the program's biggest supporters to this day.

But in 1963, while Schaly was still at his first job at Midview High School in Grafton, Ohio, Wright accomplished something that few pitchers have

Marietta College baseball dates back as far as 1874, and this picture of the 1915 team proves that there was baseball before Don Schaly—whether it seems like it or not! *Marietta College Archives.*

ever done or even tried. In true "Iron Man" fashion, he pitched and won both ends of a double-header against Denison.

Wright, a native of Camden, New York, pitched a six-hitter to win the first game, 5–1. John Sipple started the second game but ran into immediate trouble. When Denison scored twice in the top of the first and threatened to score more, Stubbs relieved him with Wright. Wright, now retired and living outside Denver, Colorado, said:

> *I was about the only pitcher we had. We played nineteen games [10-9], and I pitched in about fourteen of them, sometimes on one day of rest. I started the first game that day and went all the way. Stubbs asked me if I could go the second game, and I said, "Why don't you let someone else go?" He started Sipple.*
>
> *When the first three guys got hits, he told me to warm up. I threw about two pitches, and he said, "You're coming in." There were two outs, so I pitched six and a third innings of that game and 13 ²/₃ innings for the day.*

As a sophomore in 1963, Mike Wright pitched and won both ends of a double-header in the season before Don Schaly arrived to coach the Pioneers. *Marietta College Archives.*

Marietta rallied to win the second of the seven-inning games, 6–4. Besides being the winning pitcher in both games, Wright had four hits in the double-header, two in each game.

"I ended up messing up my arm my senior year," Wright said. "I don't know if pitching almost fourteen innings that day had anything to do with it or not."

That double-header ended the '63 season, and when the Schaly era began the following year, it was Wright, the ace, who was on the mound again.

A coach only has one first game. And in Schaly's case, that landmark was magnified almost beyond belief. On April 4, 1964, the Pioneers traveled to Charleston, West Virginia, for a double-header victory over Morris Harvey (now the University of Charleston) by the scores of 4–0 and 7–6 in seven-inning games. That would be a nice way for any coach to start his career, but what was particularly memorable is that in the first game, Wright pitched a no-hitter. What a way for Schaly to begin his career! Wright had eight strikeouts and one walk. Only two runners reached base—one on the walk in the first inning and the other on a throwing error in the fourth.

Wright said:

The thing I remember most is that my dad [Jesse] *smoked at the time. Schaly was so nervous that he ran out of cigarettes, so by the end of the game, he was bumming cigarettes from my dad. The second game of the double-header, we were behind* [6–1 after three innings] *but came back and won* [with four runs in the seventh], *and he was still bumming cigarettes!*

Schaly had everyone autograph a baseball for me with the date and score. I still have it—someplace!

This Fab 4 from Don Schaly's first team at Marietta College in 1964 included (left to right) Skip Freidhoff, Jeff Turecki, Bob Wolfarth and Mike Wright, who pitched a no-hitter in Schaly's first game. *Marietta College Archives.*

Marietta's catcher was Skip Freidhoff, another of the core of players Schaly inherited. In fact, Freidhoff and Schaly were both from Ellwood City, Pennsylvania, and knew each other because Freidhoff once was the batboy for the American Legion team his dad coached and Schaly played on as the catcher.

Freidhoff, now retired and living in Plymouth, Indiana, said:

> *Mike had really good stuff against Morris Harvey, and he and I were on the same page most of the time. He had a good fastball that day, and his curve was awesome. He was hitting the target. He was one heckuva pitcher. Without a doubt, he was a pro prospect until he hurt his arm. He was a pretty hard thrower with excellent control, which was his best asset.*

We were all aware he had a no-hitter going, and no one said a word about it! That was a huge deal for all of us. Everyone was jumping up and down when he got the last out. Schaly must have been thinking, "Wow! What a heckuva coach I am!"

Freidhoff added with a good-natured laugh.

The fact that Freidhoff was already a player at Marietta and had positive experience with Schaly helped the new coach gain quick acceptance, because Freidhoff told the other players about him in advance, said Wright.

Freidhoff said:

Schaly was a heckuva ballplayer, as competitive as anyone you'd ever want to see. My dad was a great baseball man, and he absolutely loved Schaly. He liked anyone hardnosed and out for excellence. He later was the baseball commissioner and needed someone to coach that American Legion team one summer. Schaly stepped up. He probably had just started at Marietta. He did what he did at Marietta—he worked the kids hard. Some of the parents weren't crazy about all the practice. I guess they thought it was summer break or something!

The other players in the team's veteran nucleus were center fielder Bob Wolfarth, third baseman Jeff Turecki and first baseman Bill Neeb. And a month after Wright pitched his no-hitter, a sophomore lefty named Andy Ivan pitched the second seven-inning no-hitter of Schaly's first season, beating Otterbein, 1–0, in the second game of a double-header. Ivan, later a pilot who was shot down and killed in the Vietnam War, struck out seven and walked one.

Ivan's no-hitter saved the day, if not Wolfarth's psyche, which suffers to this day from his role in Marietta losing the first game of that double-header, 4–3, at Westerville.

Wolfarth, who was playing center field, recalled:

Mike was 6-0 for the season, and we were leading, 3–0, in the bottom of the fourth with him pitching. Otterbein had runners on second and third. The wind was blowing in. I can recall this like it happened five minutes ago. There was a ball hit to short right-center, and I'm calling everybody off. By the time I get there, I'm not too far from Sam Wiley, our second baseman, and I dropped it, leaving the bases loaded.

The next batter grounded to shortstop Bob Huffman, who bobbled the ball and then threw it past first, allowing all three base runners to score and tie the game, 3–3. Otterbein then executed a squeeze bunt to account for what proved to be the winning run.

Wolfarth, who is a manufacturer's rep and lives near Philadelphia, moaned:

> *Mike got beat, but it wasn't his fault. That was his only loss of the year. So he should have been undefeated. He was very impressive.*
>
> *In 1991, we got together for a reunion back at Marietta at the field house. I started telling the story about the Otterbein game. When I finished, Mike says, "I don't remember the play." Then Sam Wiley, who I was calling off all the time, said, "I don't remember the game."*
>
> *So Dave Wilcoxen* [right fielder], *the other guy I called off, shows up after the story, and he begins to tell it—it's the same story, except he says* he *dropped the ball! I'm thinking, "Wait a minute. I'm off the hook!" Actually, I think he was talking about the play right before that.*
>
> *Over twenty-five years later, the pitcher doesn't remember the play, the second baseman doesn't remember the game and the right fielder thinks he dropped the ball. My wife thinks I might get over that play someday. Maybe on the fiftieth anniversary!*

Wolfarth may or may not have cost Marietta that game, but the fact is that he remains one of the most accomplished two-sport athletes in Marietta College history. He lettered four times in both football and baseball. In football, he held the school's career record for receptions and receiving yards for years. Even though he played in a drastically different era, he still ranks sixth in receptions (119), and the five in front of him played in the 1990s and 2000s. The same in receiving yards, where he still ranks fourth (1,607).

In baseball, he still holds the Ohio Athletic Conference record for most steals in a game (six, including home in the first inning), set in 1965, his senior year, against West Virginia Wesleyan. He also finished fourth in the nation that season in stolen bases per game, and his thirty-two steals in twenty-six games set a Marietta and OAC record at the time. He was captain of the 1965 team that went 21-4, and he won the Way-Weigelt Award as the college's most outstanding athlete. After graduation, he was drafted and signed by the Detroit Tigers, the first of Schaly's players to play pro ball.

Schaly's second team, the 1965 Pioneers, posted a 21-4 record and also was the first of his teams to wear the sleeveless pinstriped uniforms that became a tradition. *Marietta College Archives.*

Wolfarth's story is a classic tale of "Go Midwest, Young Man, Go Midwest." As a high school senior in New Jersey, he'd never heard of Marietta College and found out about it only when his principal suggested it. Wolfarth recalled:

> *He said, "Marietta, Ohio," and I didn't even know where Ohio was, let alone Marietta! It got into the spring, and I had no place to go to school. Somehow Marietta must have contacted my high school. They sent them some football film. Baseball wasn't even in the picture. They got me in school, and it really was to play football. My love was football, though I probably should have concentrated on baseball.*
>
> *I never saw the place before I got there. My father dropped me off at the train station in Newark, New Jersey, in August 1961. He said, "This ticket will take you to Washington, D.C. You change trains there, and this one will take you to Parkersburg, West Virginia. Good luck. I'll see you at Thanksgiving."*
>
> *That was it. Off I went. I got into Clarksburg, West Virginia, at midnight. My background was in Newark, New Jersey. There were more people on a block in Newark than there were in the town of Clarksburg in 1961.*
>
> *I walked into the train station, and there's only one person. I said to him, "I'm supposed to be on a train to Parkersburg." He said, "Yeah, it's at two*

o'clock in the morning." At two o'clock, a train pulls in, and the guy said that was my train. I said, "But it's a freight train." He said the last car was a passenger car. I was the only passenger on it!

My parents gave me enough money to get a cab from Parkersburg to Marietta. I finally got to Marietta sometime in the morning. The sun was up. I remember that.

When he was inducted into the Marietta College Athletics Hall of Fame in 1985, Wolfarth closed his remarks by thanking Schaly, saying, "Although winning was very important to Coach Schaly, he never taught winning at all costs. He had a very simple philosophy. If you treat your players right and are concerned about their welfare, they will go out and bust their tails to try to produce a winner for you."

When Wright, Wolfarth, Freidhoff and company played for Schaly, the coach wasn't much older than them. Consequently, they probably had a closer relationship with him than most of the players who followed, and they saw him in some situations that their successors can't imagine.

Wright said:

When we were seniors, we had a freshman pitcher come in from Ellwood City—Bob Poholsky. He was a darn good pitcher, and he was supposed to have his first start at Kenyon on Saturday. Friday night, Coach and Sue invited Skip and myself and our girlfriends for dinner. Coach gets a call from the police department in Reno, just up the river on Route 7.

Poholsky had been drinking, and we had to bail him out. We didn't have any money, but Skip used to have a "honeymoon fund"—a big glass jar that he put money in. Coach didn't have enough, I didn't have enough… well, we bailed out Poholsky with Skip's honeymoon fund.

The next day, Coach still pitches him. He's out there having trouble, walking guys, and Coach says, "He's going to stay out there until he figures out how to get out of it." I think we wound up winning, but Coach was going to make him suffer out there.

Freidhoff, who lost his honeymoon savings, said:

Poholsky was from the same high school as me. He had pro potential. There were quite a few scouts around because of him. All I remember was I had about $100 in the honeymoon fund, and everyone else was chipping in, too.

I don't remember ever getting reimbursed. We [he and wife Joann]
just took a shorter [honeymoon] *trip! We went up to the Poconos, and
we didn't stay in the nice honeymoon suite. I took one for the team and an
Ellwood City boy.*

Wright, by the way, was the best man in Freidhoff's wedding, and those
two and Wolfarth remain in touch. Such relationships are not uncommon
among former Marietta College players. Schaly played a big role in
encouraging that by creating a regular baseball fraternity newsletter that he
mailed to former players regularly. Brian Brewer continues that tradition.

Wright said:

We had a little get-together in 2010 at my place. Pat Tatum [1975
assistant coach], *Kim Stanbery* [1972–75], *Jim Fryfogle* [1970–73],
Rob Czech [1973–76]. *The wives came out and stayed at our house. We
played golf and went to Rockies games and had dinner with* [Rockies
manager] *Jim Tracy* [1975–76] *on Sunday night. From going to all the
games back there, that's how I knew all the guys.*

*Coach developed this fraternity. He put out those newsletters, and he kept
guys in touch with each other. That's the family part he brought to it.*

Freidhoff pointed out that Schaly immediately began the tradition of
taking the baseball team on a spring trip in search of warmer and drier
weather.

"He was as cocksure as our team was," said Freidhoff. "We were a cocky
group. We went down into Virginia. We all wore black berets. Somebody
got the idea to get berets. We even got one for Coach. We walked through
campus with them on, and everyone was looking at us like, 'Who the heck
are those yahoos?' We were an odd group!"

After graduating from Marietta and spending three years in the army,
Wright reconnected with Schaly and the baseball program and visited
campus and attended as many games as possible, home and away. His
job resulted in several moves to various parts of the country, including
California and Florida, but he still remained in contact and supported
the baseball program financially, as well as by going to games whenever
possible. He said:

*Schaly and I became good friends. After I got back from the army and was
working in Lancaster* [Ohio], *we'd pile the kids in the car and go down*

for games. We'd stay at his house, spend the weekend and go to the games. We always stayed in touch, wherever I was. I'd go back for the alumni games and tried to support the program the best I could. I considered him a real good friend. He was the kid of guy where it was always about you, not about him.

We were down there for a weekend one time, and my wife had taken belly dancing lessons. I must have said something to Coach about it. Anyway, we're sitting around talking one night, and all of a sudden, Coach disappears. In about ten minutes, here he comes. He's got a towel or something wrapped around him. He's got something over his head, and he comes out there like a belly dancer. I thought we were going to die laughing.

Not too many former players ever saw anything like *that!*

Many things were different in Schaly's early years, not the least of which was the lack of a home field due to the fact that he refused to have his team play at Don Drumm, the football stadium where there also was a track running through what was supposed to be the outfield.

Wolfarth said:

We had a good group of people, and we were totally committed to winning. That's what made that team so great [14-4 in 1964]. Schaly basically let us be ourselves, because he knew we were committed to winning. Over the years, he became much more disciplined with his players. But he was twenty-six years old, and we were twenty-one. He was even a member of the same fraternity as a lot of us. It was a challenge for him, I think, with the players he had, but he knew how to handle us. We just really enjoyed playing for him, and he really held the team together.

We didn't even have a place to play. We played at the [Washington County] Fairgrounds, and we played a lot in Parkersburg and a few other places. I used to tell Schaly when all of our records were being broken that there was one record that would never be broken: most home fields played on! We had a hard time figuring out where we were supposed to be.

Mike pitched opening day our senior year, and we beat Marshall, a much bigger school than us, beat 'em in Parkersburg. I think it was a three- or four-hit complete game, but he hurt his elbow and was done for the year. We lost our ace, but we still finished 21-4.

The tempo for the Schaly era was set.

Chapter 6

ASTERISK, ANYONE?

For teams that reach the post-season, there's often a fine line between winning the national championship and not winning it. Marietta College knows that all too well, because in spite of winning it five times, the 'Etta Express also has been the runner-up seven times.

The first of those seven second-place finishes, however, deserves to have an asterisk next to it. The year was 1975. The "fine line" could be defined by a flagpole. And Marietta—technically—was the Division III national champion. The only problem is 1975 was the last year for the Small College World Series, when D III schools were lumped in with Division II competition, schools that gave athletic scholarships. It almost didn't matter.

Don Schaly's Pioneers, making their first ever World Series appearance, made it all the way to the championship game before losing to Division II opponent Florida Southern, 10–7. So it could be said that Marietta was the Division III national champion, since Schaly's team finished higher than any other D III school. No such distinction has ever been sanctioned, but the 1975 season definitely was one of the most special in Pioneers history.

Jim Tracy, now manager of the Colorado Rockies, recalled:

> *What was interesting is the manner in which we got to that championship game. We won the OAC Tournament, and I hit a home run in the first game off a man named Ed Miklavcic, a much older player who might have gone into the service before college. I remember he had a tremendous curveball. He was a right-hander for Ohio Northern.*

We played them at Pioneer Park, and in the middle of the game, maybe the sixth inning, the game is hanging in the balance and he threw me one of those breaking balls and hung it. I hit it out. I hit it a pretty good ways, as a matter of fact, to right-center. We ended up winning, 4–3.

Marietta then won the second game easily, 11–4, to claim the conference tournament and earn a berth to the NCAA regional.

In order to get to the World Series and that flagpole in question, which was located at Lanphier Park in Springfield, Illinois, Marietta first had to get through the NCAA regional at Charleston, Illinois. That was no easy task, but a few pizzas and a few pitchers of suds wound up turning the tide.

Marietta dug a hole right away, losing the first game of the double-elimination regional, 4–1, to St. Joseph's College of Indiana.

Pitcher Duane Theiss was one of two players on the team, along with Tracy, who went on to play in the Major Leagues. He said:

We're still wearing those wool uniforms that Schaly liked, and everyone else is in double-knits. When we got to Charleston to play the regional, it's 106 degrees.

They had the state high school track meet going at the same school. They took the temperature and humidity, and they even cancelled or delayed some of their events—but they didn't delay the baseball games! We had to play through all that, and it was so unbearably hot. I stunk it up in the first game. I balked, which was the first time—and last time—I ever balked. Nothing went right.

So the 'Etta Express was forced to battle its way back through the losers' bracket, beating Eastern Illinois, 7–0, Southern Illinois, 7–1, and Wright State (in Ohio), 10–3, to set up a rematch with St. Joseph's for the championship. Marietta needed to beat them twice to get to the World Series.

Theiss, who now works for UPS in Columbus, said:

The night before we play the double-header to win this regional, we go into kind of a restaurant/bar place [Marty's, named after former Major League pitcher Marty Pattin], *and the St. Joe team is in there. They're all sitting around drinking pop—soda—and water when we walk in. Schaly's teams, I'll tell you, could drink. When you have Kim Stanbery, Ken Laveck, Joe Vogt, they could put it away. Particularly Vogt—he looked thirty-five years old! He was a big guy and had that type of face.*

We were a manly looking group, and we acted like it, too! We walked into this place, and we just took it over! These St. Joe guys are looking at us like, "Who are these guys? They're drinking beer!" It was almost like a high minor league team where you have guys that are twenty-five, twenty-six years old. You work hard, you play hard.

Some people said—and I think even Schaly said it—that we intimidated them that night. We were a very disciplined team on the field, but Schaly gave us just enough of a loose rein away from the field so that we weren't like robots. We enjoyed ourselves. I'll put it that way.

Kent Tekulve was playing pro ball by then, but he's heard the stories about the 1975 team. He said with a laugh:

We had these guys that were big and had [beard] stubble. That group was so big, and they're in there eating pizzas and drinking pitchers of beer. Schaly said, "I've never, ever, seen a baseball game won other than on the field—except that game." Those guys beat that team the night before in the pizza joint when they saw all these big guys eating pizza and drinking beer!

Nevertheless, players remember Schaly pulling out all the stops the next day in his pre-game talk. Abbey Gladstone, a freshman outfielder at the time, recalled:

Schaly's giving us a pep talk before the regional finals. He started saying, "We have the opportunity to be the first Division III team to make it to the World Series," and then he stopped for a second and said, "Shit, that's not right. Otterbein made it last year." Otterbein didn't have quite the success in the Series that we did, but that was typical Don. He was as honest and as frank as can be.

That led to a rather dramatic ending to his talk. Theiss said:

Schaly was very, very emotional. He said how much he loved being with us, and he said the summer was coming and he wouldn't see us again. He said, "I love my wife and kids, but…" and then he just broke down.

"I remember talking to some players after we won the double-header. We just killed St. Joe's [7–1 and 11–3]. I said, "He was being honest. He loves us as much as he does his family." He really does.

Even Schaly's family admits as much.

Normally, the team would have returned to Marietta before going to the World Series, but not that year. There was a lot of rain during the regional, stretching it over a few extra days, and since the Series was in the same state, the Pioneers headed right to Springfield. Again, they did it the hard way, losing the first game, 3–2, to Montclair State of New Jersey.

"It was Stanbery that pitched," said Gladstone, who was used primarily as a pinch-runner and defensive replacement that year before he became all-conference and all-region later in his career. "He didn't ice his arm, because he figured once we lost, he wasn't going to pitch again. All of a sudden, we started winning games, and he started icing his arm every chance he got."

In succession, Marietta rolled off three consecutive victories, beating Cal State–Northridge (3–1 behind Neal Parsley), Northwest Missouri (6–1, Theiss) and Southeast Louisiana (9–2, Dan Settles) to reach the championship game.

"In our first victory of the Series, Parsley beat Cal State–Northridge, and they had like 21,000 students to our 1,200," said Theiss.

The odds certainly were stacked against Marietta, not only because of the small enrollment and Division III status but also because they had to fight all the way through the losers' bracket in both the regional and the World Series.

"From the first game of the regional to the national championship game, we were hanging on the edge every day," said Tracy. "We were constantly on the verge of elimination, because we lost the first game of the regional and the first game of the World Series."

Prior to the championship game against Florida Southern, the team received more memorable words of inspiration. Theiss recalled:

We worked out early and then took a tour of where Lincoln was buried, and Schaly talked to us a little about that. Then some alumni came around, and Mike Wright [who pitched a no-hitter in Schaly's first game in 1964] spoke to us. He talked about where the program was then in 1975 and where it was in '64 when Schaly started, which had only been eleven years. And then Mike broke down…

That's when I started to get the first sense of what this whole program means to people and the appreciation and love for one another and how special it was to wear the pinstripes of the 'Etta Express—even if they were wool!

Wright was followed by Schaly. "He was a pretty emotional guy," Gladstone said of Schaly. "He cried before the game, and he cried after the game."

Though Florida Southern won the game, 10–7, Marietta was in it all the way and actually led for quite a while until the infamous flagpole came into play—literally—because it stood in deep center field.

Tracy said:

> *I remember we led on three occasions in that game. They had a guy by the name of Frank Cacciatore. There was a flagpole at the park that was inside the playing field with a fence in front of it. If the ball hit the pole above the fence and went over the fence, it was a home run. But if it hit the pole and stayed in, it was in play. They'd never seen that happen.*
>
> *Well, after we took the lead for the third time, Cacciatore* [all-America outfielder who later played in Detroit's farm system] *hit a ball with two guys on to dead center field. We were ahead, 7–6, in the seventh inning, and they had just tied it, 7–7. I'm running like hell because I see Marty Bauer, our center fielder, running with his back to the infield. The ball hits the flagpole and bounces back in the direction of where I just left. I ran all the way back over there to get the ball and get it back to the infield, and by the time I did that, he'd run all the way around for an inside-the-park, three-run home run. Basically, that was it.*

Bauer, now a manufacturer's rep who lives in Arizona, said:

> *I never played in another ballpark where there was a flagpole in play—ten feet in play. That thing bothered me from the moment I stepped on the field. I don't think I would have caught that ball if the pole wasn't there, but it's in the back of your mind as you're running toward it. I'm looking for it. The ball was hit pretty good. But if it's not there, it's maybe a double, not an inside-the-park home run.*

Tracy summed it up by saying:

> *We were national runner-up, but the journey was incredible. From a Marietta College perspective, I guess maybe the most gratifying part of being national runner-up—because there have been national championships won at Marietta—is the fact that it was the last time Division II and III were together. If you look at the schedule we played and some of the teams*

we competed against, and talk to some of the people that have been there, I think several would say that Schaly would have told you that arguably the '75 team was the best he ever had.

I remember he was in tears afterward when he was trying to talk to us. I don't remember specifics that he said, but a lot of the emotion we saw came from his gratefulness to us, the way we laid it out there. I remember not feeling good in the pit of my stomach. I remember feeling a complete emptiness.

Joe Yazombek started the 1975 World Series as the No. 9 hitter in Don Schaly's batting order and finished it by being named the Most Outstanding Player of the tournament, batting .529 with two home runs for the runner-up Pioneers. *Marietta College Archives.*

Even though Marietta lost, catcher Joe Yazombek was named the Most Outstanding Player of the Series. Yazombek, who still lives in Marietta and recently retired from a position as an executive vice-president at Peoples Bank, said:

I had two of the best weeks of my life at the regional and in the Series. [Assistant Coach] Pat Tatum always took credit for that. He said it was his batting practice pitching. I just got really hot for two weeks. I started in the regionals and got really hot in the World Series.

I used to joke with friends that I made it from ninth up to seventh in the batting order. That was the first year for the DH [designated hitter]. *I joked that the DH made me bat ninth in the lineup all the time. In the final game of the World Series, I made it up to seventh in the lineup. I was nine for seventeen* [.529]. *There were only six home runs hit in the whole Series, and I hit two of them. I had a good defensive series, too. Of course, that was one of the reasons I played, because I was a much better defensive player than offensive player.*

We had a really talented team. Our shortstop, Ken Laveck, was one of the best amateur players I ever played with or against. He and Ozzie Kenyon [outfielder 1969–70, '72–73] *are two of the most talented players ever to play at Marietta.*

We had a great pitching staff, too. Our No. 3 pitcher was Theiss, and he wound up pitching in the Major Leagues.

Chapter 7

THE FIRST TIME

At first glance, it was just another group of tykes trying to learn the basics of baseball from just another dad who was volunteering his time to help his son and a dozen or so other T-ball players in the six-to-seven age group. The same scene was being played out on sandlots across America, as it had been for years and as it still is today.

The father in this case was trying to teach the kids a basic principle of the game that's always difficult for beginners to grasp: there's no need to hit the brakes when running to first base. It's perfectly acceptable to keep running hard right past the bag, and the fielder can't tag you out. But typically, T-ball players stop on the base and hang on to it for dear life.

Parents, visions of lucrative pro contracts dancing in their heads, watched with interest as their youngsters received some of their very first instruction on an athletic field. The volunteer coach lined up his players at home plate for the drill, which was a sprint down the line to first base.

"Go!" he yelled.

And as the first boy lit out for first base, the coach followed right on his heels. "Keep running! Keep running! Keep running!" the coach yelled all the way down the line, leaving no doubt in the player's mind that he better not stop on the first-base bag.

On and on they went, each youngster getting a chance to learn not to stop running at the bag. And each time, the coach followed, yelling, "Keep running! Keep running! Keep running!"

It's safe to say that at the end of the drill, there was at least one team in that T-ball league that fully understood that players are supposed to overrun the first-base bag.

The Story of the 'Etta Express

The coach succeeded in accomplishing his objective. Don Schaly happened to be that coach, and his stern, demanding methods would later make him a legendary baseball coach at Marietta College, though his forty-year career there was barely beginning at the time.

One of the T-ball players Schaly was coaching that day was his oldest son, John. Sue Schaly, herself on the way to becoming the matriarch of the Pioneers baseball program, recalls the scene:

> *We only had one car. I dropped Don, John and* [second son] *Jim off at the T-ball field. He expected these little six-year-old kids to be like his college kids. I ran to the grocery store, and when I came back, I'm sitting in the car, and he's teaching these kids to run to first base "properly." He's yelling at these little kids at the top of his lungs. "Run hard! Run through the bag!" Just yelling at these kids. And here's the parents sitting in the stands…I could have died!*
>
> *Well, he gave up coaching Little League after that year. He didn't have the patience to deal with that. He just didn't have the temperament to do it.*

T-ball players might have been a tad young for Schaly's approach to coaching baseball.

"My mom said she was so embarrassed by that, but we knew how to run past first after that, and a lot of kids on the other teams didn't know how," said John Schaly, one of the kids in that drill who learned his lessons so well that he's gone on to win more than nine hundred games as a college coach and now is in his fifteen season at Ashland University in Ohio.

John's career as a player at Marietta College provided his dad with the highlight of his coaching career that included three national championships, not a single losing season in forty and more awards than you can shake a bat at, including induction into the American Baseball Coaches Association Hall of Fame in 1995 and recognition as the Division III Coach of the Century in 2000.

It was Schaly's eighteenth season (1981) that culminated in Marietta's first national championship. That alone likely would stand as any coach's proudest moment. But in Schaly's case, the accomplishment was magnified to larger-than-life proportion by the fact that John—the oldest son he taught to run past first base in T-ball—not only was the starting second baseman on that team but also was named the Most Valuable Player of that World Series.

It had to be every coach's dream come true. But it's just a fantasy for most of them. What made it even more extraordinary is that Schaly nearly

Second baseman John Schaly batted .398 as a junior in 1981, when he hit .667 in the World Series to lead his dad and Marietta College to their first NCAA Division III national championship. *Marietta College Archives.*

cut John in his freshman season. "There was doubt about if I was going to be good enough to play at Marietta," John admitted. "My freshman year wasn't very good. I hit about .120."

And that was with the JV team. He didn't get a single at-bat with the varsity as a freshman in 1979.

Sue Schaly said:

> *After fall ball John's freshman year, when they had to make the cuts, as far as Don was concerned, John was on the cut list.* [Assistant Coach] *Paul Page literally saved John. He told Don he definitely thought there was potential there and that John was really uptight because he was the coach's son, and Paul thought he should get another shot.*
>
> *I remember Don saying during fall ball that John was a marginal player at that time. I threatened him with divorce if he cut my son! But I don't think that held any weight, because Joe Schaly came along a few years later, and he cut Joe.*

John, however, used everything his dad taught him through the years and every bit of drive and determination that had been instilled in him to overcome his deficiencies and eventually became all-America, as well as the 1981 World Series MVP.

"My biggest problem was I had to get stronger, so I got after it in the weight room," John said.

As a sophomore in 1980, he began to turn the corner and earned regular playing time, hitting a respectable .284 and displaying a base-stealing acumen (thirty-three that season) that made him a valuable commodity as a leadoff hitter and put him in the Pioneers' record book.

Then he really blossomed as a junior, hitting .398, even though his stolen base total dropped to twenty-five due to an early season hamstring injury that cost him quite a few games.

"John worked hard, and he did a lot of things that didn't show up in a box score," said Mark Talarico, a sophomore outfielder on the 1981 team who went on to play pro ball in Italy and build a successful career as a sporting goods executive, now with Baden Sports.

> *He was the best bunter that I've ever seen. John would try a bunt once a game, and the other team knew he was going to try it once a game. He would still do it and succeed. If someone tried to cheat on him, he'd hit the ball by him. He also turned himself into a very good base runner, base stealer. He wasn't the fastest guy, but he was a very good base stealer, just heads up and ability...He played hurt. I remember him getting hurt a few times, and he never said a word, just went out and played.*

Of course, John likely had that toughness drilled into him practically from birth. Anyone who played for Don Schaly had their hands full trying to live up to the expectations he put on all his players. For John, the demands probably felt twice as heavy, even though he says he was just another player in his dad's eyes.

"If I had it all to do over again, I feel like I'd go to Marietta and play for my dad again," he said. "I felt he treated me the same as everybody else. A lot of times the father treats the son harder, but I didn't feel like he did that. I was treated just the same—of course, he was hard on everybody. He couldn't get a whole lot harder!" he added with a laugh.

The 1980 team was one of the college's best, record-wise. It won the conference tournament and then rolled undefeated through the NCAA regional to carry a 41-2 record into the World Series at Pioneer Park. The Division III World Series was held in Marietta for twelve straight years, beginning in 1976. Schaly's team was unable to take advantage of the home-field advantage the first four years, and 1980 proved no different. The 'Etta Express won their first two games in that year's Series, only to lose the next two and the national championship to Ithaca of New York.

Assistant Coach Page recalled:

> We were undefeated going into the championship game. Ithaca had to beat us twice to win it. They beat us, 5–4, in the first game, and I remember our guys walking across the field like we had lost ten straight games. The fact that they hadn't lost much all year, combined with losing like that… we'd have been better off to lose 10–2. We played horrible the second game, and Ithaca won it, 12–5.

So in spite of the 43-4 season, it was back to the drawing board in search of the elusive first national championship. And in 1981, the Pioneers would not be denied.

Talarico said:

> We were fairly young, not many seniors. Coach Schaly brought back a fifth-year senior he cut two straight years [1979–80], Dan Munday. He started in the late '70s as a catcher and DH, but he got in the doghouse, and Coach cut him.
>
> Munday comes back, and I never saw another guy have a year like that. When he swung and missed, it looked like he hit it hard. He fouled balls back hard. Every ball he hit was right on. He had a year where

*every ball he hit was right on the money. He was huge. He was in the
middle of the lineup.*

*We went to Florida and didn't really know how good we were going to
be. All these positions were open, and there's a bunch of sophomores and
juniors. There were a couple of positions you know—Munday was going
to DH and Tommy Mohl was going to catch and Kenny Lisko at third.
The rest was just whoever was playing good at the time. The next thing you
know, we're rolling off a year like you can't believe. The pitching was really
solid, and mainly with younger guys.*

Marietta was 50-4 heading into the Ohio Athletic Conference
championship game against Wooster.

Talarico said:

*We were getting beat and weren't in this game. It was tight, 2–0, but we
never threatened. Then we get a dunker and a hit batsman. Two guys on
and Munday comes up. They don't walk him, and he hits a ball—he
was a left-handed hitter, about five-foot-eight or five-foot-nine, really stocky
and well built—he hit a ball that I don't think ever got more than ten feet
off the ground. It took a light out of the ball/strike indicator on the new
scoreboard. And that was it. We went ahead, 3–2, and ended up winning
the game, 8–4. It had to crush them. We ended up playing them again in
the regional and beating them [13–6]. But we never threatened, never even
sniffed it and then this guy hits this ball…when it came back, it had a
circular cut where it hit the light indicator.*

The NCAA Regional was played at Ohio Northern, and the Pioneers got
off on the wrong foot, losing, 10–7, to York of Pennsylvania. That was to
be their last loss of the season. They stormed through the losers' bracket,
winning five straight games, the last one a 17–6 thrashing of Alma of
Michigan for the right to play in the World Series at Marietta.

At the time, the Series was a four-team, double-elimination tournament.
In the opener, the Pioneers drew Ithaca, the team that had beaten them in
the championship game a year earlier. Marietta won, 6–5, in the strangest
of ways. Ithaca managed only two hits, both singles, but Pioneer pitchers
walked nineteen to make the outcome far too interesting.

"The home plate umpire would not call strike three," said John Schaly.
"He was okay on strike one and strike two, but the pitch could be right
down the middle and he wouldn't call anybody out on strike three. He was

scared, overmatched, and it got to the point where the hitters knew it, so they wouldn't swing."

The winning run was scored in the bottom of the seventh when Pancher got a one-out single, stole second and scored on a single by shortstop Jon Shuler. It was one of eleven hits by the Pioneers, who drew just three walks.

In the second game, Marietta beat Wisconsin-Oshkosh, 12–6, in a game that was played over two days because of rain. Shuler hit the first home run of his college career. Marietta put away the game in the top of the eighth with five runs that turned a 7–6 lead into a 12–6 rout. John Schaly had the big hit, a two-run double that gave him two hits for the game to go with two more he had in the Series opener.

That brought about a return match with Ithaca, which had emerged from the losers' bracket. The result was a classic game in front of a packed Pioneer Park.

Page said:

There was an absolute overflow crowd for the game. There weren't enough seats for all the fans, so lo and behold, the decision was made to let people go out and sit inside the field—down the left field line. And when Coach

Pioneer Park was the place to be when Marietta College and the community played host to the NCAA Division III World Series for twelve years, from 1976 to 1987. *Marietta College Archives.*

Schaly saw that, oh, my God! He went ballistic. "We will NOT do that!"
There already were a lot of people down there, on the warning track, in foul
territory down the left field line by the batting cage.

Once officials got the fans in suitable locations, a slugfest ensued.
Unfortunately for Marietta, Ithaca did most of the slugging initially, scoring
six in the first and opening a 7–1 lead through three innings before the
Pioneer bats got in the swing of things. The 'Etta Express took an 11–10
lead by scoring four runs in the seventh, but Ithaca, the home team, retook
the lead, 12–11, with two in the bottom of the seventh. Marietta tied the
game, 12–12, in the eighth inning on an unearned run, and that's the way it
remained until the twelfth.

Talarico said:

> *It was 12–12 after nine innings, and we got two runs in the twelfth to win,*
> *14–12. It doesn't sound like it was a great game, but there were never any*
> *big swings in runs. I remember how tense every situation was.*
>
> *I never remember anyone being at all flustered by being down six runs*
> *early. It wasn't in this team's nature. You win fifty-nine games in a*
> *year, and you're never out of a game—never—not with those guys in the*
> *middle of the lineup—Mohl, Lisko, Munday. You could get three runs*
> *really fast.*

Yet it was Steve Riley, normally a pitcher but playing first base because
Pancher was ill, who came through with the big hit. In the twelfth, he
delivered a two-run single to drive in the decisive runs, giving him four hits
and five RBIs for the game. Dale Hurst pitched the last four innings in relief
to pick up the win, making him 15-2 for the season.

John Schaly was a perfect four for four with a double, three RBIs, two
stolen bases and a sacrifice fly in the championship game. With the game
on the line, the hot-hitting second baseman was walked intentionally with
runners on base in both the ninth and eleventh innings. Then he turned a
double play—one of the Pioneers' four in the game—for the final two outs
in the twelfth inning. Schaly finished the series with a tournament-leading
.667 batting average.

Marietta placed five players on the All-Tournament team—Hurst, Lisko,
Shuler, Schaly and Mohl.

"I was kind of hot for those three days, and they even walked me
intentionally in that last game—as the leadoff hitter. I told everyone they

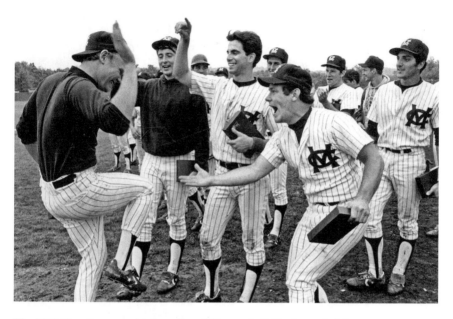

The 1981 'Etta Express celebrates after picking up individual awards following their 14–12 victory over Ithaca in twelve innings for the first national championship in the program's storied history. *Marietta College Archives.*

were afraid of my power—but I don't think that was the case!" Schaly said with a big laugh.

> *That's something you remember the rest of your life. I was fortunate I had a good series. Things came together for me. After all the post-game celebration and pictures and stuff like that, I do remember going back to the field house. Dad was a guy that didn't say a whole lot, but before we walked into the field house, he told me he was proud of me for what I did, and he gave me a big hug. He said it made winning the national championship much more enjoyable for him.*

John's mother, Sue, said, "It was a wonderful experience for John to be on that team. When I got to him in the dugout, we both sat there and cried with our arms around each other."

The little second baseman who was nearly cut by his dad survived to play the role of hero in the biggest victory of his father's career. The irony of the situation was not lost on John's teammates. Pancher said:

It was very emotional when John was MVP in 1981. Being in that position was very difficult for John, because right away, people who don't know think, "Well, he's playing because his father is the coach." And that was the furthest thing from the truth. It was very emotional, very touching after that game. Here's John, a kid that wasn't very big, but was very hardworking and very hard on himself because of the upbringing.

Talarico concurred, saying, "John had a great game in the '81 championship game, but at the same time, it wasn't like he hit a 460-foot home run. It was him taking advantage, taking an extra base, doing all the little things, stealing a base. It was amazing. It had to be a lot of satisfaction for him and for Coach. John really knew how to play the game and how to play it the right way." The Schaly way!

However, it remained for Page to deliver the postscript:

We had just won the national championship, and we had all these great players, most of them underclassmen, almost everyone coming back. It was incredible. We won the national title, his son is the Most Valuable Player in the national championship game and when we get back to the locker room, the first thing he said was, "We're going to really have to get on these guys next year."

I said, "Coach, we just won the national championship. Can we enjoy this for an hour? Give me an hour."

He said, "The heck with that. Let's go get another one."

Chapter 8

TWO PLUS TWO

The period from 1983 to 1986 was the most successful four-year run in Marietta College baseball history. The Pioneers won national championships in 1983 and '86, sandwiched around two runner-up finishes in the World Series. Don Schaly's teams had consecutive records of 49-9, 53-7, 46-11 and 48-13 for a 196-40 composite and an .831 winning percentage.

Of those 196 wins, right-hander Jim Katschke was credited with 47, just a hair under one-quarter of them. That was a school record at the time and a total that still ranks second to Matt DeSalvo's 53 in 1999–2003, which happens to be the NCAA record.

Funny how numbers work out sometimes. Katschke wore uniform no. 47 his entire career.

Besides winning a lot of games and helping Marietta to two national championships, Katschke had another big assignment from Schaly. His work/study job was to do the team's laundry. That's Division III baseball—a three-time all-America pitcher did the team's laundry! But not without a mishap or two along the way, as Katschke well remembers. And not with just any uniform. Katschke, who has built a successful business, Western Awards, in the Denver, Colorado area, said:

> *I had to wash the home pinstriped uniforms one day in the back of the field house in those monstrous machines. I threw all the jerseys in that machine after using Fels-Naptha soap to get that pine tar off the shoulders. Coach Schaly used to tell me, "When I give you this bar of soap, you*

better take care of it." I'm looking at it, and thinking, "It's just a bar of soap!" He said, "You're not getting another one until I think you need it." So I guarded that bar of soap like it was my baseball glove!

We come to the first game of the district playoffs, and he says, "Jim, make sure they look good." It's like 9:30 at night, and he takes off. I put the pants in, and when they're done, I put them in the dryer and throw the jerseys in the washer. You couldn't dry the pants more than four minutes, because they would shrink. So I took them out and hung them on the racks to dry. Same with the jerseys. I put the jerseys in the dryer and closed the door on the dryer, which is like closing the door on a jail cell!

Jim Katschke won forty-seven games in his Marietta College career, second in school history, and he also kept the uniforms clean, though not without a couple of mishaps with Don Schaly's No. 50! *Marietta College Archives.*

I decide to study for a few minutes, and all of a sudden, I realize the jerseys have been in there for twenty minutes. I opened the door, and one jersey had gotten stuck in the door jam, so it was stuck while it was tumbling. It tore a hole right between the 5 and the 0 on Schaly's No. 50 jersey.

I stayed up almost all night and got to Schaly's office at five o'clock the next morning to tell him what happened. I'm standing at his door when he comes in and he says, "What the hell are you doing here, Katschke?" I told him I had a little problem I needed to talk to him about. I said, "We need to go into the equipment room so I can show you something." I have his jersey right there, he sees it and says, "What the hell happened to my jersey, Katschke?" I didn't know whether to crap, cry or run away.

For that double-header, he wore that blue jacket, with his jersey on, so you could see the MC. It was 100 degrees, and he never took off that jacket. He never said another word about it. If I could have sewn the MC and 50 on another jersey, I'd have done it. That was one time when I disappointed The Man, and I didn't know what to do. I called my dad and mom. I told my suitemates, "He's going to kill me."

As if that weren't enough:

> *When we were seniors, I had done the jerseys and hung them up. As I was hanging them up, Coach Schaly came in and said, "Katschke, do you have my jersey in there?" I said, "Coach, you know I've got your pants and jersey right there." And he said, "Looks good. See you tomorrow." I said, "I'll walk out with you." I locked the door and went out.*
>
> *The next day, he called me and said, "Katschke, where's my jersey?" I said, "I don't know. You and I left last night, and it was there when we walked out."*
>
> *Someone took his jersey. He didn't even question me. He knew someone took it, and he said, "It may not happen today, it may not happen next year. But I will know who took my jersey." He wore his jacket again. I said to [second baseman] Frank Schossler, "He's going to start freaking out on me, or I'm going to lose my work/study laundry job."*
>
> *At Coach's funeral, I'm sitting there with Frank and Sudgy [first baseman John Sudges] and Jim [E.] Tracy. I go up there [to the casket] and I said to him, "Coach, you know I didn't take it. You know who took it now. Whatever you want to do, you go ahead and do it. But I didn't do it." Here I was twenty years out of college, still trying to justify it to him!*
>
> *There is no one that will ever be able to let anyone know he stole that jersey. It's like stealing the Hope Diamond! You better be sure you never let anyone know you did it, because you will be ousted from the MC baseball fraternity, and your name will be tarnished until you die!*

It was never easy to earn a spot on Schaly's talented teams, and that was particularly true, of course, in the 1983–86 period. Schossler, now CFO of the Ohio Health Information Partnership and a member of the college's board of trustees, remembers that Schaly warned him about that in advance when he was a senior coming out of Oil City, Pennsylvania. Schossler said:

> *I remember going to Marietta for my visit. Schaly could sell anybody. He'd see the family outside, and as the parents are walking away, they're saying, "This guy is great. He's unbelievable."*
>
> *I remember sitting in his office talking about the program. He goes through everything, and I looked at him and said, "Coach, when do you envision me having an opportunity to play?" He looks across the table at*

me and says, "Play? Hell, Frank, I don't know if you can make this team! There are a lot of good players here."

Here I am trying to figure out if I want to go there or not! That was the best thing about him—he was brutally honest. A lot of people didn't like that, but from a player's perspective, that's all you really wanted—to know where you stood and what you needed to do to have an opportunity to play. He was always honest about that.

Schossler, in fact, did not get any significant playing time as a freshman. He had but four at-bats. So when the '83 World Series came around, he was not on the roster, and his dad came to pick him up to go home for the summer. Schossler said:

[Jim] *Pancher was playing ahead of me my freshman year. Jim was built like a rock and was just a great hitter and a great player. He was MVP of the World Series my freshman year* [1983] *when they won it.*

My dad had never seen Marietta play. He came down to pick me up because I didn't stay for the World Series. He said, "Let's go out and see some of the game." We went to the park, and he kept saying, "I know they're good, but I can't understand why you didn't get more playing time as a freshman."

I said, "Well, Dad, they're pretty good." He said, "Well, who's the guy playing ahead of you?" I said, "He's coming up to bat here first." He said, "Well, he's not very big either." I said, "No, he's not."

The first pitch the kid threw, Pancher hit a ball—I've never seen a ball hit that hard to this day—a line drive over the 410 sign in center field. He's running around the bases, and my dad looks at me and says, "He hit that pretty good!"

I told Pancher that story when he got inducted into the [Marietta College Athletics] *Hall of Fame. I told him that my dad couldn't figure out why I wasn't playing, and I appreciated him hitting the first pitch out of the park because it helped me a little bit!*

Pancher, the director of athletic facilities and equipment at John Carroll University since 1987, was the starting first baseman on the 1981 national championship team as a sophomore. By the time he was a senior in 1983, he was on his way to hitting .413 for the season and posting a career batting average of .395. He was a force in the middle of the lineup and had developed into a left-handed-hitting power source as the regular second baseman.

Talarico said:

> *Jim didn't hit a lot of home runs. But his senior year, he really prepared that winter like an animal. All of a sudden, he got on a run and hit six or seven in a short period of time. It was completely unexpected. On one of those, he missed a signal, but he ended up hitting it out. He's coming in, and we're all shaking his hand, but Coach calls him over and got in his ear. He said, "Did you see the bunt?" Jim said, "No." Coach said, "How could you miss it?" He said, "I just missed it." And Jim would no way overlook it if he saw it.*

The balance of power in the conference appeared to be tipping away from Marietta and toward Otterbein. After winning five straight conference titles from 1977 to 1981, the Pioneers placed third in the OAC in '83 for the second consecutive year.

"Otterbein beat us in the conference that year, and they beat us in the first game of the World Series," Pancher said. "We went to the regional in Burlington, Iowa, and won there, and Otterbein went to Wisconsin-Oshkosh and won there."

Already in the losers' bracket after the first game of the Series, the Pioneers put themselves in jeopardy of a quick exit.

"We're playing California State–Stanislaus in the second game," Pancher said. "They get four runs in the first inning, and then the rains came. I thought, 'Best thing that could happen. Let's get regrouped.'

"We come back the next day, and in the second inning, they get four more, so it's 8–0! Everybody's thinking, 'What the hell happened here?'"

How bad did it look?

"My father was packing the car and figuring out how he was going to pick me up and get me home!" said Talarico.

Pancher continued:

> *Heading to the bottom of the seventh inning, it was 12–3…but we ended up picking away, picking away, picking away, and we won the game, 13–12. It was one of the most incredible games I've ever been involved with.*
>
> *We were at the brink of elimination. I had five hits in that game, including the game-winning hit. It was a gap shot to right-center.*
>
> *The really interesting story is Cal State–Stanislaus had a nine-run lead, and they were still running on us. They were a very mouthy team. They did this stupid little cheer between innings. "How many ducks are on the*

pond," and they would "quack, quack!" It was disrespectful. I was playing second base. I was fiery and kind of foul-mouthed. They're stealing on us, and we pitched out. I remember standing right in the baseline with this kid sliding. I blocked the bag, way in front of the bag, and I just raked him from his groin, knocked his helmet off and almost incited a brawl. But I was like, "Somebody's got to make a stand here."

A couple of innings later, I'm sliding in, trying to break up a double play, and I didn't intentionally do it, but I got called for going out of the baseline, so it was an automatic double play. I come back in the dugout, and I get jumped by Schaly about, "Why did you intentionally do that?" I said, "I did not intentionally do it."

One thing leads to another. He always has to have the last word. I'm the type where I need to have the last word. Now we're going at it, back and forth. He walks away, and I say something. He comes back. I'm walking away, and he says something. I come back. So now we're almost nose to nose in the dugout. We're losing by nine at the time. I get pulled away by Talarico and [center fielder] Marty [Sberna].

I'm at the end of the dugout, and I'm saying, "You've got to be kidding me. This is the way we're going to end our career? Me getting into a fight with Schaly, and we lose the first two games."

Well, we come back and win.

They did it with five runs in the bottom of the ninth, no less. Trailing 12–8, Marietta opened with a single by Steve Riley. Jon Shuler walked. Marty Sberna grounded into a fielder's choice, leaving runners at first and third with one out. Jeff Chaney was hit by a pitch to load the bases. John Hefner walked to make it 12–9. Jeff Wiktorski also walked, making it 12–10, with the bases still loaded and one out. Then the Cal State pitcher balked, making the score 12–11. Monte Duncan grounded out to first, allowing the tying run to score. Pancher followed with a single to right, and the game was over.

It might not have been the most picturesque rally, but five runs in the bottom of the ninth to win and avoid elimination was enormous! And even more drama followed.

Pancher said:

So, we're up at the dining hall, and I'm in line. All of a sudden, I hear, "Pancher!" and it's Coach. I'm like, "Oh, no! Now what?" He says, "I want you to know something. There's only one other person I've come that close to striking. You came that close."

What can I say? Now I'm scared to death. But I'm not going to say anything. Then he says, "And one other thing…one helluva ballgame!" And he walked away.

I looked at Marty [Sberna] *and was like, "What the hell?"*

After that, we just rolled.

That's an understatement. After nearly being sent home following two games, the 'Etta Express won the next three in dominating fashion for Marietta's second national championship in three years. They beat Eastern Connecticut, 12–6, behind a complete-game effort by lefty Terry Mulholland and two home runs apiece by Pancher, who had four hits, and Talarico, who had five hits.

Then Marietta got another complete game, this one from Jim Kennedy, to beat North Carolina Wesleyan, 6–4, sending the Pioneers into the championship game against OAC rival Otterbein. What transpired was the most lopsided whipping one team has ever administered to another in NCAA World Series championship game history.

Trailing 2–1, going to the bottom of the third inning, Marietta scored 33 runs in the next four innings—6 in the third, 12 in the fourth, 9 in the fifth and 6 in the sixth for a 36–8 victory. Remarkably, all 36 runs were earned. Otterbein did not commit an error, though its pitchers walked nineteen. Marietta pounded out thirty-three hits, only one of which was a home run, and that was by Shuler, who had five hits and eight RBIs. Pancher and Hefner had four hits apiece. Every Marietta starter had at least two hits, two runs and one RBI. Pancher was named the Series MVP.

The 1984 team reached the World Series championship game only to lose to Ramapo of New Jersey, 5–4. The 1985 team did the same thing, this time losing to Wisconsin-Oshkosh, 11–6. However, the 1986 Pioneers finally got over the championship game hump to return the World Series championship to Marietta.

Of course, there was plenty of drama along the way, especially in the regional, which was played in Columbus, Ohio. North Central College of Illinois beat Marietta, 12–6, in the second game to put the Pioneers in the losers bracket. Once Schaly's team disposed of Baldwin-Wallace and MacMurray State of Illinois, next up was North Central once again, this time for the right to go to the World Series.

Bill Mosca, the starting first baseman on the 1978 national runner-up team who was Schaly's assistant coach from 1986 to 1994, was coaching third base at the time. He said:

The game was so nerve-wracking I was in the bus during the game! It was one of the best games I've ever been part of, a high-scoring game, 13–11, over North Central Illinois. We had Mike Brandts up for the third or fourth time, and he had already hit two home runs. We had runners on first and third, and Coach [Schaly] was giving me the steal sign. There was a left-handed pitcher on the mound, and I'm shaking my head, "No, I'm not doing it." He keeps giving me the sign, and he's getting pissed. I didn't give the sign, so he finally yelled, "81!" because Roger Thompson, our center fielder, was on first. That was a verbal for the centerfielder to go.

Roger steals second, and then Mike's looking down at me, and I'm saying, "Get back in the box!" Sure enough, Brandts hits a three-run home that puts us ahead. I got in the dugout, and I'll never forget this…I sat next to Coach, and I said, "The only reason we're winning this game is because that guy [the North Central coach] is dumber than you are!" After the steal, he should have walked Brandts! We had Bill Holmes up next. He was a great hitter, but he was a freshman, and it would have been lefty v. lefty.

Mosca probably was the only player or assistant coach in Schaly's forty years who could get away with saying such things, but he did it regularly and survived longer than anyone else who ever coached under Schaly.

"Mosca made such a huge difference on that team," said Schossler. "He was a good balance for Schaly. He wasn't afraid to tell Schaly he was full of shit sometimes."

It's difficult to argue with Mosca's logic under any circumstances, but especially in light of what Brandts did as a senior. He put together an absolute monster year, setting single-season school records that still stand for home runs (twenty-four), RBIs (ninety-three, tied by Jay Coakley in 2000), runs (eighty-nine) and total bases (196). That was in sixty-three games with 218 at-bats. The third baseman from Holyoke, Massachusetts, also batted .440.

Brandts, now vice-president of Microcal, a biotechnology company in Springfield, Massachusetts, recalled, "Their [North Central] pitcher was looking at the coach like, 'Should I walk him?' I'm looking at the coach, and he's saying, 'Pitch to him.' That was a good day! I don't think I ever hit three home runs in a game anywhere else."

He credits Mosca with helping him achieve great success in 1986, including being named MVP of the World Series. In fact, other players say much the same and believe Mosca's encouragement was a big key to the season. Brandts said:

Mosca was the balance Coach [Schaly] needed, because Coach was great at everything except confidence building. We needed it at that age, and he certainly helped us believe in ourselves. I hit a little cold spot before playoffs. This is when I was glad Mosca was there. I was feeling it from Coach Schaly, but Mosca was saying, "Get over it. You're the best. Go get 'em." I snapped out of it and finished really strong.

Mosca's positive approach was exactly what the Pioneers needed after losing in the national championship game two straight years.

Scott McVicar, the starting shortstop who is now associate director of admissions at Marietta College, said:

I remember sitting in our dorm rooms after losing the championship game for the second year in 1985. Parents were coming in, and people were packing and leaving. And just as Mike Brandts was getting ready to walk out with his suitcases, he said, "Well, guys, we're No. 2—again!" We kind of chuckled. I think that's where some of us said, "We're done with it. Let's get it next year." That kind of summed up how we felt.

Mosca came in as an assistant that fall, and he told us from day one, "This is a national championship team. I'm coaching a national championship team." Right through the whole season, he said, "This is my national championship team."

Marietta opened the World Series with a 12–6 victory over Methodist of North Carolina behind Katschke and then ran into old nemesis Ithaca, which the Pioneers had beaten for the 1981 national championship but lost to for the 1980 title. This time, Ithaca won an 18–12 slugfest in spite of a grand slam by Thompson, sending Marietta to the losers' bracket.

The Pioneers beat Methodist, 18–14, to stay alive. McVicar, the No. 9 hitter in the order, led the attack with four RBIs. Then came a 9–4 victory against Montclair State of New Jersey, in which Brandts hit his twenty-fourth home run of the season and his third of the Series. Senior pitcher John Hamborski had a shaky first inning, spotting Montclair a 3–0 lead, but he gave up just one run over the final eight innings for his ninth win of the season.

That brought about a rematch with Ithaca, which was averaging nearly 15 runs per game in the Series. The 'Etta Express would have to beat them twice for the national championship, and that's what happened. Marietta won the first game, 7–2, behind a five-for-five performance by Brandts

(including a triple and double to bring his Series average to .589) and the complete-game pitching of sophomore Steve Oberhelman.

The next day, Katschke fell behind, 6–1, through five innings, thanks in large part to some uncharacteristically shaky Marietta fielding. But the senior ace hung in to finish the game, winning 11–6, for his forty-seventh career victory. The Pioneers rallied for 10 runs over the last four innings, including 3 in the sixth and 5 in the eighth.

Catcher Drew Witouski finished with four of the Pioneers' fourteen hits. Brandts had a hit and two more RBIs to give him a .524 average for the Series with three home runs, ten RBIs and fifteen runs scored, earning MVP honors. Katschke, Witouski and left fielder Sean Risley joined Brandts on the All-Tournament team.

Mosca, now dean of students for Worthington, Ohio schools, said:

> *I don't think it was our best group of individual players, but it was our best "team." The players give me a lot of credit, but I knew no other way. That's who I was. That's what I came there for. I wanted to teach baseball. But I also wanted us to get another national championship. I wanted to get a ring. I was being selfish!*
>
> *I remember the last out like it was yesterday. I was sitting next to Coach. We were in the first base dugout. The guy hit a fly ball to center field, and Roger Thompson caught it. Coach grabbed my hand and I grabbed his, and I said, "Coach, we did it!" Everyone emptied the bench. Watching those young men jump on each other…I never ran out on the field. I thought it was their moment, and Coach believed that, too. They'd put up with our crap all year. It was a thrill to watch young men you love and care about jump on each other like that. It was a great moment for Coach and for me. It was real special to grab his arm and know we did that.*

Another big factor in Marietta's success in 1986 was the addition of a transfer, Risley, from Eastern Connecticut, an excellent program where he was an established star.

"When he left Eastern Connecticut as a junior, I think he pretty much owned every hitting record there," said Schossler. "He was a stud hitter. He was a real cocky Eastern kid. We'd say, 'Hey, Sean, why are you coming to Marietta?' He'd look you right in the face and say, 'Schaly's going to make me an all-American! Schaly's going to make me an all-American!'"

"Actually, I said, 'I want to win the national championship and be an all-American,'" said Risley, equipment manager at St. George's, an exclusive prep school in Middleton, Rhode Island.

He got both. He also set the Marietta and NCAA season record for hits (103), and he still holds the NCAA record for career hits (275 combined between Marietta and Eastern Connecticut).

Schossler recalled:

He also was just a character, and he got away with a lot of things for some reason. I think Schaly was just in disbelief at some of the things he did. I can remember him getting called out on strikes—it didn't happen very often. He comes walking back to the dugout—not running, walking—mad as hell, walks right by Schaly, right by the bat rack, and he's got a green thirty-two-inch Easton in his hands, takes one step toward the dugout pole and swings the bat as hard as he can against that pole and it just rattles. He turns right around and looks at Schaly and says, "Did you see that call? Can you believe that?" and walks away. We're all thinking, "He's going to get killed!" Schaly just kind of shook his head, didn't say a thing and that was it.

People thought we'd be good but never win it all. I remember people doubting us, but we just never quit. We played well as a team. The biggest individual was Risley, who was pretty outspoken at first, but he fell right into place with us and became a leader. Schaly actually named him a captain halfway through the season.

Chapter 9

FORCE OF NATURE

When Don Schaly was coaching Marietta College baseball, there were two ways of doing things—anything. There was his way, which was the right way…and then there was every other option, all of which, of course, were wrong.

This was a truism every day for his forty years as coach. And it was particularly etched in stone at Pioneer Park, which later was renamed in his honor. He built it, like everything else in the Marietta baseball program, from scratch. It was his own personal slice of Earth, and he regularly referred to it as "heaven."

Visitors beware! Enjoy the ballgame, but show respect for the facility and follow the rules. Anyone who didn't toe the line had better be ready to endure the consequences, and it didn't matter who it was.

Debbie Lazorik is now an associate professor but was the college's athletic director—Schaly's direct supervisor—from 1991 until he retired in 2003. She said:

> *Don did not discriminate. It didn't even matter if you were president of Heidelberg University, because we got into it with him a number of years ago when he brought his dog into the stadium! There were no dogs allowed, and that was posted. It was one of those little dogs you can put in a purse. The president's wife brought it in.*
>
> *The game day administrator asked them not to bring it in, but they ignored it. When I got there, I was told about it. I could see the little dog*

sitting on the bleachers. I said, "Pray that Don doesn't see that dog." Let's just get out of this game.

Well, I was up in the press box, and he was glaring at me from the dugout. It gives you a sick feeling in your stomach. I'm standing there, and the phone rings in the press box, and I hear, "Coach Lazorik, Coach Schaly is on the phone." The first thing out of his mouth was, "What the hell are you going to do about that dog? Get that dog…"

I said, "Coach, the dog belongs to…" He said, "I don't give a damn who it is." And then he said, "I heard it was the president. I don't give a damn. You tell him…"

We actually had to have a security person…but that president wasn't budging. He and his wife were not budging with that dog. Here I am trying to negotiate this. Finally, the president gets up and leaves, and as he's leaving the stadium, he's yelling at me, "By God, when Marietta comes to Heidelberg, people are going to know how we were treated." It was ugly.

They still—and I'm not kidding—still tell that story at the OAC meetings! Every fall, someone brings it up.

Like Lazorik, most people who knew Schaly, whether they were Marietta College baseball players or those who found themselves around him in any other capacity, discovered that he was as stern and gruff and demanding as any man who ever planted roots in the first permanent American settlement in the Northwest Territory—at least dating to its founding in 1788.

In fact, many who didn't know him well or weren't around him enough to see the heart and soul under the tough exterior undoubtedly regarded him as a monster. In reality, though, he was anything but a tyrant.

Schaly could be an absolute teddy bear, and few people experienced that side of him as much as some of the women who worked for him and around him. Oh, he made most of them cry at some point, too, just like he brought many tough jocks and grown men to their knees. But in the end, they usually discovered that he was as genuinely wonderful and caring as anyone they would ever know. They cherish his friendship and the lessons he taught them to this day, just as they still chuckle with delight at the indoctrination they endured before they were welcomed into a very select group the legendary coach referred to as "Donnie's Girls."

In 1990, Sheri Martin, a senior in the sports medicine program, was assigned to be the first female student athletic trainer to work with the baseball team. Schaly fought her appointment tooth and nail, relinquishing only when administration told him he had no other choice

but to accept her. He barely spoke to her when she began working with the team, but by the end of the school year, he regarded her as the daughter he never had.

Martin, whose married name is Martinelli, said:

> *You can't really leave student athletic trainers alone today, but back then, you were assigned to a team. I guess there was a big scuttlebutt because Coach Schaly didn't allow a female athletic trainer. The newspapers got involved. Coach Schaly was like, "I don't care. This is my team."*
>
> *But the school put pressure on him because the story got into the newspaper. Doc [Paul] Spear [head of the sports medicine program] said, "I need you to do this for me. You can do it and create minimal waves." I was designated to do it.*
>
> *I distinctly remember reporting to his little office, filled with smoke. I said, "Coach Schaly, my name is…" He didn't even look up. He just said, "I don't care what your name is. It doesn't matter to me. You're just here because you have to be."*
>
> *I thought, "Oh…okay. Thank you," and I walked out. I'm thinking, "Oh, my God." At the time, I was intimidated, but I was still a college kid. I just said, "I'll do my business. I'll play by his rules, whatever he wants me to do. I'll try my best."*

Now a mother of three young children as well as a full-time physician's assistant at a busy orthopedic practice in the Boston area, Martinelli remembers showing up for 5:00 a.m. conditioning workouts with the team, sitting in the bleachers at Ban Johnson Field House and going about her job. She took care of the players, as needed, and turned in reports to Schaly. She said:

> *I was with the team from five in the morning until six in the evening, except when I was in class. It was an intense program. I was pretty much deathly afraid of Coach Schaly, of course. I would always call him "Sir." I'd tell him a player couldn't play, and he'd say, "Well, he's going to play!" I didn't say much. I just did what I needed to do.*
>
> *During indoor practice, he wasn't mean to me, but it was like I didn't necessarily exist. Then at the end of indoor time and the beginning of outdoor practice, he started coming around, chatting a little. When the players were running, we'd walk, and he was very gentlemanly, though gruff, but he taught me how men should always walk on the outside of*

the sidewalk next to the road. He said, "Sheri, don't ever date a guy that won't do this." He was very old-fashioned about things.

During practice leading up to the annual spring trip to Florida, Martinelli never went in the dugout. She worked from the bleachers.

"I was fine with that. I didn't even want to be in the dugout," she said. "I was kind of clueless, but I think I handled it well. Then right before the spring trip or maybe it was when we got to Florida, he said, 'Sheri, get in the dugout!' I said, 'No, no, I'm okay.' And he said, 'Just get in the dugout!'"

It was a monumental moment for Marietta College baseball, because until then, no woman had ever been in the Pioneers' dugout. But from then on, Martinelli was "in." Schaly not only accepted her, but she became one of his favorites and became a lifelong member of the Marietta baseball fraternity, a distinction she still treasures.

"I'll never forget toward the end of the year, after he'd definitely warmed up and we were buddy-buddy, he said, 'You know, Sheri, I never had a daughter, but if I had one, you'd be her.' He gave me a hug and a kiss, and that was a really big thing for me to have that type of approval from him."

When Schaly died in 2005, Martinelli and her husband, Vince, who played baseball at MIT, were living in California, just outside San Diego. She didn't have children yet, but she was working part time as a physician's assistant and also running a coffee shop that the couple owned. She dropped everything and made the 2,500-mile trip back to Marietta for Schaly's service.

"Coach holds a special place in my heart," she said. "He was gruff and leathery, and the smoking...But he had that little twinkle in his eye. When you got a smile or a laugh from him, it was so special. And that little twinkle in his eye was really something."

Freshman Ellen Bonnette began working for Schaly as his work/study secretary in 1987. She nearly quit in the first semester because he was so demanding. But she stayed and worked for him for four years, including summers because she lived in Marietta. When she graduated, she cried because she wouldn't be working for him anymore. Bonnette—now Ellen McVicar, married to Scott McVicar, the starting shortstop on Marietta's 1986 national championship team who's currently associate director of admissions at the college—said:

That first semester, I was searching for another job on campus because I thought I couldn't take him anymore. Now I might cry just talking about him, because when I graduated, I cried because I didn't want to leave him.

Coach Schaly was so particular. Everything that went out of the office had to be perfect—right down to where the staple was on the papers. It had to be straight across—not diagonal. And the envelopes—we used typewriters—when addressing envelopes, I remember him standing there and having me push the return button ten or twelve times. He said it has to be the same on every envelope. You had to tab over so many times. Every thing had to be very particular.

But you know, what's scary is I teach school—first grade—and anything that goes home and I have to staple it, the staple looks the same!

Thinking back, there's nothing wrong with wanting your work to look nice. And the mailings went out all over the country, and it was a reflection on him. So he wanted it to look nice. I respected him a great deal.

I think college, at first, was overwhelming, and then I felt pressure from him. I had to keep up my grades and I couldn't even relax at work because he's looking at where the tabs are on the typewriter! I guess I learned to tolerate him and realized I could stick it out. After a while, I enjoyed going to work when I knew his routine and what was expected of me.

McVicar had the added incentive of being a baseball fan who had grown up watching her father and her cousin playing baseball and softball. She said:

Some of my favorite times with Coach would be in the summer. He'd be coming in from a meeting or just coming to work, and he'd open the door real quick and say, "Come on, let's go!" I didn't even ask where we were going. He might have just been walking me across campus. Those were fun times, because when I was walking across campus with him, I felt like, "We are on a mission."

He made sure that money coming into the baseball office was credited where it should have been, and a lot of times the business office wouldn't get it right. So we would take the books over, and by golly, when we got back, it was right! It was funny. I think people dreaded seeing him coming, because everything had to be right!

When Pioneer Park was being redone, he took me out there, and the railings weren't even on the steps going up to the press box. I was scared to death. He insisted I go up to the top—on top of the press box—to get the full view. He was so proud of it. He took my arm and walked me up there. And that made me feel special. He didn't want women out on the field, but

one time he walked me out on the field and said, "You're the first girl that's been out here." So I thought I was something!

They say everyone touches so many lives, and he is such a good example. Just look at all the lives he touched. Just within his family, all his kids are involved in baseball in some way. Then the secretaries and the players and their families. So many people would come back for alumni weekend and the correspondence he would get from them. People wanting him to know about their lives so he could put it in his newsletter. He'd tell everyone to write him so he'd know what was going on in their lives. That whole fraternity was so important to him.

I still have a letter he sent to my parents, telling them what a good job I'd done and what a truly outstanding person I was and that he was going to miss me.

Tammi Milner, who lived in the same dorm suite as Sheri Martin, was one of Schaly's work/study secretaries from 1986 to 1990 and likely was the person responsible for talking Bonnette out of quitting. Remarkably, she says Schaly never made her cry, but she experienced his harsh orientation.

Now Tammi Weigand, she's still an accountant for Marathon Oil, where she went to work after graduating from Marietta, and lives in Findlay, Ohio. She recalled:

Coach would get out a ruler and measure the margins. That was a famous thing he did. When you were a new secretary, he would get out the ruler and measure. I remember him doing that to me, and I just looked at him. He said, "Well, Tammi, you know, everything we send out represents the program."

But I am so grateful that I knew him and for that experience. When I came to work [at Marathon in 1990] and the secretary would type something for me, I was appalled. I never asked her to type anything else for me. I did it myself. I was in a pool of accountants, and we had one administrative assistant. We didn't have PCs on our desk, so if you needed something typed, you had to take it to her.

When I think about Coach, I think about leadership. He was a leader, first and foremost. Now that I'm in a leadership position, I remember more of what Coach taught me than what I've learned here from people. He always said, "Thank you." Always—every day—just to appreciate people. He always said, "Surround yourself with the best people," and I always remembered that, as well, and try to do that. Right now I manage

six people, but I have managed as many as twenty-four. I think that's what I took away most.

I think the key for me is he didn't intimidate me. He normally made most of his secretaries cry at some point, because they were not used to him. But I don't think he ever made me cry. Like when you played for him, you went through a phase when he was tough on you. And he was tough on us, too, because he wanted you to perform a certain way. I remember sitting there my freshman year and thinking, "I can't believe this has to be typed to perfection." But once you got beyond that and realized that's just the way it is, it was fine.

Coach was such a kind, warm person, and you didn't get that right away. But once you spent time with him, you realized it. That warm side was there, and we were fortunate enough to see it much more than the players saw it. I remember talking Ellen through it, and she decided to stay, and I'm sure she doesn't regret that decision. We all loved him. The lessons I learned from him probably were more important than what I learned in my classes. He was tough, but we're all better people for it.

Jeanne Arbuckle is Marietta's softball coach, a position she's held since 1987. She says Schaly was such a dynamic individual that she describes him as a "force of nature." But she also became good friends with him and learned a lot from him—though, not surprisingly, they had occasional run-ins. She said:

We practice in the morning, from six to eight, and Coach didn't usually come in until nine, because he'd first go out to the field and decide what needed to be done. But this particular morning, he came in early, and I noticed him standing in the corridor watching our practice. It was a little intimidating. He stood there for what seemed like a long time. It probably was only a few minutes, but it seemed like a long time.

Later that day, I had a message from him, asking me to stop up to see him. So I went up to his office. He was sitting there and took off his glasses and said, "I have a bone to pick with you."

I had no idea. I said, "Really? What's wrong?"

"Well," he said, "you didn't have that basket behind the screen—and you never asked if you could use it."

They [the baseball team] had a basket mounted on a post that they would use [to hold balls] when throwing batting practice. So when we were throwing BP, I just brought the basket down and used it, and then

we'd put it back. I never really thought twice about it. In hindsight, it was theirs, and I clearly should have asked to use it.

He was kind of glaring at me in the way that he could with those steel blue eyes, and I said, "Coach, you're right. I'm really sorry."

And he did not know what to say, because he was so used to a more confrontational manner. From that point on, that's when I wasn't afraid of him anymore, because I saw this look in his eyes, and he didn't know what to say when I said, "I'm really sorry." He just said, "Well, you can use it, but be sure you put it behind the damn screen [so it wouldn't get hit and damaged by a batted ball]*!"*

You couldn't work with him and not bump heads with him. But we came to really respect each other, and things always worked out. There was some give and take. There might have been a little more give on my end, but I was the new kid on the block. That went with the territory.

Arbuckle came to Marietta College in the fall of 1987, the year after Schaly won the third of his three national championships in a six-year period. His program was at its height, and so was his reputation.

Arbuckle admitted:

At first, I was terrified of him. When I came here, he was this sort of mysterious figure that had an office in the upstairs area of the building. The office was notorious for having a big, blue cloud of smoke and this gruff, old guy up there. His reputation always preceded him, so there was this notion that he was a mean, tough, no-nonsense guy. And he could be—no question about it!

But anyone who worked with him over any period of time knew there was a big, soft heart in there. Most people never got to see that side of him. As sexist as it may be, he referred to us as "his girls," and he meant that with great affection and love. Debbie [Lazorik] *and me and a number of women that worked in his office over the years. If you were lucky enough to be one of—and he would say this—"Donnie's Girls," then you knew you'd struck a chord in his heart, and in his eyes, you were someone special.*

We had a wonderful relationship. He was just such an inspirational figure for me.

Arbuckle credits Schaly with helping her develop both her coaching style and techniques, as well as her philosophy for working with students. She said:

We became really close friends over the course of our time together. I would go in and talk to him about situations. Even though baseball and softball are quite different, there are a lot of similarities. Just coaching in general, there are a lot of challenges that coaches face, and it doesn't matter what sport, you're coaching young people and trying to move them in a particular direction. He was masterful at that.

He was the absolute best at motivating and getting everything out of his players. He was a tremendous role model for me. It was a very sad day for me when he retired. And when we lost him, obviously it was a tremendous loss. He was bigger than life and such an important person in my development as a coach.

We had little run-ins over the years, but it was always about something that was important to him, and those disagreements never caused any friction in our relationship. I just loved that guy.

He was such an important figure, a true one-of-a-kind. I'd never met anyone like him before, and there will never be another guy like him. He was a force of nature!

Lazorik probably had the most unique relationship with Schaly of any woman at Marietta College, because she first worked with him as a fellow coach (women's basketball and volleyball) and then later became his boss as the athletic director (1991–2007). She said she was initially "terrified" of him, and though she had to fight many battles with him over everything from budget to his smoking addiction and his reserved parking space, they remained friends until the end, when she was with him and his family when he died in Florida. She said:

I interviewed at Marietta the day after Marietta lost to Ithaca in the 1980 World Series. That really meant nothing to me, but I did come from a baseball school. Gordie Gillespie has the most all-time wins of any college baseball coach. He was my mentor. The reason I'm in this profession is because of Gordie. I worked for him for three years at the College of St. Francis [now the University of St. Francis].

So I was around a big baseball program, but I didn't know about Marietta baseball when I applied for the job. When I interviewed here, Vi LeClair, who was the only part of women's athletics at Marietta at the time, picked me up at the Lafayette Hotel. Driving to Ban Johnson [Field House], *her exact words to me were, "We're going to need to tiptoe around the building, and when you see Coach Schaly, just be real quiet, because*

they lost to Ithaca." I didn't understand the significance of it at the time, but I've always remembered that like it was yesterday.

My first encounter with Don was during registration that year. We were in a classroom in Thomas Hall. I was new and was the volleyball [and basketball] coach. We had a practice schedule put together for the start of school. I requested a time slot for a practice, and we were looking at the winter, too, scheduling classes and practice time. And Don said, "You can't do that." I really didn't even know who he was. "Baseball is going to have to use the floor at that time. We've never done that."

I said, "Well, we have to practice basketball, too." I just looked at Bill Whetsell, because he was scheduling the building, and said, "What about the women?" because frankly no one cared about the women practicing.

They were going to give us a half court to practice. We could use an end court. I said, "The game is going to be played on the big court," so we wound up going round and round, and we got it resolved. But that was my first encounter with Don, who essentially was going to dictate our space and time. So I got a sense about the role he played in the department at that time.

Once Lazorik became athletic director in 1991, she suddenly had the upper hand on Schaly—at least on the organizational chart. She said:

When I transitioned to athletic director, that was a challenge—because Don always challenged people. That was his nature. For a while, that was a difficult time, going from being a colleague or peer to being Don's boss. I never really prepared to be an athletic director. The opportunity presented itself, and I decided to go that route.

But you better be prepared when you deal with Don Schaly. You better know the rules. If you're going to be a coach or an umpire, you better be prepared. Well, in my first year, I wasn't prepared. So there were times when Don would want an answer or a decision about something or he wanted to know which direction we were going with budgets. It was a challenge to our relationship, the AD to coach part, not personal.

He helped me—forced me—to mature and grow up in that position faster than I might have if I didn't have a person like Don.

Chapter 10

HIGH DRAMA

When the video game *MVP 06: NCAA Baseball* was released on January 18, 2006, Mike Eisenberg was one of the first to snatch it up.

"Finally, a college baseball video game!" he exclaimed, remembering the experience.

At the time, Eisenberg and his Marietta College teammates were beginning serious preparations for what would be a landmark season. Little did they know just how the season would play out or that Eisenberg's video game could somehow play a role in it, even scripting the plot.

"Mike went to Walmart the day it came out," said third baseman Justin Steranka. "The only reason he got it was there was a feature where you could create your own team. He made Team Marietta and came up with every player. It was neat, and he took a lot of time to create every single player. You could even customize the body style, facial features, hair color, and he literally did that—as close to authentic as possible. It was hilarious!"

Shortstop Ryan Eschbaugh, now a fourth-year medical student and aspiring orthopedic surgeon based at Grandview Hospital in Dayton, Ohio, remembers it all very well, too.

"I don't know how we had time for that, but we played all the time," said Eschbaugh. "Mike and his roommate rented this massive TV—it was like sixty inches. They brought it into Parsons Hall, where we all lived, from Rent-a-Center."

Many of the players were involved, but Eisenberg was the ringleader.

"We used to play this game all the time," said Eisenberg, then a junior right-hander who would enjoy a season that culminated with him being named NCAA Division III Pitcher of the Year.

Mike Eisenberg had a dream season in 2006, going 13-2 with a 1.33 ERA en route to being named the Division III Pitcher of the Year and working 8+ innings in the national championship game to earn co–Most Outstanding Player recognition (with Justin Steranka). *Marietta College Archives.*

"We created Marietta College in the game against all Division I schools. We gave all the players realistic abilities based on their real abilities, their real pitches, real batting stances, everything. It was fun. We played the season and tried to make it as realistic as possible."

The clincher, of course, is that Marietta won the national championship in the video game.

"Not only did Marietta win, but on top of that, [right fielder] Tony Piconke caught the final out—and he caught the final out in the real championship game, too. It was impressive. We got to the final game, and I said, 'I guarantee if we win this game, we will win the real national championship'—and we did!"

Yes, they did. For the first time since 1986, the 'Etta Express, under third-year coach Brian Brewer, swept impressively through the Division III World Series at Grande Chute, Wisconsin, winning all four games and beating Wheaton College of Massachusetts in the championship game, 7–2.

Not that the video game had any real role in what the Pioneers accomplished, but who really knows if it might have put a positive spin on the outlook of a player or two, particularly Eisenberg, who was 13-2 with a

1.33 ERA for the season, striking out 138 and walking just 35 in 115 mostly dominating innings.

"He was that sort of superstitious kind of guy that would believe something like that," Steranka said of Eisenberg. "He would use that as momentum and think it was going to work out. Maybe he was right!"

The season was anything but a video game, though. It had plenty of swings for everyone, including Eisenberg, right down to the national championship game. In fact, Marietta lost the first three games of the season, hardly national championship form—real life or video game.

"We went to Salisbury [North Carolina] to start that year, and it was awful—brutal conditions," said Eschbaugh. "The wind was thirty-five to forty miles per hour, and it was about thirty degrees. It was the coldest I've ever played baseball in my whole life. We played three games and lost all three. Everyone was thinking, 'I thought we were a little better than this.' That start kind of threw us for a loop."

But after a week off, the Pioneers went to Texas for their spring trip and began to turn things around. They won seven of eight games.

"We played some quality opponents and beat some quality opponents," said Eschbaugh. "We took two games at the end against Texas Wesleyan, an NAIA school that was supposed to be really good. We had some momentum going."

Mike DeMark, now showing promise in the Arizona Diamondbacks farm system, beat Texas Wesleyan, 1–0, in the first game of a double-header, and Eisenberg won the second game, 5–0.

Before heading home, there was a little celebration at Billy Bob's, billed as "the world's largest honky-tonk," in Fort Worth, according to Eschbaugh. The short version is that a handful of upperclassmen got out of hand, resulting in Brewer suddenly yanking the team out of the establishment.

"Everyone was scared to death what Brewer was going to do," Eschbaugh said. "He ended up keeping those four or five guys on the bus and giving them a screaming. Then they all got up and ran in the morning. It was a pretty interesting evening. I think a few people kind of straightened out their act after that."

Marietta proceeded to win fourteen of the next fifteen games, including thirteen in a row over a three-week stretch before being sidetracked at Muskingum, 5–4. However, what followed four days later was much worse. It could have proved to be the unraveling of the season.

In a double-header at Otterbein, Brewer's team took a 2–1 lead into the bottom of the seventh in both games with aces Eisenberg and DeMark on

the mound. In both games, Otterbein scored twice in the bottom of the seventh to win a pair of 3–2 decisions.

Eschbaugh said:

> *For some reason, Otterbein had our number. I don't remember a lot about that season, but I do remember the Otterbein games. They say you remember things that stimulate you emotionally, and that certainly was the case. They were our biggest rivals.*
>
> *They didn't like us. We didn't like them. When we went up there, they had students in the outfield. They'd bring their couches from their frat houses, and they'd make signs and look up all sorts of information about us, especially our outfielders. There were kids from* [right fielder Justin] *Merryman's hometown yelling at him about his sister, all kinds of stuff.*
>
> *We played pretty well. Eisenberg threw really well in the first game. In the seventh inning, he walked the first batter and then things just blew up. It was kind of devastating. The second game was almost identical, except it was DeMark. Again we lost in the seventh.*
>
> *I think that was the turning point for the whole year. Brewer was just furious, absolutely furious. We stopped at a buffet on the way home—the Flying J truck stop, a Brian Brewer special. I don't know if he had it in his mind already, but we all think he did. He purposely stopped at a buffet. He said, "Take your time." So we eat, and we eat.*
>
> *Then, as we pull into Marietta, he said, "No one take off your uniform, and I'll meet you on the track in ten minutes." We're all in our gray uniforms, and we go up on the track. We have probably the worst running session I ever had as a Marietta College Pioneer. Right after that double-header.*
>
> *He was furious. He ran us and ran us and ran us and ran us and ran us, just yelling at the top of his lungs the entire time. I remember at least two guys, maybe more, hugging trashcans and then lying down—they just couldn't do it anymore.*
>
> *For me, that was the turning point of the season. It was late, dark. When you're in Dyson Baudo* [Recreation Center] *at night, there's all the windows, and you're looking right at Parsons and McCoy* [dorms]. *All the kids are probably looking from their porches with beers in their hands wondering why the baseball team's in their uniforms running on the track at that time of night.*
>
> *Whether it made us focus a little more or what, we obviously knew he thought we were good enough to do better, and that was why he was so*

angry. It was brutal. To this day, we don't know if he planned it—wanted us to get loaded with food so we could go home and make us yak.

When we finally got showered, I think we were all pretty somber at that point. We just got beat twice by our big rivals and then we got run into the ground by our coach. Everyone was just ready to call it a night. Usually after those running sessions, I tried to get food as fast as I could, but after that one, I had no interest in eating at all.

The team rallied behind Brewer's message. Marietta reeled off a twelve-game winning streak before running into Otterbein again in the conference tournament. Otterbein beat Marietta, 11–6, in the second game of the tournament to put the Pioneers in the losers' bracket. Brewer's team came back to reach the finals, beating Otterbein in the first game, 12–5, but then losing the championship game, 5–4, in twelve innings.

Otterbein was the OAC champ with a 29-14 record (.674) and destined for the NCAA regionals. Marietta, with a 35-10 record (.778), was headed home, quite possibly with the season at an end.

"We're destroyed because our season is over. Everyone thought that," said Eschbaugh. "No one thought we'd get a bid. The two years prior we'd had pretty good seasons but never got a look from the NCAA. We thought it was over."

Steranka, a senior, even thought it might be time to go find a job:

We didn't know if we were going to qualify for the regional. It was out of our hands. The [selection] panel had some mercy on us. I remember getting the voicemail from Brewer super late at night. I had gone to bed, and there were almost tears in my eyes. I'm sitting there in my bed, and it was really tough. If we didn't get a bid, that was it. Go find a job!

I didn't sleep at all. I was looking at my five-dollar Walmart phone. A little light would start blinking if I got a message. I remember that light blinking, and I swear I remember running out into the hallway and screaming as loud as I could. The entire team was up, running up and down the staircases. The season was extended.

Suddenly, we felt like nothing was going to stop us. We seemed to have so much momentum, and we went out and dominated and had a lot of confidence. Our whole season changed, and we got hot at the right time.

In the regional at Terre Haute, Indiana, Marietta breezed through the first two games but ran into a tough adversary in the winners' bracket finals.

Manchester College of Indiana led the Pioneers, 9–6, going to the bottom of the ninth inning. But in typical Marietta style, the Pioneers refused to lose, as they demonstrated so many times over the years.

Jarrod Klausman started a rally with a single to right. Steranka then hit a popup to the third baseman, who lost the ball in the sun, and it dropped for an infield single. Justin Merryman doubled to center, driving in a run to make it 9–7. Josh Beebe reached on an error by the second baseman, scoring Steranka to make it 9–8. Ryan Belanger grounded to second, and Merryman, representing the tying run, was cut down at the plate for the first out of the inning. Lee Guerrera grounded into a fielder's choice at third, leaving runners at first and second with two outs. Then Brewer called on Dom Winters to pinch hit with the game on the line.

Brewer said:

> *Winters was a senior that had lost his starting job but was still our first pinch-hit guy. They were making a pitching change, so I got together with Coach [Mike] Deegan and Dom, who'd become known for taking first-pitch fastballs for strikes. I said, "Dom, I don't care what happens in this at-bat, but please swing at the first pitch." The kid threw him a first-pitch fastball, and Dom kind of dumped it over the third baseman's head. I thought he caught it at first…he dives, bounces, rolls over and then you see the ball. A run scored, and we tied it.*

It was an unearned run, but it was 9–9, which is all that mattered. Manchester decided to intentionally walk Chris Hendricks to load the bases, which proved to be a bad decision. Piconke then drew a walk to force in the winning run and send the 'Etta Express to the championship game.

"It's one of the most amazing wins I've ever been part of," said Brewer. "It was really special. We tell everyone you can do everything right and still not win a national championship. You gotta get lucky, get a bounce, get a call. And we got a bit of a sense right there that maybe that was the turning point for us. It ended up propelling us to the national championship."

The only problem is that Otterbein, also assigned to the same regional, emerged from the losers' bracket. So Marietta had to face an opponent that already had beaten them four times in five games that season.

Make that five times in six games, because Otterbein beat the Pioneers, 4–1, breaking a 1–1 tie with three runs in the top of the ninth off Eisenberg, only his second loss of the year. However, since it was Marietta's first loss of the regional, they got another chance against their

nemesis, and this time they beat Otterbein, 8–7, when it mattered most, even though it took eleven innings. Relievers Scott Dunn and DeMark shut out Otterbein over the last six innings, and Marietta used two singles, a walk and an infield grounder by Winters to push across the winning run in the eleventh.

The good news was that Otterbein was out of the way and the World Series was next. The bad news was that up next for the Pioneers was one of the best pitchers in the nation, Jordan Zimmerman of Wisconsin–Stevens Point. Zimmerman is now in the starting rotation for the Washington Nationals and posted the tenth-best ERA (3.18) in the National League in 2011. But Marietta was set to counter with Eisenberg.

"I wanted to be the best Division III pitcher in the country on the best team in the country," said Eisenberg. "That's all I wanted that year, whether it was reasonable or not. If we'd have lost the World Series, it might have been Jordan Zimmerman [that got that award]. It didn't hurt that we won that game and the Series."

Zimmerman and Eisenberg put on quite a show for a large and wildly enthusiastic crowd. The game's only runs were scored in the fourth. Marietta got two in the top of the inning, and Stevens Point countered with one in the bottom.

"That game was the greatest college baseball game I've ever seen," said Eisenberg. "We went pitch for pitch, strikeout to strikeout. We both had two innings where we had the bases loaded, and everyone was on their feet because it was practically a home game for them. As far as D3 baseball goes, it was one of the most amazing games I've ever heard of or seen."

Marietta got what proved to be the winning run on a foul ball. Steranka singled in Belanger with one out for the first run and then stole second and went to third on the catcher's throwing error. Joe Litke hit a foul fly ball to left that their left fielder would have been better off to let drop. Not knowing how scarce runs would be, though, he caught it, allowing Steranka to tag and score.

"The first pitch Zimmerman threw me was a fastball right down the middle, and I didn't even see it," said Steranka.

Zimmerman went the distance, allowing four hits and one walk and striking out eleven. Eisenberg also gave up just four hits in eight innings plus one batter, walked two and struck out twelve. After a leadoff single in the ninth, DeMark relieved and closed out Stevens Point.

"That Stevens Point team was a stud team," Eisenberg said. "They had like fifty-five or sixty home runs, but they struck out a lot, so I knew going

in it was going to be a good game. If teams struck out a lot, I usually did well against them. The crowd was ridiculous—three thousand people in D3 baseball. That might as well be Yankee Stadium. They were all cheering for Stevens Point. It was full-on intensity."

Judging by the scores, the rest of the series was a cakewalk for the Pioneers. They beat Montclair State, 7–4, Chapman University, 10–4, and Wheaton College, 7–2, for the program's fourth national championship and first since 1986. Still, there was plenty of drama.

DeMark said:

> I closed the first game and then started the second game—which went on rain delay [after the second inning]. We left the field around midnight. I had this herniated disc thing, and Doc [Paul] Spear had me in the pool and put me through an aquatic workout until one o'clock in the morning. We had to get the bus at seven in the morning, with the first pitch at eight—picking it up in the third inning.
>
> I talked to Coach Brewer and said, "I want to go back out, because this is what it's all about," and he said okay. I pitched four more innings.

DeMark held Montclair hitless through the first five innings—spread over two days—and struck out a season-high eleven in six innings.

The next day, Marietta beat Chapman of California easily, spurred by Belanger's home run on the first pitch of the game. That gave Brewer's team a day off before the championship game against Wheaton.

Rested and with Eisenberg on the mound, Marietta jumped to a 7–0 lead through six innings, with all seven runs coming on home runs. Steranka hit two, and Piconke hit one. In the midst of it all, there was a bit of a distraction, though.

Marietta was provided with a local "host family" to help the team with any questions that came up during the series. Pat and Barbara Nicholson had a son, Alex, who served as a batboy for the team. Eschbaugh said:

> In the second inning, Piconke is in the on-deck circle, swinging a big weighted bat, a warm-up bat. He swings it back, and we heard this thud. He cranked this kid in the mouth in the middle of the national championship game. The kid is bleeding everywhere. He's got a couple of teeth knocked out.
>
> Tony was just sick about it, but he had to hit and hit a little popup to second base. I don't think it got into anyone's mind after that, but it was something Tony had to play with. He ended up hitting a home run his next

time up in the fourth inning. The kid went to the dentist and came back and saw us off after it was all over in the parking lot. Tony told him he hit the home run for him.

It could be said that the Pioneers coasted after getting a big lead, but Marietta baseball teams don't "coast"—at least not for long.

Eisenberg said:

I'd pitched 115 innings that year and pitched 8 innings three days before in the opening game. It was the 7th inning of the championship game, and we're up, 7–0. I was pitching great, but I walked the first two guys in the 7th because I was getting tired. They manufacture two runs that inning to make it 7–2.

I get back to the dugout, and Brewer just tears me to shreds in front of everybody. He gets in my face. I knew we were going to win that game, and I was going to wind up leaving the program [turned pro] *most likely. So Brewer gets in my face, and knowing it's probably the last chance I'll get, I got back in his face.*

We had this yelling match in the dugout. I was saying, "Three days rest, one hundred pitches, I'm giving everything I've got." I sat down and went back out the next inning and got them out. I came back in and we looked at each other, and he laughed and I laughed.

I went back out for the ninth, and the first guy got a single, so he took me out. DeMark finished it [meaning he pitched in three of the four Series games]. *Brewer rode me until the last inning of the championship game. We were up plenty of runs. There was no reason for him to get on me at all, but eventually I understood why.*

Eisenberg and Steranka shared the World Series Most Outstanding Player Award. Eschbaugh and Klausman joined them on the All-Tournament Team. Marietta, which outscored opponents 26–12 in four games and finished with a 43-11 record, joined Eastern Connecticut as the only two programs to win four NCAA Division III championships at that time.

The significance of Brewer winning it all in his third season should not be lost. He was following a legend, and there undoubtedly were people waiting to see if he could handle the task.

Deegan said:

I think that first one—and he's never said this, it's just me—there probably was a little bit of relief in that, "What I believed in was

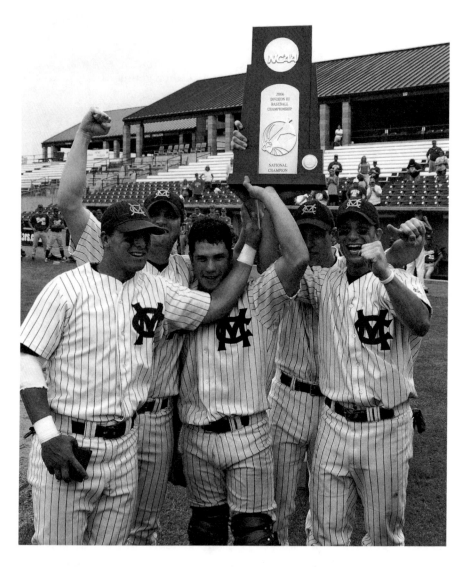

Left to right: Jarrod Klausman, Mike DeMark, Lee Guerrera, Justin Steranka and Chris Hendricks hoist the 2006 national championship trophy, the school's fourth and the first under Brian Brewer. *Marietta College Archives.*

right." People had to be saying, "Can he ever be like Schaly? They're never going to be the same."

So there had to be a little relief. "We did it. We finished this." He's not an emotional guy, plus we win in Wisconsin, and the next thing you know, we're on the bus riding ten and a half hours. Of course, he was proud—really, really proud. He still handled his business—he's still the head coach. He has to make sure the guys are getting on the bus, getting into the restaurants, taking their caps off. But at night, I think he could unwind and say, "It all came together."

Indeed it did.

Chapter II

THE SUCCESSOR

M any people—experts and casual observers alike—consider the most
difficult job in sports to be succeeding a legendary coach. It's nearly a
no-win situation, and there are plenty of examples of coaches who couldn't
live up to their predecessors' image, even if they produced good teams.

For example, four basketball coaches left UCLA in the nine years after the
legendary John Wooden retired. In football, despite Ohio State's immense
success, many fans have never been pleased with the results produced by
Woody Hayes's successors.

Marietta College baseball is hardly on the scale of UCLA basketball
or Ohio State football, but Don Schaly's remarkable .814 winning
percentage and three national championships established an incredibly
high standard. In fact, it was such a lofty level of sustained excellence
that at least two potential replacements wanted no part of the job and
even advised Brian Brewer not to take over the 'Etta Express following
Schaly's retirement in 2003.

Brewer, of course, did take the job and has won two NCAA Division III
national championships (2006 and 2011) in his first eight seasons, leaving
no question that he's both a worthy successor to Schaly and also is quite
capable of sustaining the Pioneers' baseball program at the highest level
in the nation. Shortly before this book was printed, the American Baseball
Coaches Association even named Brewer the 2011 NCAA Division III
Coach of the Year.

No less an authority than Kent Tekulve, who perhaps was closer
to Schaly than any other member of the MC baseball fraternity, says

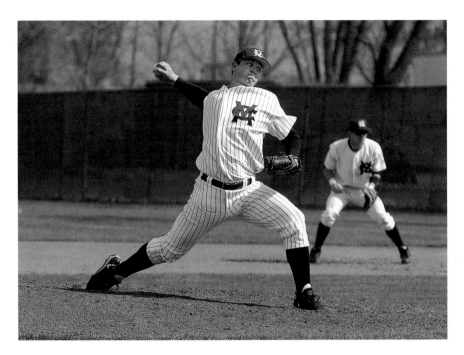

All-American Mark Williams beat Buena Vista, 5–1, in the third game of the 2011 World Series to end his career with an 8-1 record and 1.59 ERA before signing with the Milwaukee Brewers. *Marietta College.*

Brian Gasser was named Division III Pitcher of the Year in 2011, posting a 14-1 record that made him 28-5 in his first three seasons with the 'Etta Express. *Marietta College.*

The Pioneers received their 2011 national championship rings during a ceremony at a football game at Don Drumm Stadium, and here (left to right), Jake Double, Matt Moormeier and Josh Ungerbuehler show off their new bling. *Marietta College.*

Joe Thomas was one of the most accomplished players ever to play for Schaly, winning Division III Player of the Year honors in both 1996 and '97, setting school records as a hitter and also posting a 20-4 career record as a pitcher. *Marietta College Archives.*

Don Schaly
1964 40 2003
season's

Marietta College vs. Muskingum College
May 6, 2003 • Pioneer Park
Coach Don Schaly's Final Regular Season Game

This special oversized ticket, measuring nine by four inches, was given to fans attending Schaly's final regular season home game in 2003 to commemorate his remarkable forty-year career. *Marietta College.*

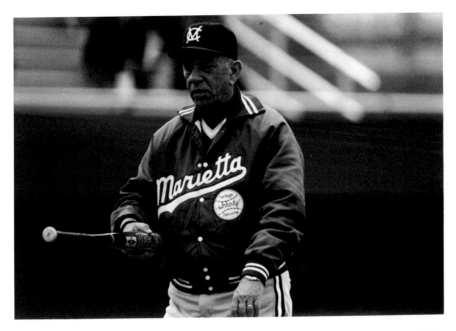

Don Schaly was old school all the way, but even though he was extremely demanding of his players, most of them came to love and respect him for helping to make them better people, as well as better baseball players. *Marietta College Archives.*

Coach Schaly, wearing his now retired jersey No. 50, prepares to catch an inning of Kent Tekulve's pitching in the 1990 alumni game. The player waiting to bat (right) is current 'Etta Express coach Brian Brewer, who was a freshman at the time. *Marietta College.*

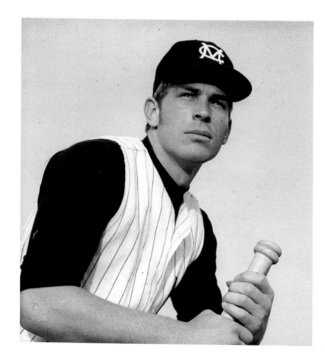

Ozzie Kenyon was an all-America outfielder in 1973 when he batted .363 and set several single-game and season records. He batted .412 in 1972 and ended his career with a composite .361 batting average. *Marietta College Archives.*

Above: This historical marker located in downtown Milwaukee marks the spot where former Marietta College catcher Ban Johnson, a member of the National Baseball Hall of Fame, led the formation of the American League in 1901. *Gary Caruso*.

Right: The oldest son of Don and Sue Schaly, John Schaly (standing) was MVP of the 1981 World Series and now coaches at Ashland University in Ohio. He owns more than nine hundred college coaching victories. *Ashland University*.

The Marietta College Pioneers celebrate a victory in the 2001 World Series in Wisconsin, where they finished second for the sixth of seven times in school history, including 1975, when they were matched against Division II competition. *Marietta College Archives.*

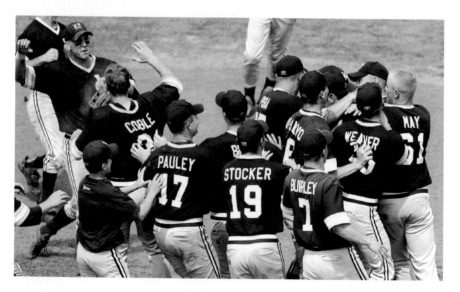

The 2001 'Etta Express, led by pitcher Matt DeSalvo, who can be seen in the midst of this celebration, had plenty of big moments in a 48-9 season but finished second in the Division III World Series. *Marietta College Archives.*

A two-time all-American and a member of the 1981 World Series All-Tournament Team, Tommy Mohl probably was the fastest catcher in Marietta College history. He holds school records for triples in a season (thirteen in 1982) and in a career (twenty-three). *Marietta College Archives.*

Ken Lisko, a two-time all-America third baseman, had ninety-nine hits, eighty-five RBIs and 170 total bases in 1981, all school records at the time, though since surpassed. He also had a twenty-eight-game hitting streak that year, still third in school history. *Marietta College Archives.*

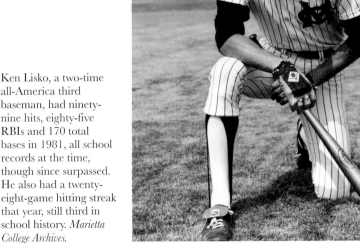

Fiery Jim Pancher sparked the 'Etta Express to the 1983 national championship while nearly inciting a brawl with Cal State–Stanislaus and getting into a nose-to-nose shouting match with Coach Don Schaly. *Marietta College Archives.*

Mark Talarico was a three-time all-America outfielder who played on national championship teams in 1981 and '83, went on to play seven years of pro ball in Italy and remains one of the program's biggest supporters. *Marietta College Archives.*

As a senior in 1986, third baseman Mike Brandts set school season records that still stand for home runs (24), RBIs (93, tied by Jay Coakley in 2000), runs (89) and total bases (196) in just 63 games and 218 at-bats. *Marietta College Archives.*

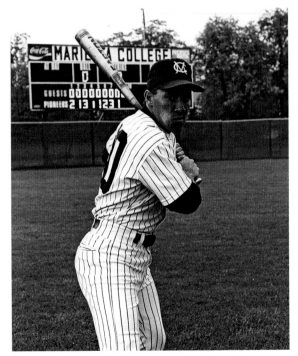

Sean Risley transferred from Eastern Connecticut to Marietta for the 1986 season in hopes of winning the national championship and becoming an all-American. He accomplished both and, in the process, set the school record for hits in a season (103). *Marietta College Archives.*

The entire 2006 'Etta Express savors Marietta College's fourth national championship moments after beating Wheaton, 7–2, to wrap up a 43-11 season. *Marietta College Archives.*

Ryan Belanger was the sure-handed second baseman on the 2006 national champion team and also made all-conference and all-region during his career at Marietta. *Marietta College Archives.*

In the midst of the 2006 national championship game, Tony Piconke, swinging a leaded bat, accidentally smacked the batboy in the mouth with it, sending teeth and blood flying. He later hit a home run "for" the boy in Marietta's 7–2 victory over Wheaton of Massachusetts for the school's fourth World Series title. *Marietta College Archives.*

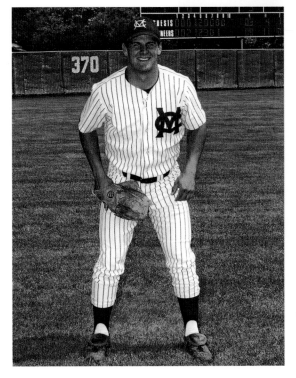

Outfielder/first baseman Jarrod Klausman batted .560 in the 2006 World Series and was selected for the All-Tournament Team. *Marietta College Archives.*

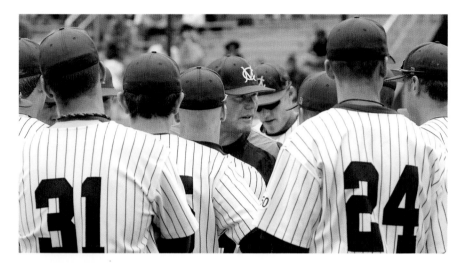

Before replacing Don Schaly as head coach in 2004, Brian Brewer, seen talking to his players, played for Marietta (1990–93), was an all-America designated hitter in 1992 and worked under Schaly as his top assistant coach for four years (2000–3). *Marietta College Archives.*

Brian Brewer talks to Kirby Becker, the junior starting second baseman on the 2011 national championship team. *Marietta College Archives.*

Above, left: When Coach Schaly saw Brewer run as a freshman outfield candidate, he immediately told him to get a first baseman's glove because he wasn't fast enough to play the outfield. But there was never any question about his bat, which produced a .371 career average with sixteen home runs. *Marietta College Archives.*

Above, right: Chris Beatty, sliding, was an all-America designated hitter for Brewer as a senior in 2010 and also won Marietta College's Way-Weigelt Award that year for the way he represented the school on and off the field. *Marietta College Archives.*

A new era in Marietta College baseball began when lights were added to Pioneer Park in 1994. The lighting system is among the best in the college game, meeting the standards for Triple A minor-league baseball. *Marietta College Archives.*

Above: Three Pioneers—(left to right) John Schaly, Kent Tekulve and Jim Tracy—get together at the 2011 American Baseball Coaches Association convention in Nashville, where Schaly assembled a program that included Tekulve and Tracy as speakers. *Marietta College Archives.*

Below: Terry Mulholland, who pitched for twenty years in the Major Leagues, returned to campus to have the street leading to Pioneer Park named in his honor as recognition for making the lead contribution of $250,000 for the lights at Pioneer Park. *Marietta College Archives.*

A collection of some of the memorabilia that was created during the twelve-year run of the NCAA Division III World Series in Marietta from 1976 to 1987. *Carole Hancock.*

After a career at Marietta that included all-America recognition in 2004 and '05, outfielder Chris Sidick has gone on to play seven seasons for the independent Washington Wild Things of the Frontier League. *Marietta College Archives.*

Above: Jack (Leon) Jackson (left) and Bob Wolfarth (right) were among the former Marietta College players on hand when Coach Schaly (center) was inducted into the American Baseball Coaches Association Hall of Fame in Chicago in 1995. *Jack Jackson.*

Below: Six players from Schaly's first two teams returned to Marietta for the annual alumni game in 1985. They are (left to right) Jeff Turecki, Skip Friedhoff, Mike Wright, Jack (Leon) Jackson, Dave Wilcoxen and Bill Neeb. *Jack Jackson.*

the coach's oldest son, John, the MVP of Marietta's 1981 national championship and now a highly successful coach at Ashland University in Ohio, was his dad's first choice as a successor.

"Brewer actually was the second choice to John Schaly," Tekulve said. "The college wouldn't go for it since it was Coach's son. I can understand the thinking behind it. When he found out it wasn't going to be a family member, Brewer was the next choice."

However, Debbie Lazorik, the college's athletic director from 1991 to 2007 and currently a professor at MC, says such an option was not discussed. Whether or not it was, it probably was a moot point, according to Brewer.

"I talked to the boys [about taking the job]," he said, meaning Schaly's four sons. "To be honest, the feedback I got was that John [Schaly] and Paul Page [a highly regarded assistant coach from 1978 to 1984 and now the head coach at Ohio Dominican] were the two viable candidates. Neither said they would be interested—and they thought I'd be crazy to take over after a legend!"

Crazy like a fox, perhaps. With two national championships in six seasons, including the most recent, Brewer is sitting on top of the Division III baseball world.

"It's not easy to replace a guy like Schaly," said former MC all-America outfielder Jim Tracy, now manager of the Colorado Rockies. "Brian's case, on a much smaller scale, is like stepping in to replace Bear Bryant as the football coach at Alabama. And he's won two national championships already, which is absolutely incredible."

Brewer, without question, is a Schaly protégé. A Marietta alum, he played for him from 1990 to 1993 as a slugging, hard-nosed first baseman and designated hitter who was third team all-America as a junior, as well as first team all-region and all-OAC. As a senior, he was a team captain and made first team all-OAC.

After six years of coaching at John Carroll University in Cleveland, two as a graduate assistant and four as head coach (1996–99), he returned to Marietta as an assistant under Schaly from 2000 to 2003.

The summer after his senior season at Marietta, Brewer played independent league pro ball for the Ohio Valley Redcoats of the Frontier League. After that, he began his graduate assistant's job at John Carroll under Head Coach Jerry Schweickert, founder of that school's baseball program. Schweickert, who's now retired, recalled:

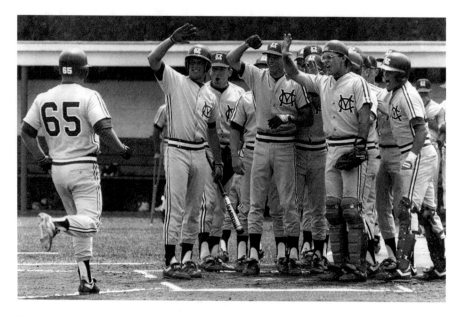

Brian Brewer (65) created some heroics as a player, including this home run in the 1992 Mideast Regional championship game, a 12–11 victory over Ohio Wesleyan that sent the 'Etta Express to the World Series. *Marietta College.*

We played down there—Marietta—and we were talking about this first baseman who was going to leave at the end of the season. Brian was a great player offensively. I didn't know much else about him. But my GA [graduate assistant], *who was getting ready to leave, did because he coached first base and talked to Brian a lot between innings. As we concluded the season, we talked about Brian, and I spoke to a couple of other coaches in the league about him. They all said he gave every evidence of knowing the game, and from being in that program, he was well prepared by the coaching staff.*

I approached him and asked if he'd be interested in being our GA, and he said he would. There were some things to talk about. He didn't have a car. One of Marietta's coaches [Bill Mosca] *brought Brian up partway, and I drove down and picked him up and moved him to Cleveland. You talk about high-budget programs in Division III!*

It all came together rather quickly and informally. Before Schweickert got into the picture, Brewer was prepared to return to Baltimore, where he's from, to pursue a job teaching physical education. Brewer said:

Coach [Schweickert] came up to me before one of the games, maybe during BP. He called me to the backstop and asked if I'd be interested in a GA position at John Carroll, and I said, "What's a GA position?" I had no idea what it was. He explained the position, and I said I'd certainly consider it. We won the conference tournament and the next week went to the regionals, where we lost. At my exit interview, I talked with Coach Schaly, who was aware of the position, because Schweickert talked to him about it. He thought it might be a good opportunity.

Brewer quickly discovered that there were a lot of differences between Marietta and John Carroll, not the least of which was weather.

"One day that winter, Brew walks in when it's nineteen below zero!" Schweickert said. "He says, 'What the hell is going on?' He couldn't believe it. He said, 'What did I do?'"

Brewer, who earned his master's degree there in education with a concentration in chemical dependency, remembered:

It was pretty cold! My first year they set the snowfall record at that time, and my second year, they set the cold record. And I was walking everywhere. I didn't have a vehicle. It was an awakening! The nose hairs were freezing together that first day—and there was a lot of that, not just once a winter.

In the spring, we'd come back from Florida and have to spend another week or two inside to allow the weather to catch up. We'd get forty-degree days, and those kids were used to it and wanting to wear short sleeves. It was like mid-spring to them. But there is no spring in Cleveland.

Nevertheless, Brewer made the best of it, so much so that Schweickert realized the timing was right to retire while there was an able successor at hand.

"It became obvious to me that he was the right guy to come up here," Schweickert said. "I was already thinking about how much longer I wanted to coach and that I'd like to leave the program in good hands. I told our AD, 'This is the guy you need to put in here to take my place.'"

Though Brewer had three losing seasons in his four as head coach at John Carroll, his 1998 team was 25-18, finishing runner-up to Marietta in the OAC, resulting in him sharing the conference Coach of the Year award with Schaly.

After the 1999 season and four years with his own program, though, Brewer was headed back to Marietta, if only for an assistant's job.

Schweickert recalled:

> *I remember him coming to me and saying, "Coach, I talked to Coach Schaly and he's got an assistant coaching position open. What do you think?" I said, "He's got sons coaching. What was the indication about what he's going to do down the road? He's not getting any younger either." He said, "I can tell you this. The next head coach at Marietta is not going to be named Schaly. What do you think?"*
>
> *I said, "Brian, jump at it. First of all, get out of any weather north of the [Ohio] turnpike! It's ten degrees warmer down there."*

Schaly discussed the job with Brewer when both Marietta and John Carroll were in Panama City during their spring trips. Brewer insists he was never told that he would be Schaly's replacement when he retired. Brewer recalled:

> *Coach didn't say, "It's yours if you want it." He was just saying where he was and what his thinking was at the time. This was the year before I came back, and he still coached for another four years. I told him I was flattered that I was even considered, though nothing was done. It was an amazing compliment that he would even consider me to be one that would come in and help him run the program and eventually take it over.*
>
> *We had some conversations throughout that winter and spring. We had a bit of a bad year at Carroll after three good ones. He called, and I went over for dinner with he and Sue and we talked further. I made my application and put my résumé in. It was a national search. I met with Debbie Lazorik, the athletic director, the provost, the president—went through the works.*
>
> *While no one would say I would be the next head coach at Marietta College, all understanding was that I at least would be the leading candidate. Coach had pretty much assured me as much as he could. Obviously, he wasn't directly responsible for the hiring, but I felt pretty comfortable that if he felt I was the right guy for the job, I'd get the job, and that's the way it worked out.*
>
> *I went into it [leaving a head coaching job for an assistant's job] with some expectations, for sure, but the loyalty piece, the alma mater piece, the Marietta piece…I've just completely fallen in love with this community. Those were all contributing factors, as well.*

The Story of the 'Etta Express

It was February 14, 2003, when Schaly announced he would retire at the end of the season and that Brewer would be his replacement. Brewer said:

I really didn't [feel any pressure]. *Knowing how much this program meant to Coach Schaly and him basically handpicking me was the biggest vote of confidence anyone could have. I don't know if people will understand just how much this program meant to him. For him to say, "I want you to take this thing over" removed any inkling of doubt I had.*

It was around January of '03, his last year. I had been talking about applying for some head jobs. He said, "Just hold on, hold on." In the middle of January, he told me, "I've been meeting with Debbie. I'm thinking about announcing my retirement if, at the same time, they'll announce that you're the next head coach." He'd worked on it for a while behind closed doors. Then around the beginning of February it began to come clear.

February 14—Valentine's Day—he said what better day to announce it, because he had such a love affair with Marietta College and the community. So on Valentine's Day of '03, they had the press conference.

I called John Schaly and Joe Schaly and some of the guys that were in coaching and Paul Page. Paul has said repeatedly since then, "You have to be crazy to come in after a guy like that, because there's no way to go but down." But I think those guys were joking. I knew I had their support. I knew Kent Tekulve, I knew Jim Tracy, I'd met Terry Mulholland. I was a product of the program.

As Coach would say, I coached elsewhere, so I appreciated the program that much more, and had come back, so I was familiar with the program. But more importantly, I was with the Marietta College baseball fraternity and some of the heavy hitters in that fraternity. I knew I had their support. So I got the chance to know these heavy hitters and they let me know they were going to continue to support me, and they let Coach Schaly know they were going to continue to support me.

The biggest thing was the fact Coach said, "I think you're the right man for the job." I knew him for a long time. It wasn't a long conversation. We were sitting in his office in the new building. He just brought me in. I knew we were headed in that direction, based on previous meetings. He basically got it all figured out, and said, "They've agreed to name you the next baseball coach at Marietta College. We're going to move forward with this."

I think this was a day or two before February 14. We were in the middle of our pre-season practices, and I knew I had a while before I was the next

head baseball coach, so we had to focus on getting that group ready. We had a team meeting right before the press conference in the locker room, and he told the guys what was going on. He was just the way he was—never overly high or low, just, "This is what we're doing. This is how it's going to be. Everything's going to be fine. Let's do it." And once it was done, we went back to preparing for that spring.

His family wasn't overly emotional at that time. They'd all reached out to me, either right before or right after the announcement, to show their support. John was at Ashland and Joe was at Thiel. They offered their congratulations and support. Sue said the same, "Congratulations. You're going to do great. We'll continue to do whatever we can for you." And I got a lot of those phone calls—Tracy, Tekulve, Page, all those guys called.

Then once we lost in the conference tournament that year, Sue especially was very emotional. It was pretty tough.

I was walking out to the bus—it was at Heidelberg, and they beat us. Sue gave me a hug. She was crying at a pretty good clip, she was letting it go. She cried for a while, and I think I started crying, too. We shared that moment, our disappointment, but I guess it was sort of a celebration, too, though we didn't think about it at the time, and some relief probably for her. We didn't say much at all. I think she told me she loved me, and I told her I loved her back, and we got on the bus.

In his last year, the saddest thing was we broke a lot of streaks. We'd won thirteen straight conference championships going into that year, we'd been to twenty-seven consecutive regional tournaments, but we did not get a regional bid. There were a lot of streaks that ended.

I've talked to Sue about this, that as bad as it was for him to go out that way, it was good for me that those streaks were broken. It was less pressure. At the time we're putting stuff away, he says it's the first time in a long time he'd put away the equipment that early in May. It was sad to see someone so deserving of going out on top to go out that way, but it certainly doesn't lessen what he achieved over forty years.

Brewer and Schaly, as would be expected, enjoyed a very close relationship. That, however, is somewhat surprising, considering the way it began.

Brewer makes it sound like he wound up at Marietta almost as an afterthought or a last resort. He never even visited the campus until he showed up to enroll in the fall of 1989. Some recruits might not have bothered, considering how his first interaction with Schaly unfolded.

"Marietta was recruiting a shortstop on my American Legion team, and I was just kind of a throw-in," said Brewer, who was from Glen Burnie, Maryland, a Baltimore suburb. "We had a really good team, and I ended up being the only starter that didn't play Division I. I was supposed to visit, but we played something like seventy-six games that summer, and I never got the time to visit."

Someone on Schaly's staff, however, was supposed to watch Brewer play in a Legion tournament in Binghamton, New York, but that never happened. Brewer said:

> I had to cancel a couple of visits because of our Legion games. Then right before they were supposed to see me at this tournament, I busted my arm open, so I couldn't play that weekend. I called to tell the coaches, and Coach Schaly answered the phone.
>
> It was the first time I ever spoke to him. I told him I wasn't going to be in Binghamton because I cut open my arm and had to get forty-four stitches. He asked me how I did it, and I said, "Sliding into first base." He said, "Well, good! You deserve it! You should never slide into first base unless you're avoiding a tag!"
>
> I was a little taken aback, because this was the first time I'd had a conversation with him. But I was quick on my feet. I said, "I was avoiding a tag," even though I wasn't!

Brewer resumed playing a week or two later, and his Legion team made it to the regional tournament, which caused him to be a couple of days late for school.

> My mom and dad took me over. We pulled up in front of the field house, walked up to his office and my dad immediately loved him because my dad was a smoker, and Schaly was sitting in his office smoking. He took us for a little tour of campus, took us out to the facility, got me straight with the registrar as far as scheduling classes. My mom was pretty impressed that he was that involved and interested in a kid that they never saw play.
>
> It was a good first impression, especially on my parents. He was rather gruff and pretty intimidating. But I think my mother liked that because she could immediately see the discipline. It was similar to the way my dad was. I had some concerns all along, but he took me out to the facility, where I got a chance to meet some players who were working on the field. That's when it became clear to me that I was at least going to give it a shot.

Fate, more than anything, is what brought me to Marietta. I was getting recruited by a couple of Division I schools—Nebraska, who signed another kid on our team instead of me, University of Maryland–Baltimore County, Towson State. Some things fell through with admissions, etc., and I was wait-listed a couple of places. I was disappointed. Everyone thinks they can go to a Division I school.

Fortunately, my mother filled out the financial paperwork, and I wound up getting a pretty good financial package from Marietta, because we were a lower-middle-class family. That was the biggest reason I went there. I was the only person in my immediate family that went to college. I wasn't incredibly motivated academically at that age, so the small class size was a big plus.

Wherever I ended up, I wanted to be in a competitive program, and I felt I had a better chance of playing for championships at Marietta than at the other places I looked at. I got a recruiting brochure, and I think the first one had the national championship trophies [1981, '83, '86] on it. That would have been 1988–89, that's when they were at the high point of the program. They had plenty of propaganda, written and otherwise, that was very attractive to me. It was pretty clear that they were very successful. That was a big draw.

Brewer had to make big adjustments, though, both on and off the field.

"The coaches and a couple of teammates really helped me through the first couple of months, because I was pretty homesick," he said. "It was culture shock, too. I was coming from just outside the city of Baltimore to Marietta—a big change."

Brewer quickly found out that his baseball world was going to be a lot different, too:

I was a right fielder all through high school and Legion ball. My Legion coach told me in the summer I should probably take ground balls during BP, because being a lefty, I could improve my stock by learning to play first base. Our first day of activities at Marietta is the run-and-throw day. You run a sixty [yards] two or three times, then you throw three balls as hard as you can off the mound and three balls as far as you can in the outfield. I ran a 7.1, 7.2 in the sixty.

Coach Schaly came up to me and asked if I had a first baseman's mitt, and I said, "No." He said, "You better get one, because you're too darn slow to play the outfield." And that was it. I never stepped foot in the

outfield again. My only concern was we had a returning all-American at first base, Scotty Barber. I knew my opportunities as a freshman were going to be pretty limited. But it motivated me. I had my work cut out for me to get in the lineup.

Mainly a JV player as a freshman, Brewer also managed to get a couple of varsity starts due to injuries to other players, and by the end of the season, he was pinch hitting regularly on the varsity. After that, he was in the lineup consistently at first base or DH his final three years.

During the spring trip to Panama City, Florida, in his senior year (1993), the hard-charging Brewer had to come out of a game early. In a game against Gulf Coast Community College, the batter hit a popup in "no-man's land" in short right field.

I went for it, Mark Johnson, our second baseman, went for it, and Matt Warden, our right fielder, went for it. Matt was my roommate. I dove headfirst, and Matt slid feet-first for the ball and kneed me in the head. I don't think I lost consciousness, but I couldn't see colors. I remember sitting up and everything was black and white.

Doc [Paul] Spear [Marietta's longtime athletic trainer] came out and was checking me. I was dazed and looking around and remember something running down my face, and it was blood. Doc patched me up a little and got me to the dugout.

When we got to the dugout, the first thing Coach Schaly said was, "Dammit, Brewer, get that jersey off. You're getting blood all over it!"

Spear took me to the locker room behind the dugout, through the locker room and put me in someone's mini-van out back and sewed me up right there in the back of the mini-van. My roommate's mom was a nurse, and she assisted. I got maybe six or eight stitches on the top left side of my head. I was good to go the next day.

Spear knows Brewer better than most. They even room together on road trips, which is something Spear says some of the players wonder how he can take, particularly after a loss.

"After we played our last game Brian's senior year, he was at the fence and everybody else was on the bus," Spear recalled. "He was just really upset that his career was over. He was very dedicated and really into it. He gave everything he had. He's a workaholic, too, and he knows the game."

One thing no one has ever questioned about Brewer is his toughness, and it undoubtedly is a quality that helped endear him to Schaly. He came by it naturally, as a product of his childhood environment in Baltimore.

Brewer said:

> *It* [toughness] *came a little bit from my upbringing, a little bit from the coaching I had and a lot came from Don Schaly.*
>
> *Dad was tough, pretty much a disciplinarian. Whoopings were still allowed when I was growing up. I had a few of those, and deservedly so. I never met my biological father. My* [step]*dad, as I knew him, was Tom Bahner, who was with me from the time I was two. He passed in 2001 when I was back here as an assistant coach. He was a smoker, fought some obesity issues and was a recovering heroin addict.*
>
> *I didn't grow up in a bad neighborhood, but it wasn't a good one. We were kind of lower middle class. We lived in an apartment, and I shared a bedroom with two sisters until I was eighteen years old. We didn't have a lot, and when you don't have a lot, you're around some people that maybe have questionable character.*
>
> *I was kind of a punk growing up. Maybe it was some insecurity. Coach obviously had a lot of impact on me on the field, but off the field, he and Sue really impacted my life. The discipline piece, the commitment…They helped me understand the value of making good decisions. I don't think I was a bad kid, but they kind of put me over the top in discipline, making good choices, surrounding yourself with good people. I got here and was surrounded by all good people, making all good choices, and I figured out some stuff.*

From the time he began his coaching career as a graduate assistant and then head coach at John Carroll, Brewer has never left any doubt in anyone's mind about his tough, disciplined, competitive approach to running his program and what he expects out of his players.

Marc Thibeault played four years for Brewer and then became his graduate assistant before taking over the head coaching job he still holds when Brewer returned to Marietta. He said:

> *He was the GA when I got to Carroll. When I came to visit the school, the players told me he was pretty intense, and I came from that school—playing for intense people—so I didn't think it would bother me. It probably would be what I was used to. He was my head coach for three years, but really in that GA year, he kind of was the head guy, too.*

The tough, hard-nosed Brian Brewer doesn't hesitate to stand up for his players with the umpires, nor does he refrain from getting in a player's face if he thinks the situation calls for it. *Marietta College Archives.*

I had a good time playing for him, but I knew if I only gave 99 percent, he was going to know it. I was a pretty competitive guy, so that's how I related to him, and I understood 99 percent wasn't good enough. Aside from myself, he's probably the most competitive guy I know. He won't take 99 percent from anyone. He challenged me as a player.

He also probably has the most baseball knowledge of anyone I've ever met. He knows how to manage a game well. He knows how to teach it.

Even though John Carroll had sub-.500 records in three of Brewer's four seasons there, Schweickert said:

I think we made a quantum leap when we brought Brian up here, because he is a baseball man. What I liked about Brian was that he was hard on the kids. He pushed them. You're not going to win with kids that don't want to deliver when it's tough. And Brian's certainly done a masterful job at Marietta.

What I find interesting and exciting after seeing what I saw in the guy is he's been there eight years and won two national championships. Don was there forty years and won three.

Not that Schweickert or anyone else, least of all Brewer himself, is ready to begin making comparisons with the icon who started the Marietta College baseball tradition almost from scratch. But it's impossible to talk about any aspect of the MC program without Schaly's name creeping in, because he started it, he was incredibly successful and he hasn't been gone long.

Mike Deegan played for Schaly (1998–2001) and returned to Marietta to be the top assistant coach when Brewer moved up to replace Schaly. He said:

Brew came into a situation where there's a large shadow looming. I think a lot of people would have run away from this situation, and I'm not sure some didn't. As good of a job as this is, there was the thought, "How are you going to match up to Don Schaly?" But Brew is very confident in himself. Like most good leaders, he had a vision of where he thought this program should go—building off and maintaining what already was in place.

What always sticks out in my mind about Brew is that he was confident in what he was teaching and what he believed. He was able to keep that focus, maybe when some other people might have looked in other directions and questioned themselves. He didn't do that. He stuck with what he believed in, and slowly but surely, we started piecing together some things. He's very confident, very easy to work for in that he lets you coach and do your thing. I think that takes a man that's confident in himself.

One of the turning points in this whole thing was in his first year as a head coach [2004]. We played really poorly in a game, and the next day, we had a running session in the morning because he didn't like the way the guys played. Two guys chose not to come. That afternoon, those two young men went into his office and said, "Coach, we're willing to take the punishment for not going to the running this morning. We just didn't think it was right to run for a loss. We talked it over with our families, and we didn't think that was right."

He said, "Well, that's good. I'm glad you made that decision, but just make sure your stuff is out of your lockers by the end of the day." I think that was the first time as a head coach he faced, "How can we push this guy? What can we do?" I think that kind of laid the foundation. It's not a dictatorship, by any means, but there has to be someone in charge.

From that day forward, I don't think anyone has questioned to what length he's willing to go, because those guys factored into the playing mix. They were part-time guys fighting for spots that we could have used. Those calls as a head coach are tough, because you never know how it's going to affect the team, whether those guys were best friends with other players.

Coach Schaly was the same way. They don't really concern themselves with the politics of the team the way most coaches do. I think Brew's thought that day was, "These guys are challenging my authority and this program." He had to make the call. And like Coach Schaly, he made the decision based on what's best for the organization.

It's not much different than the CEO of a company. Sometimes it can come off hard or callous. It's hard to tell guys who then have to go home and tell their parents they got kicked off the team, but what's even harder is allowing this organization to become where the inmates are running the asylum. We can't have that.

There is, of course, no way to compare Brewer with Schaly—not that anyone really wants to do that. Schaly took literally nothing and built it into arguably the best Division III baseball program in the nation. Brewer took things over when the team, the program, the facilities, the fraternity, the reputation were firmly in place. Yet he seems to have found a way not only to sustain the excellence but also to build on it.

Page, a 1973 Muskingum grad and native of Williamstown, West Virginia, who's in his twenty-fifth season at Ohio Dominican, said:

In my opinion, Brewer's job is a lot more difficult than Schaly's was. When I was there [1978–84], Coach Schaly recruited 99.9 percent of his players with letters. He didn't go out and watch baseball games. There weren't showcases and big summer tournaments. Now the competition for players is so much more intense. There are so many more schools working at it.

So it's a real compliment to Brewer for what he's done. It's tough to get players. Now Coach Schaly is still "there." There's no question about that. It's a big part of the continuing success they have. But it's a great credit to Brian. He had to follow a legend—and a legend with a personality as big as the whole city of Marietta. Everybody knew him or knew of him.

Mosca played for Schaly (1975–78) and then coached under him longer than anyone else (1986–94), including during Brewer's playing career. He

had a close and unique relationship with him that may be unequaled, even by Tekulve. Yet he can't say enough about the job Brewer is doing:

What Brian has done there—and not just the winning, but what he has carried on for what Coach wanted—has been more special than winning two national championships. He's kept Coach Schaly's spirit alive. He's done it the Marietta way.

As someone who had the privilege of coaching him…Brian was a real good player. He was tough, one of the toughest kids I ever met in my life. He was so strong. He could wrestle. He'd get me in a bear hug sometimes, and I couldn't get out of it. He was an animal. He's a person that God only knows what would have happened to him if he didn't go to Marietta. He was a rough kid.

What he's done and the way he's done it—with class. And when Coach passed away, how he handled all that and took care of Sue. As people who are in the fraternity, we could not have picked a better representative for Marietta. I'm as proud of him as a father could be. He's done a wonderful job. It's remarkable what he's done. The winning is great, and we all appreciate that. But it's the way he's done it. He's carried on and taken it to a whole new level.

Brewer, to his credit, knows the score and is pleased and proud of the place he holds in the Marietta College baseball story. He said:

Coach Schaly won three national championships within just a six-year period, and I [wouldn't have won] *the two we've won if he had not achieved what he accomplished. I will never, at any point—if I die tomorrow or in fifty years—contend that I am half the baseball coach or the human being that Don Schaly was.*

I loved him like a father and knew him and respected him. I will never be the man or the baseball coach that he was. But I will certainly strive to become that, and I think he knew that, knew I was a competitive person, a driven person and clearly the right person for the job, or else I wouldn't be sitting at this desk right now. His starting point was way different from mine, and his finishing point was a pretty good place for me to start from.

Chapter 12

THE AMBASSADOR

T all and skinny, Kent Tekulve never looked like a "workhorse" pitcher,
but he set Major League and National League records for endurance
that have stood for a quarter of a century and may last a good deal longer.

As a senior at Marietta College, Tekulve stood six feet, four inches and
weighed about 155 pounds after eating a big meal (though Clark bars were
his food of choice). In his next-to-last game as a senior in 1969, he showed
the type of mental and physical fortitude that would make him one of
baseball's best relief pitchers from 1974 to 1989.

It was a demonstration of endurance that few pitchers have ever matched
at any level, yet it resulted in a costly defeat that Don Schaly never let him
forget. That's because Schaly, six years into his forty-year career at Marietta,
had yet to win the first of his remarkable twenty-seven Ohio Athletic
Conference championships. This loss sealed that fate for another year.

Tekulve, now a member of the Pittsburgh Pirates' post-game broadcast
team, as well as president of the club's alumni association, recalled:

> *My final game of my senior year we were playing at Ohio Wesleyan.
> In my four years, we never won the conference championship, we never
> went to a regional, we were the bare-bones beginning* [of Schaly's
> success].
>
> *We counted pitches back then, but we didn't count them for the same
> purpose that they do now. We charted pitches, and sometimes afterward
> you'd say, "How many did he throw?" and go back and count them.*

This game was on a rainy day at Ohio Wesleyan [in the Columbus suburb of Delaware]. If we win, we win the Southern Division of the OAC. Schaly was always quick to remind me that if I had covered first base in the first inning, we'd have won.

It's raining all day long, not a downpour but a solid drizzle the whole day. The field is getting wetter and wetter. In the first inning, they had a man on third with two outs and there was a ground ball to the first baseman. I didn't get off the mound to cover, and they scored a run. It was 2–2, for 10 2/3 innings.

I got beat on my 201st pitch. There was a man on second and two outs, so he's running. The batter hits a looping fly ball to short left field. Dan Feist came in, made a lunging catch, but on his next stride, his knee hit his glove and knocked the ball out. The [unearned] run scored, and we lost.

It was ironic when we went back and looked at it later that it was my 201st pitch. It was a long game, and it was awfully wet. Ohio in the spring! For all the years Schaly and I were together after that, all I ever heard about was not covering first base!

There was never another time in my career as a professional that I did not cover first base. I'm not sure why I didn't that day. I guess I just froze or something. But I knew if I didn't cover first base again, I'd hear about it from him!

You never worried about how many pitches you threw back then, not even in pro ball. If you were throwing okay and getting people out, you stayed in there.

Managers and coaches at any level would never let a pitcher throw two hundred pitches in a game today. Major League pitchers usually are at or near the end of the line at one hundred pitches. And even in bygone eras of baseball, few pitchers ever put so much stress on their arm in one game. Not many ever got the opportunity, because the circumstances would be so rare for it to happen.

That loss was a tough way for Tekulve to end his Marietta College career, but looking back, it also served as an omen for his unique professional career that followed and made him the ambassador for Marietta College baseball for over three decades—and counting.

Teke, as he was known in pro ball, or Carney, as he was nicknamed at Marietta, led the Majors in games pitched four times and appeared in 90 or more games three of those seasons. His last 90-game season was 1987 with Philadelphia when he was forty years old, making him the oldest pitcher ever

to reach that number of appearances. He also holds the National League record for innings pitched in relief (1,436 2/3). His 1,050 career games—all in relief—ranked second all-time when he retired to Hall of Famer Hoyt Wilhelm (1,070). He also owns career records for most games and innings without making a start.

Only two pitchers have ever appeared in ninety games more than once. Both Tekulve and Mike Marshall did it three times. Interestingly, Marshall was a burly five feet, ten inches, 180 pounds, the direct opposite of Tekulve in physical stature.

There are many interesting statistical accomplishments on Tekulve's résumé, one of the most impressive being his lifetime 2.85 earned run average. In his sixteen-year Major League career, his season ERA didn't exceed 3.60 except in his first and last years. In ten of those fourteen seasons, it was 2.99 or less, including 1.64 in seventy-six games in 1983. He finished fifth in voting for the NL Cy Young Award in both 1978 and '79 and made the NL All-Star team in 1980.

Kent Tekulve (27) and Jim Tracy (23) were raised within walking distance of each other near Cincinnati, became outstanding players at Marietta College and then played against each other in the Major Leagues. *Marietta College Archives.*

When Pittsburgh won the 1979 World Series, he appeared in five of the seven games, saving three of them (2.89 ERA), including game six and decisive game seven at Baltimore. They weren't easy saves either. In game six, he worked the last three innings, and the next day, he pitched 1 2/3 innings.

Believe it or not, Tekulve's push toward big-league success all began at Marietta College, simply because no other school showed interest in giving him a chance to pitch beyond Hamilton Catholic High School. Tekulve said:

> *I came from Hamilton, just outside Cincinnati. I wasn't as attractive to colleges as a lot of other guys coming out of high school. I was not very big. I was six-foot-two, 145 pounds my senior year. Tall and skinny already. I started my senior year in high school by pitching two no-hitters in my first two starts. So I'm thinking, "This is great! Ohio State!" That's where I wanted to go.*
>
> *But first of all, probably no one [colleges] knew about that, and secondly, no one cared. What it boiled down to is Marietta College is the only place I got a letter from asking me to play baseball in college. Of course, that was from Schaly.*
>
> *We visited, and Schaly was a great salesman. This was the first time he recruited a full class. As we found out later, he was throwing out a line and trying to get as much in as he could so he could sort it out later. Because it was the only place that offered me the opportunity to continue to play, it became very attractive. I liked the small campus, liked what he had to say about the baseball program and I was more interested in going to college to play baseball than I was in going to college.*

Schaly's first baseball season was the spring of 1964. He brought in some recruits that fall, but it wasn't until the fall of '65 that he had a full class. That's when Tekulve enrolled before his first baseball season in the spring of '66.

> *My guess is he just basically sent letters to every high school coach in the state of Ohio, asking if they had anyone they would recommend for Marietta College. I don't think his first letter to my high school coach [Terry McGuff] was specific to me—just a form letter asking if he could recommend anyone, and he recommended me, and we went from there.*
>
> *I think I was 4-2 or 4-1 as a senior. It was Ohio baseball. You don't play many games. My first year at Marietta, we played 19 games [in '66]. We were 10-9, and we're still to this day as close in Schaly's tenure as anybody to .500. After that, it just took off.*

There were 110 of us as freshmen. That's how he built the program. To this day, it haunts the program because everyone tells kids, "You don't want to go there because they bring in all these guys and cut so many of them." On most days, we literally would start workouts at six o'clock in the morning, and we would be done with our baseball day by the time we went to eight o'clock class. The freshmen were up early. We were running, we were doing it all.

Schaly was a dictator. He was someone that definitely had an idea of where he was going and how he was going to get there. And you were either going to be in the boat or out of the boat. There was no room for compromise. There was a definite plan in place.

This was the mid-'60s. We had the hippie generation going on around us. Well, the first thing you learn from Schaly is the hair thing. We were all going to look like him with a crew cut. That was part of the deal. Boy, did we stand out on campus! No one had long hair.

He definitely had goals and ideas of how to achieve those goals with his baseball team and his baseball program. He was only going to include people that were willing to do what he needed done to get the program where he wanted to go. The numbers dwindled quickly, because some guys weren't willing to jump in the boat.

No bad feelings if you wanted out, but that's the way it was going to be. A lot of guys wanted out by the end of their first year, one because of the haircut requirement and all that, and two, the amount of work you did, which was one of the tenets of Marietta College baseball and still is. "Nobody will ever be in better shape than we are." They may play better than us, but they're never going to outlast us.

Tekulve got even more conditioning work than the other freshmen—at least that first year. As it turned out, though, his right arm may have been more taxed than it was in his 201-pitch game. He said:

I played basketball my freshman year. That was one of Schaly's great ideas! I didn't even play basketball in high school. I was on the team, but I didn't play. For some reason, Schaly talked to [basketball coach] Don Kelley and got them to include me in this basketball thing. I don't know why. I guess they thought I'd be in better shape when it came time to play baseball. I was part of the freshman basketball team, but all I did was sit on the end of the bench all year.

The worst part was that during the week, I was one of the guys that was a scrimmage dummy for the varsity. I was the center on the scrimmage team. I'm six-foot-three to six-foot-four and still was around 150 pounds. We've got this varsity center by the name of Jack Marks, who was a senior. Jack was a big boy—six-foot-three or six-foot-four but 220 to 230 pounds.

I remember when we were going to play the University of California [Pennsylvania], just outside Pittsburgh. They had a center named Frank Pilsitz. I'll never forget that name. His big play was he'd start out by the foul line, and when he'd get the ball, he'd drive the lane and do an underhand scoop layup. Guys would foul out like crazy against him, because they'd all whack his arm.

Well, Marks—our center—had to figure out how to handle this, and I'm the dummy. I'm not sure how my arm even survived that week. I'd keep coming down and scooping, and he'd whack the hell out of me every time. It took forever for him to learn it was going to be this underhand scoop, and I'm dying because I'm getting beat to death!

Of course, Tekulve not only survived his basketball experience, but he thrived in spite of it. However, there was little sign of the excellence he'd eventually attain in the Majors. As a senior in 1969, he made second team all-OAC. That was the extent of his all-star recognition in college. No all-region or all-America.

He was hardly "untouchable," as outsiders might think a great Major League pitcher would be in college. But he savored the challenges the Pioneers had in Schaly's early years, when the schedule frequently included some Division I schools. He recalled:

Virginia Tech and Duke were on the schedule for the spring trip my senior year. I'm going to pitch the opening game against Virginia Tech. The night before, we wanted to do something to keep the guys together. I said, "Let's go bowling."

So we go bowling, and the next day I don't have squat. There's a big coliseum right behind left field at Virginia Tech. They are beating balls off that wall like nobody's business. Johnny Oates [later a Major League catcher and manager] was on that team. Schaly liked to tell that story, too. He'd say, "You wanted to go bowling, and then you couldn't pitch the next day!"

It was set up so that I was going to pitch twice on the trip, and I got to pick my teams. I wanted to pitch against Virginia Tech and Duke.

I get walloped by Virginia Tech, so we wait a while and go to Duke. [Jim] Potter is catching me. We're tied, 1–1, in the bottom of the ninth, and they've got a man on third with two outs. Some little guy was up that had zero chance of getting a hit—left-handed hitter, I'd seen him three times, and I knew he didn't have a chance by the way he swung.

I forget the count, but Potter tries to pick the guy off third and throws it into left field, and we lose, 2–1. As he cocks his arm, I could hear myself internally screaming, "No!" So, I'm 0-2 on the spring trip.

After Pittsburgh won the 1979 World Series, Kent Tekulve, who saved decisive game seven, returned to campus for a day in his honor and had a little fun at Coach Schaly's expense. *Marietta College Archives.*

Stories are many and oft legendary from the spring trip that typically got the team's season started in warmer surroundings. Tekulve remembers what it was like when the budget for the trip, never grand, was especially small:

On spring trips in the early years, we might have one college van and then guys would drive their cars. We only went to Virginia or North Carolina. We didn't go to Florida or Texas like they do now. Most of the time, we didn't stay in hotels. We stayed in dorms or slept on cots in field houses. We didn't have the money to pay for hotel rooms.

I can remember my freshman year, Skip Trombetti was the equipment guy. His job when we were staying in dorms or a field house was to make sure everyone was up in the morning, and he took great pleasure in doing that. Your wakeup call was him beating on a garbage can.

My senior year when we went to Virginia, there were four seniors—me, Feist, Barry Chasen and Joe May. We traveled together—in Chasen's Corvair! We're pretty good-sized guys in a Corvair going to Virginia. Unbelievable!

Though his support was sometimes lacking, Tekulve had an excellent senior season, posting an ERA of 0.94, which ranks fifth in school history.

When the team got back to Marietta, Tekulve found he had a new catcher, but not one that was a stranger. It was his brother, Jerry (Como), who was a sophomore.

"Potter caught me on the spring trip [1969], but once we got back, Como started catching me," Tekulve said. "He was a heckuva catcher, a very good catcher, built like me which made it pretty hilarious—two tall, skinny guys. That just kind of came together my senior year. It's not like Schaly to think, 'This is neat—two brothers.' He had to think it worked for some reason. The chemistry was pretty good, and Como just caught me so well."

Al Prish was an outfielder for the Pioneers from 1967 to 1970, a year behind Tekulve. He was first team all-OAC as a sophomore and senior and third team all-region as a senior. He still holds the school record for fastest average time to first base (3.91 seconds in 1967) and eventually—like Tekulve—had a tryout with the Pirates at Forbes Field in Pittsburgh.

"I thought Carney was a very good pitcher back then, but never would I have thought he'd do what he did. Never," said Prish, who is retired from the medical sales field and lives in California. "He wasn't underhand [delivery] at the time. I was blown away by what he accomplished. I was very happy for him when he made his mark."

Not even Tekulve's brother, Jerry, who went on to captain the 1971 team when he was first team all-OAC, had an inkling that big-league stardom was in the future for his big brother.

"He was a sidearm pitcher in college, and it wasn't until he was in the minors when he dropped down and started throwing lower," said Jerry, a computer programmer for Progressive Insurance near Cleveland. "That's when his ball started moving more. He was good in college, but never in my wildest dreams did I think he'd wind up having the type of pro career he did."

Prish and Jerry Tekulve weren't alone. No one could have guessed how successful Tekulve would become, probably including his biggest backer, Schaly. The pros didn't even show much interest, as evidenced by the fact that he wasn't drafted.

It remained for Tekulve to go to a Pirates' tryout at Forbes Field in the summer of '69—once Schaly pushed to make it happen—and even after signing there, he had to work his way slowly up the ladder for most of seven years before finding a home in Pittsburgh.

Tekulve said:

Coach Schaly had a lot to do with me getting a tryout. With Marietta being in Ohio, the guy that was responsible for that region was a scout named Joe Consoli out of Buffalo [New York].

I pitched at Morris Harvey, which is now the University of Charleston [West Virginia], *one game, and Dick Coury, a local scout from Wheeling, saw me pitch down there, liked what he saw, got to the regional guy, Consoli, and said, "I'd really like to be able to look at this guy." Consoli told Coury not to worry about it, because they were already going to send in a draft notice on me—"We've got him covered." Coury said, "Fine." Then comes the draft, and I don't get taken by the Pirates or anyone else!*

Schaly didn't know Consoli as well as he knew Coury. When I didn't get drafted, Schaly called Coury and said, "What the hell happened?"

Who knows? Consoli probably did send in the draft report, but that doesn't mean every club drafts everyone they have a report on. That's how I slipped through the cracks in the draft. Schaly talked to Coury and eventually set up this tryout at Forbes Field in Pittsburgh. It supposedly was a "select" tryout. It was a month after the draft, late June or early July. So I went to this tryout, which ironically was run by Consoli. That was how it came about. Schaly retraced steps with Coury and got me to the tryout where I eventually signed.

Not that it was easy. As with all tryouts, the players are first tested for foot speed. Tekulve was so slow that he was told to go sit in the stands. He watched the others going through the tryout and finally took it upon himself to tell the scout, "I don't run the ball up to the plate!"

His point being made, he was finally given a chance to pitch, and the Pirates liked him enough to sign him on the spot. His pro career began at age twenty-two when he was assigned to Geneva, New York, in the short-season Class A New York–Penn League. It was a long way from the National League, but it was a chance, which is all Tekulve ever wanted.

The turning point in his pro career came in 1974, when he was playing at the Double-A level. He was told he needed to come up with a new weapon if he was going to make it to the Majors, and that's when he changed his delivery from sidearm—which he used at Marietta—to a more underarm or submarine approach that created a devastating sinker.

Schaly wasn't shy about using Tekulve as the "front man" for his program, featuring him on recruiting material, among other things. He was justly proud of Tekulve's growing accomplishments, and he knew it was a major sales point for his program.

Tekulve said:

I could tell by looking at him that he was proud of me. He wouldn't say a lot about it, though. I think it was 1975 when he was first able to get to Pittsburgh to see me. He and Sue and the boys came, and my parents were there, too. I remember just the two of us being alone on the side, and he asked me, "What are your goals as a big-league player?"

I told him, "Number 1, I want to play this game and be successful at it and know I did everything I could to help my team on an everyday basis. Number 2, I want to make enough money to buy the house I want to live in for the rest of my life and have it paid for. And Number 3, I want to walk away as the same sonofabitch I was when I walked in. I don't want my personality to change."

Then fifteen years later, they're having a day for me in Pittsburgh after I retire in '89. We're up there in the Allegheny Club at Three Rivers Stadium having a big to-do, and he grabs me. We step outside, and he says, "Well, is your house paid for?" I said, "Yep." Then he says, "Well, you made it."

Until he brought it up, I didn't even remember saying that to him fifteen years before. That was one of those instances when he let me know he was proud of me.

All of Pittsburgh was proud of Tekulve, too. On that "day" the Pirates held, he was given many gifts of appreciation, including a golf cart, a painting of himself and a crystal bowl, and his wife, Linda, received a gold necklace with twenty-seven diamonds to signify his uniform number.

Few players got close to Schaly while they were undergraduates, but after leaving the program, they sometimes became friends with him. There's probably no better example of that than Tekulve, who would train with the Pioneers in the winter as he prepared for spring training with the Pirates. Sometimes he even stayed at Schaly's home, much to the chagrin of Jeff Schaly, the youngest of four brothers and now an assistant athletic director at Marietta. Jeff said:

When Tekulve first made the pros, he'd come back and work out before spring training, and he'd stay at the house. All my buddies used to think that was so cool, but I didn't like it. Tekulve kept a little different schedule than the ordinary kid. I'd get home from a half day of kindergarten, and he'd be in bed sleeping. Mom always told me I had to be quiet and not wake up Carney, so I didn't think it was cool that he was there!

As Tekulve's professional career progressed, he became even closer to Schaly, donating time and money to the baseball program and eventually sending his oldest son, Chris, to Marietta, where he became an all-region and all-conference first baseman in 1998–2000. His support of the program continues today. He presented the 2011 team members with a bottle of champagne with a special label commemorating their accomplishment. That's a tradition he began in 1975, the last year of the combined Division II and III World Series, when Marietta, the lone Division III team in the tournament, finished second to Florida Southern. He said:

> *I buy them champagne when they win the national championship or they're runner-up. When they win, they get the magnum bottles of champagne. If they only get to the championship game, they get smaller bottles. I have special labels printed. It's the same pattern every time, just the year and names of the players change. The names of the players run up and down both sides.*
>
> *As I tell the guys, all the information about the overall record, OAC champs, regional champs, World Series champs is nice, but the most important information is the list of names. "Those are the guys you went to war with. Thirty years from now when you see this bottle sitting around your house, you'll think back to what you did and who you did it with. That's why I put all the names on it, because you might need a nudge to remember some of the guys one day."*

In 1994, the press box at Pioneer Park, now Don Schaly Stadium, was named the Kent Tekulve Media Building in recognition of his financial contributions to the project and to the program in general, as well as of his long-standing overall support in many areas.

Tekulve has remained involved in baseball in a variety of roles since throwing his last pitch for his hometown Cincinnati Reds in 1989. After spending most of his career with the Pirates, he pitched four seasons with Philadelphia (1985–88), leading to a position on the Phillies broadcast team from 1991 to 1997. Among his many roles with the Pirates, including broadcasting and running the alumni organization and fantasy camp, he's also served as an advance scout.

Chapter 13

THE TEKULVES

It's certainly no surprise to anyone who's followed Marietta College baseball that the name "Tekulve" can be found throughout the team's record book and in the media guide. But what is rather shocking is that most of the references are not to Kent, the most accomplished Major Leaguer the program has produced. Instead, the Tekulves referenced more often than Kent are his younger brother, Jerry, and Kent's son, Chris.

Jerry, or "Como" as he was nicknamed, was an excellent catcher who did things his brother never accomplished. He was captain of the 1971 team, and he was first team all-Ohio Athletic Conference as a senior in 1971 when Marietta won its second straight OAC championship. Kent was never a team captain, nor did he make first team all-OAC (second team in 1969) or play on a conference championship team.

Chris also was a captain in 2000, making him and his uncle the only two family members ever to hold that honor at Marietta. And he exceeded his father and his uncle in all-star recognition, gaining all-Mideast Region honors at first base in 1999 (second team) and 2000 (first team).

The list of Tekulve contributions to Marietta College baseball is long, and even Kent and Jerry's father, Henry, or "Pink," as he was known, got in on the act. It was he who planted the seed in Jim (E.) Tracy's head to attend Marietta, where he became a first team all-America outfielder in 1976 on his way to a distinguished pro career. The senior Tekulve even built the Major League–style batter's box chalker that's been in use at Pioneer Park/Don Schaly Stadium for decades.

However, the most unique and lasting piece any Tekulve gave the Marietta College baseball program just may have been Jerry coining the nickname 'Etta Express in 1971 that's still used today—including in the subtitle of this book.

"I really don't know where it came from," said Jerry, now a computer programmer for Progressive Insurance near Cleveland. "I was the only senior on the team, which is why they chose me captain. There weren't a lot of options! Anyway, I took it upon myself to do some things, including the *Poop Sheet*, and I think the 'Etta Express was something I came up with for that."

The so-called *Poop Sheet* was a page of notes about the team and players that was updated each game and given to fans as they came to the ballpark to help inform and entertain them. It continued to be a staple of the program for several years until Schaly felt it got a little too entertaining and pulled the plug on it.

Jerry, a math major, also had an artistic interest and used that to design the baseball windbreakers with script "Marietta" across the front and a baseball with the player's last name embroidered in it. "I think I patterned the design after the Yankees and what they had on their jackets," said Jerry.

Like most brothers, Jerry and Kent were competitive, but because of their age difference, they didn't get to experience batter-pitcher confrontation until they were both at Marietta in the fall of 1967.

Jerry said:

Kent was always a couple of years ahead of me, so I never faced him in summer ball. I don't think I was even on the same team with him except maybe one year. And that year, Dad was the manager, and I only got to play two innings!

So when we got to Marietta, I'd never batted against him. The first time I did was in fall ball [informal league for college and community players]. *We were over at the fairgrounds, and I hit a line drive down the left-field line. The left fielder tried to make a diving catch and the ball got past him, and I went all the way around for a home run. But between third base and home plate, Kent tackled me so I couldn't score! That was my claim to fame, and I remember a bunch of the older guys giving him a hard time about it.*

Jerry also pointed out something else he can hold over Kent's head:

The summer between my junior and senior year, me and Nick Grabko [1969–71] went up to play in the Cape Cod League. We were from a small college, so you don't really know if you're any good or not. But Yogi Berra's kid was the catcher on that team—Larry Berra—and I ended up beating him out at catcher and making the all-star team. So we got to play at Yankee Stadium. That was really cool, and Kent never played there!

Of course, he did play in quite a few other Major League stadiums.

Kent actually sent three of his four children to Marietta College. Besides Chris, his daughter, Beth, and third son, Brian, also attended MC. Brian was in school and the baseball program for only one semester. He and John, Kent's second son, both work in the ski industry out west. Beth graduated from Marietta's physician's assistant program and is a PA at a hospital near Pittsburgh.

It was Chris, however, who made a big impact on the baseball program. His records include:

* Tie—Most hits, game (6)
* Tie—Most RBIs, game (10)
* Tie—Most home runs, game (3)
* Tie, 5th—Most doubles season (21)
* 5th—Most RBIs, career (199)
* 4th—Most doubles, career (51)
* 5th—Most total bases, career (383)

Kent said:

Chris had opportunities to go other places—Ohio State, West Virginia—he got letters from both but never really visited. Obviously, he knew Coach Schaly, because we'd go back there a lot. What it really came down to with Chris is that he really wasn't comfortable going anywhere else but Marietta. For Marietta, Chris was a coup.

Most Division III players are good athletes that are undersized. Chris was about six-foot-three, 185 pounds at the time, a bigger kid, and Marietta didn't get many like that at that time.

Anyone who knew Schaly knew Chris wasn't going to receive any preferential treatment just because of his dad's long-running relationship with the legendary coach. And Chris's new teammates quickly realized that was the case, too. Chris said:

Of course, I knew Coach on a different level than the other incoming freshmen. But my very first baseball meeting on campus—even before fall ball tryouts; it might have been to bring your class schedule—a buddy of mine and I forgot our schedules. I volunteered to run back to the dorm to get them.

So I'm late to the very first meeting. Right out of the gate. Before I'd even been on the field, I found myself a member of the twenty-lap club!

There were fifty to seventy incoming freshmen trying out for the fall league. I'm freaking out. I'm a freshman and I'm already in trouble. This is horrible. But I get out there, and there are thirty guys running already, so I figured it must not be anything too uncommon. The thing about Coach is that he wanted you to be accountable for your actions, and if you screwed up, you knew what your punishment was going to be. You're going to run laps. But once you served your punishment, there were no other consequences. You were back to square one. I always respected that about him.

A catcher in high school, Chris was immediately switched to first base at Marietta, though he also ran drills at catcher—his uncle's position some twenty-five years earlier—as a freshman. "On more than one occasion, Coach Schaly would accidentally call me by my uncle's nickname [Como]," Chris said. "The first couple of times, I didn't pay much attention, because I didn't realize what was happening."

Schaly, however, quickly got his name right once Chris started swinging the bat. One of his more unique accomplishments at the plate came in Marietta's 48–0 thrashing of LaRoche College of Pennsylvania in 1999. In the third inning, when the 'Etta Express scored an NCAA-record 24 runs, Chris fell only a double shy of hitting for the cycle. That's right. He got four at-bats in the same inning and had a triple, home run and single before lining out to left field for the final out of the inning.

"I made the last out of the inning on probably the hardest ball I hit all night—a line drive to the left fielder," said Chris, now an insurance claims adjuster in Pittsburgh. "He didn't even move. If the ball had been three feet either way, I would have had four hits in the inning and probably a double for the cycle."

Chris quickly points out that the competition was not good, though LaRoche has since upgraded its program considerably. He also had another very memorable game against Ohio Valley College in 2000 when Marietta won, 45–2. He went six for six with two doubles, a triple, a home run and ten RBIs.

That senior season was far from a picnic for him, though. In fact, he played nearly the entire season with a painful and disabling injury that would have put most players out of commission, possibly for the season. He recalled:

> *My senior year, we were ranked No. 1 in all the pre-season polls. We went to Panama City [Florida] on the spring trip, and in the second game of a double-header [March 6 v. Viterbo College], I hit a ground ball or line drive down the first base line. I turned first and dropped like a ton of bricks and had to crawl back to first. I didn't hear anything pop. I wasn't sure what happened. All I knew was I couldn't walk.*
>
> *They took me out of the game. At first, I thought it was a cramp and I'd be okay. But as it turned out, I tore my hamstring. I had to decide if I wanted to take a medical redshirt and save a year of eligibility or try to come back with it.*
>
> *This was the group of guys I'd played with for four years, and with the rankings and the expectations the team had, I didn't want to miss the season. We made it to the World Series the year before [finished fifth] and only lost one starter from that team.*
>
> *Instead of taking a year off, I rehabbed as much as I could. I did all the therapy down there and ended up playing the last game in Florida. I played the rest of the season, but it was my left leg, and being a left-handed hitter, all my power was generated from the left leg. I couldn't hit off my backside and turn on anything. So all my power was to center and left-center.*
>
> *It became a whole routine getting ready for a game. If we were on the road, the trainer would meet me in the training room an hour before the bus and we'd work on the leg, stretch it out, do all the electrotherapy and everything that needed to be done just to get me through the season. I certainly wasn't the 100 percent I would have liked. It was a challenge.*

Unfortunately, the team didn't make it to the World Series. They were 44-7 but lost to Ohio Wesleyan, 1–0, in the regional final.

"The wind was blowing in like crazy," Kent recalled. "Chris flied out to the wall in left field in the ninth inning. It would have tied the game. He crushed it, but the wind was too strong."

Even with a bad hamstring, Chris still hit .449 with twelve home runs as a senior. And in spite of only getting to one World Series in Chris's four years, Marietta was 177-32 (.847) during that span.

"I wanted to go someplace where baseball was important, where I knew I'd have a chance to play on a winning team," said Chris, whose wife, Joanne, also played softball and soccer at Marietta. "I probably could have gone to a bigger school but maybe not had that winning experience that I was pretty sure I'd have at Marietta. It was a fun experience."

Kent, however, thinks that playing with the hamstring injury probably kept Chris from getting the opportunity to play pro ball:

> *What he couldn't do—because it was his left hamstring and he was a left-handed hitter—was he couldn't hit off his back side, so he had twelve home runs basically to left-center field. He could get through the games, but he couldn't hit off that back leg. All the scouts thought, "He just doesn't pull the ball." They know he's hurt, but they don't know if he can pull the ball. If he's going to be a first baseman in pro ball, he's got to pull and hit it out of the park. By then, he was six-foot-three and a half and 225 pounds and had gotten stronger. But he didn't get a chance to play.*

Chapter 14

SOME FIRST IMPRESSION

When Xavier University in Cincinnati decided to drop its football program for financial reasons after the 1973 season, it unwittingly set in motion an unlikely series of events that led to Jim Tracy becoming the National League Manager of the Year some thirty-six years later.

At the time, though, Xavier's decision led Tracy, a wide receiver with a love for baseball, to scrap plans for playing college football and to follow a friend's advice to attend Marietta College. In just two years, he became one of the greatest outfielders Don Schaly ever produced, leading to a remarkable professional baseball career that continues today as manager of the Colorado Rockies.

A standout receiver at Badin High School in the Cincinnati suburb of Hamilton, Tracy was known for his pass catching ability. If he could get his hands on the ball, most likely it was a completion. He said:

> *In my senior year at Badin, it looked like it was signed, sealed and delivered that I was going to end up at Xavier on a football scholarship. They wanted me to play spring football my freshman year, but then my sophomore year, they would allow me to play baseball, too. It was a full scholarship, so I'm headed there.*
>
> *But just prior to signing my letter of intent, we got a phone call from the recruiting coordinator and the head football coach at the time, Tom Cecchini, informing us they were dropping the football program, because the financing of it was becoming too much.*

As any high school athlete would be, Tracy was disappointed and didn't know what to do next. Planning to play Division I football, he didn't even have little Marietta College on his radar. In an ironic twist of fate, a family friend who happened to be the father of former Pioneers pitcher Kent Tekulve, who was still laboring in the Pittsburgh Pirates' farm system, stepped in and introduced Tracy to the school and the coach he now credits for shaping his baseball career.

"I'm out of luck," Tracy recalled. "I've got a couple of other places—Youngstown State and Morehead State were a couple of them—where I could have gone and played football. To be honest, I was not overly enthralled when I made my visits there. So I was stuck."

The Tekulve family lived in Fairfield, literally within walking distance of the Tracy family, who lived in Hamilton. Tracy's father, also Jim, and Tekulve's father, Henry (nicknamed "Pink"), were both former baseball players who were very active as coaches in the youth baseball program in their area. They coached against each other and had known each other as friends for quite a few years.

Tracy said:

> I'm on Christmas break my senior year at Badin. They dropped football at Xavier, and I'm not interested in going to the other places that offered me some money. So here comes Pink, walking over one day. And he starts selling Marietta College, because they can't come out and physically recruit.
>
> He talks up the program and talks up Don Schaly. He talks about what a benefit it was for his boys [Kent and Jerry] to go to school there and how much Schaly and his wife, Sue, looked out for their two kids. He said what a great coach he was, what a disciplinarian he was, demanding perfection, the whole nine yards.
>
> My dad's ears perked up. Then they started talking about other things, because they were buddies, and at the end, he strongly encouraged us to visit Marietta. Mr. Tekulve said, "If you get a weekend, take a ride there, and you'll see what I'm talking about."

The word got back to Marietta that there was a good outfield prospect in the Cincinnati area who was looking for a place to go to school, and Schaly began courting Tracy the way he recruited everyone else—with a phone call and a letter, inviting him to visit the campus.

Tracy said:

We decided within a month of Pink talking to us to go to Marietta and visit. I went with my dad and mom, and right away, it was just "me." It was small, and it had that Hamilton, Ohio air to it. You knew where everything was. You weren't overwhelmed by the size. There were a lot of things that made sense for me.

The fact that it wasn't a Division I school really didn't bother me. It actually was the first time in my athletic career where I said, "Okay, I'm going to try this baseball gig on a full-time basis. I'm going to see where this all goes." I said I was going to play baseball and study and just play one sport.

And, oh, how he played it! Tracy stood out so quickly in Marietta's fall program, where one hundred or more freshmen typically tried to impress Schaly, that he quickly earned the starting job in right field for his freshman season, 1975.

Tracy recalled in amazement:

What became apparent to me back then was it seemed everyone went to Marietta thinking they're going to play baseball. A lot of people found out in a hurry that wasn't going to happen.

That fall, there were 106 freshmen that thought they were going to be part of the baseball program. Out of that 106, I was the lone freshman that played on the varsity. I played right field. There were 15 others that made up the JV team, and the rest of that 106 just kind of got moved out. That was unbelievable to me for a Division III program.

To hear Brian McKeown, another incoming freshman from the Cincinnati area in '75, tell it, Tracy practically became a starter the minute he took his first swings. McKeown, a third baseman who's now vice-president for information services at U.S. Bank, said:

We didn't know each other [before Marietta], *but we finally met at Marietta and became friends. The first day of practice, there's 106 of us. The first thing we have to do is throw the ball from right field to third base* [to test arm strength]. *That wasn't Jimmy's forte. We spent twenty minutes doing that, and then we took batting practice. Coach asked who wanted to throw, and me being the brown-noser, I raised my hand and jumped out there to pitch. Jimmy's the first guy I face, and he hits four of the first five pitches I throw over the right-field fence at*

Jim Tracy spent only two years at Marietta College, nearly helping win a national championship in 1975 and being named an all-America outfielder in 1976 before he was drafted by the Chicago Cubs. *Marietta College Archives.*

Pioneer Park. It seemed like they went one hundred feet over the fence. I mean he crushed them, and it's hard to hit them out there. It was unbelievable.

Coach said, "That's enough." He'd seen all he needed to see in five swings! Jimmy probably was supposed to swing at ten. He was an incredible hitter. He would practice hitting—to a fault— until his hands were bleeding. You wouldn't find him shagging balls or working on his throwing, but hitting, he'd be there for hours. The very next day, this is in the fall, Coach cut the senior who was coming back as the starter in right field. Jimmy was a starter from the get-go.

That spring, Tracy helped lead the Pioneers to their first major accomplishment on the national scene, a runner-up finish in the 1975 Small College World Series, the last time Divisions II and III were in the same tournament—and Marietta College was the only Division III school in the field. Tracy said:

I remember the 1975 Small College World Series like it was yesterday. It is so vivid, really the entire year. It wasn't daunting that we were going up against all Division II teams, but it was intriguing that it was the last Small College World Series and that of the eight final teams, there were seven DII schools—and Marietta College. I was the only freshman playing with those upperclassmen, and what a team we had. We were 44-6 [easily a school record for wins at the time].

Tracy also remembers a particularly long home run he hit as a freshman, one he feared would get him in trouble with Schaly:

We're playing Xavier in the first game of a double-header at Marietta. My dad [who played minor league ball for the Phillies and the Giants in the late 1940s] *and mom were there with their dear friend, Jerry Helmers, and his wife, Mary. I hit a ball with a wooden bat in the first game of that double-header that, when Coach Schaly would talk about it, said it was the furthest ball ever hit at that park.*

It was one of those swings where you hit the ball but you don't feel a thing, and as you're headed toward first base, you're thinking, "How far did I hit that?" It was just to the right of dead center field—way, way back in that marshy area. It might still be back there!

I'm a freshman, and I'm all excited. I cross home plate, and I forgot about all the parents and other people sitting right there behind the fence. As I'm going by, shaking players' hands, I just...you know, from the mouths of babes, I yelled, "I hit the shit out of that thing!"

Sue Schaly was sitting near the Tracys and their friend and still laughs at the memory: "Tracy yelled so loud you could have heard him clear back on campus! The thing that made it even funnier was that Jim's mom and dad had a good friend with them. His mother was mortified! I remember her saying, 'I can't believe he said that!' I thought it was funny, but she didn't think it was funny at all."

Nor, Tracy remembers, did Coach Schaly, a devout Catholic. Tracy said:

He just glared at me when I said it. I thought I might be in trouble. I thought, "Uh, oh. I'm running stairs!" But I didn't have to.

I wasn't the type of hitter that was going to hit twenty home runs in college. I hit the ball gap to gap, and if you made a mistake, every once in a while I'd hit it out of the park. And some of them didn't come down for a while. I did have that capability.

Tracy had an excellent sophomore season, hitting .391 with five home runs and thirty-five RBIs in forty games to earn first team all-America honors. But the 'Etta Express fell far short of expectations, going 29-12, failing to win the OAC tournament and checking out of the regional in two games.

Tracy had the itch to play pro ball, and in spite of stormy protests from Schaly, he pursued his dream. He didn't return to Marietta for the fall semester of his junior year, instead staying home in Hamilton and working at a General Motors parts plant. By doing so, he made himself eligible for

Major League baseball's January draft, which no longer exists. He had to be out of school at least ninety days in order to qualify.

"I was starting to get the itch," Tracy admitted. "I got drafted in the fourth round by the Cubs. A lot of people assume it was the fourth round of the June draft. The fourth round of the January draft would have been comparable to somewhere between the thirty-fifth and fiftieth rounds of the June draft."

With a strong team returning for the 1977 season, Schaly no doubt had his eye on winning his first national championship in the tournament's second year at Marietta's Pioneer Park. Losing an all-America right fielder was not a step in the right direction. Tracy said:

> *Schaly was not a happy camper about all this. As a matter of fact, he thought I was making a big mistake, and he was very, very upset with me for a period of time. He did not mince any words or shy away from telling me how he felt about it.*
>
> *We had a conversation before the draft, and I told him what my intentions were. The draft takes place, and he finds out I was taken in the fourth round. He was trying to discourage me from signing, and I said I wanted to meet the scout and see what he had to offer. Maybe they're going to say, "We'll give you $500 if you want to try it."*
>
> *I had a feeling that come the June draft, the landscape would be exactly the same, no matter what I did. I could only hurt myself* [by returning to Marietta]. *I couldn't help myself* [my draft position]. *So I met with the scout—Frank DeMoss. In my two years at Marietta, he'd come to see me play eight times. Nowadays, when scouts find out about players, they talk to them. Back then, he never said a word. I didn't know he'd seen me play.*
>
> *He comes to the house and winds up offering $5,000* [signing bonus]. *I remember that sounded like a ton of money. I was kind of surprised. I didn't think it would be that much. I also thought that come June, I wouldn't be offered much more than that. I could only be offered less, because in the June draft, there are a lot more players to choose from, and I would be going way down and probably only get a "take-it-or-leave-it" proposition.*
>
> *So I decided I was going to sign. Then I got another phone call* [from Schaly], *and this one wasn't anywhere near as pleasant as the one before was! Not good at all. He felt I was making a huge mistake. I probably caused him to smoke a few cigarettes—and he only needed one match to smoke them.*

Even without Tracy, Marietta finished 36-13 in 1977 and won the OAC tournament and the NCAA regional before losing the first two games of the World Series (5–3 to Cal State–Stanislaus and 11–9 to Brandeis).

But just because Tracy left Marietta for pro ball didn't mean he was abandoning the college or Schaly, who was so tough on him about his decision. In only two years together, they had formed a strong bond that continued until the coach's death and that Tracy talks freely and proudly about to this day.

When Schaly's oldest son, John, the baseball coach at Ashland University and the MVP of Marietta's first national championship in 1981, asked Tracy to speak at the 2011 American Baseball Coaches Association convention in Nashville, some five thousand coaches from throughout the nation and around the world heard about Don Schaly and Marietta College baseball. Tracy said:

> *Before I got into my spiel to the five thousand coaches in this group, I wanted to make sure they understood where I came from and who mentored me. I talked about Don Schaly and all his wins and three national championships and seven times runner-up. I just wanted everyone to know, "This is the stock I came from."*
>
> *When John asked me to be there and speak, I'd jump through hoops for him because of what his father did for me. I wanted those coaches to know, "This is where I came from, and I'm damn proud of it."*
>
> *Coach Schaly influenced me more as a manager than as a player. This was the coaches convention, so it was such a ripe time for me to say to this group that this man I played for was the best-kept secret in college baseball. He could have coached against anybody and been very, very successful.*
>
> *I know that after going through what I've been through. This guy was at the top of the class. He outworked you. He had a mantra that he would tell his players in early January, when we came back earlier than the rest of the students from Christmas break to start our practices to get ready for the spring trip. "We're going to work harder, we're going to play harder and we're going to out-prepare anyone we play against."*
>
> *I've never forgotten that. When I started as a little fish in the pond—the player that signed a professional contract who easily could have been taken off the board my first year and the Chicago Cubs organization would have been no worse off—I kept holding onto that mantra.*

Without making the Schaly "mantra" his own philosophy, it's no stretch to imagine that Tracy might well have never reached the Major Leagues as a player and quite possibly not as a coach or manager either. As it was, Tracy had an unremarkable pro playing career that included parts of two seasons in Chicago with the Cubs (1980–81). His lifetime batting average is .249 with three home runs and fourteen RBIs in only eighty-seven games (185 at-bats).

However, he never stopped working at his trade. He played seven seasons in the minors, where he was a .292 career hitter and drove in one hundred runs with Triple-A Tucson in 1982, and spent one other season (1983) in Japan, where he batted .303 with nineteen home runs.

Tracy said:

> *What I accomplished in my professional career is somewhat surprising, I'm sure. I probably was drafted as a roster filler who wasn't supposed to make it. When I first got to Scottsdale, Arizona, where the Cubs had spring training, it became pretty apparent to me that I was way, way down on the totem pole, nonexistent pretty much, just a body. You don't think that when that scout is sitting in your living room. You think you're the greatest thing since sliced bread. But then reality sets in.*
>
> *What added to it was when we came out of spring training that first year in 1977, I didn't make anyone's [full season] team. I got shipped to extended spring training. My monthly salary was $500. I'm thinking, "You've got to be kidding," and I started thinking about Schaly and that he might have been right. I might have to get to the point down the road where I'm going to have to call him and tell him I screwed up. I thought to myself, "I don't know if I want to have that conversation. He's going to get mad at me again!"*
>
> *I also had it in the back of my mind that I'm going to get busy and get the message out to somebody with my actions that I don't think I belong here. In my first ten at-bats, I got seven hits, and I mean I'm hitting bullets. I'm hitting balls all over the place, and I'm hitting them as hard as they can be hit. But that's still not a game-breaker. The difference came when a guy with our Pompano Beach club in the Florida State League slid into second base and broke his leg.*

Replacing that injured player was the opportunity Tracy needed. He didn't exactly set the world on fire at Pompano, hitting just .226, but he

somehow caught the eye of his manager, Jack Hiatt, a former journeyman catcher in the Major Leagues.

They did a lot of doctoring of my swing, because I used to hit out of a crouch, and they straightened me up. I wasn't very good. Here's this kid from a Division III program competing against all these guys from Arizona, Arizona State, San Diego State, Big 10 programs, Atlantic Coast Conference programs, etc. That winter, I went to work on all the changes they wanted me to make. I never was and never will be afraid of work.

There's that Schaly mantra again.

"I owe an awful lot to Jack Hiatt. When I went back to spring training in 1978—knowing now how the system works—I can tell you my name was probably on that board to the far right under the 'release' column. I guarantee it. I'm sure Jack Hiatt was very influential in fighting for me and seeing to it that I got another chance."

Gradually, Tracy made progress. He earned a mid-season promotion from Class-A Pompano to Double-A Midland in 1978, and by mid-1979, he was at Triple-A Wichita, one step from Wrigley Field. He finally took that step in mid-1980.

We were playing in Indianapolis, and Jack Hiatt was my manager again. After the game, we're going down through this tunnel to get up to the clubhouse at old Busch Stadium in Indianapolis, and he [Hiatt] was kind of welled up. I think it had to do with the fact that he was going to tell me that this journey—knowing good and well that I was one of these kids that wasn't supposed to make it—is going to the big leagues. He was so proud, because he knows between 1977 and '78, he stood up for me as a player. Had he not stood up for me after 1977, they would have released me. Now he's telling me I'm going to the big leagues.

Due to an injury to starter Dave Kingman, Tracy was a regular outfielder the second half of July, part of August and all of September and October in 1980. Eventually, it resulted in a couple of pitcher-batter confrontations with Tekulve, who the previous year had saved game seven of the 1979 World Series for Pittsburgh against Baltimore. Two kids who had once almost been neighbors near Cincinnati, and who went to Marietta six years apart, had the unique opportunity to face each other at the top level of the baseball profession.

"I went from the guy that was going to be released after one year to taking 185 at-bats in the big leagues [in two seasons] and having to hit off Tekulve," said Tracy. "That was terrific, knowing I was his batboy as a kid."

Imagine, long before Tracy reached the Majors or even got to Marietta College, he was learning baseball from the guy who would become the biggest success to come out of Schaly's program, as well as from that pitcher's father, who eventually pointed him to Marietta.

Tracy said:

> *When I was a kid and was playing in what they called the minor leagues for eight- to nine-year-olds, I wanted to be more challenged, and I'd go over and watch the Babe Ruth League games. I wanted to see that bigger field and see those balls get hit high in the air. I mean, that really excited me! That would keep me at the ballpark until nine or ten at night.*
>
> *I would leave our game and go over, and "Teke"—"Carney"— was managing that team in the summer between his high school senior year and his first year at Marietta College. His dad—Pink—was always there, and that year he let Carney manage the team. What was beautiful is that first of all, Mr. Tekulve taught me how to keep the scorebook. That's who I learned to keep score from. I'd be sitting there in my Little League uniform next to Mr. Tekulve. And when I wasn't sitting next to him learning how to keep score, I was picking up bats as Carney's batboy.*

Kent didn't forget who his batboy was and even mentioned it in an interview when the Pirates went to Wrigley Field late that 1980 season.

"Teke made a comment to the media to the effect, 'You know you're starting to get old when you have to figure out how to get your batboy out!' And Willie Stargell and some of the other players were teasing him about it before the game," Tracy said.

They faced each other in that series on September 28. Tracy hit a hard, one-hopper right at Pittsburgh shortstop Tim Foli, who threw him out to start the eighth inning. Tracy said:

> *Tekulve got behind me three balls and one strike, and he threw one of those heavy, bowling ball sinkers that he always threw, and I hit the heck out of it. I mean, it was a one-hop bullet right up into the face of the*

shortstop. He makes the play and throws me out, and here I am going
back across the diamond at Wrigley Field to the third base dugout, and I
mean Teke's all over me! He yells something like, "A 3-1 count and that's
all you can do with that pitch!"

The only other time the two faced each other was a few days later, on
October 4, this time at Pittsburgh's Three Rivers Stadium when Tracy flied
out to center field in the ninth inning.

"He got me out both times, but he didn't strike me out!" said Tracy,
claiming a moral victory.

Tracy hit .254 with three home runs and nine RBIs in 122 at-bats in 1980
at age twenty-four. He made the Cubs out of spring training in 1981 and
spent the first two and a half months of the season in the Majors before
being sent down to Triple A and later was recalled for September. He batted
.238 with five RBIs in 63 at-bats. That was the end of his big-league career,
at least as a player.

During the off-season, he was traded to Houston. In 1982, he batted
.318 with twelve home runs and one hundred RBIs for the Astros' Triple
A affiliate at Tucson. He spent 1983 in Japan and returned to the States for
another try in 1984, only to wind up in the minors again for his last year of
pro ball as a player.

Eventually, all the hard work led to the opportunity to coach and then
manage in the Majors. That journey began as manager of the Class A
Peoria Cubs in 1987. After seven seasons of managing in the minors,
including 1993, when he led the Harrisburg Expos of Pennsylvania to
the Eastern League championship by winning 100 of 147 games, he
was promoted to bench coach of the Montreal Expos in 1995 under
manager Felipe Alou. He was in that role for four years and then
took the same job with the Los Angeles Dodgers under Dave Johnson
for two seasons.

In 2001, the former Marietta College right fielder was named manager
of the Dodgers, then one of the most esteemed franchises in pro sports.
Tracy recalled:

Coach Schaly called the house when I was named manager of the
Dodgers. We were both kind of choked up in that conversation. I'll
never forget that phone call. The flurry of phone calls was incredible.
I think we had like 175 messages. But he called after I got back from
the press conference and interviews, and I heard his voice leaving the

message and went over and picked it up. He was semi-choked up. He congratulated me and told me how proud he was. I'll never forget that as long as I live.

It wasn't very good odds that a guy from Marietta College would wind up as manager of the Dodgers. It happened because I worked my butt off, and I prided myself on being very, very good at what I do.

Now I'm sneaking up on eight hundred wins in my career. I've been to the post-season twice. What I'm chasing now is to know what it's like to manage the very last game of the year—and win it.

Tracy managed the Dodgers for five years, winning the NL West in 2004. Former Marietta left-hander Terry Mulholland was on his pitching staff briefly in 2001-2. The Dodgers let Tracy go after 2005, and Pittsburgh immediately picked him up, though he was unable to turn around the Pirates' fortunes in two seasons.

In the off-season before the 2009 season, the Colorado Rockies hired Tracy as bench coach under Clint Hurdle. The team got off to a disappointing start (18-28), and Tracy replaced Hurdle as manager in late May. The Rockies responded by going 74-42 the rest of the way, the second-best record in baseball over that span, to climb from 14½ games behind to finishing second and qualifying for the playoffs as the National League wild card. Colorado won a franchise-record 92 games, and Tracy became just the second man ever to be named NL Manager of the Year after taking over a team during the season.

Tracy said:

> *I think a lot of Coach Schaly's influence came out in me as a manager, more than as a player. A heckuva lot of it came out when I started managing in the minor leagues back in 1987, and a lot of him has surfaced since then. His leadership characteristics, his presence, his attention to detail, his work ethic—all unbelievable.*
>
> *I still see him sitting there with that typewriter. I'm an observer, and he was meticulous. You didn't want to go into his office, because you couldn't find him in all the smoke, but he was absolutely meticulous to the second. And I embraced all that.*
>
> *He never did tell me I made the right decision* [to turn pro after his sophomore year at Marietta]. *That was the maddest he ever got at me. I know he respected me. I also know that toward the end of my freshman year and the start of my sophomore year, he recognized my*

leadership capabilities. I think that's one of the reasons he remained as hard on me as he did. I never felt any malice about it.

After we had that real good cry with one another when I was named manager of the Dodgers, he then basically, in his own way, told me how proud he was, how special a moment this was, not only for the hard work I put in as a player, coach and instructor but also from the standpoint of Marietta College and how proud they were to have one of their own managing the Los Angeles Dodgers.

Chapter 15
"DOCTOR" DEALVO

Listen my children, and you shall hear
Of the Euclid climb of Matt DeSalvo

Okay. Apologies to Henry Wadsworth Longfellow. These lines hardly are worthy of being uttered in the same rhyme as "The Midnight Ride of Paul Revere." Nevertheless, DeSalvo and his deeds at Marietta College definitely deserve legendary status.

In fact, DeSalvo's mind-boggling climb up the Euclid hill with Dusty Childress on his back is a feat of strength, conditioning and mental toughness befitting a U.S. Navy Seal. Many who didn't witness it find it difficult, if not impossible, to believe that it happened. But it did.

Chris Tekulve, son of Pioneers pitching great Kent Tekulve and an all-region first baseman in 1999 and 2000, can tell the story, because he was there for the show.

"Running up Euclid is insane. It was the worst experience of my life!" Tekulve said. "I don't know how steep it is, but it feels like ninety degrees straight up."

It was the fall of 1998, when DeSalvo was a freshman. Tekulve continued:

> *We were all sitting around complaining about Euclid, and he said, "It's not so bad. I could do it with Dusty on my back."*
>
> *It just snowballed from there. We drove out one night after practice. The people that lived on the street must have thought there was some sort of gang*

fight about to happen. We have our cars lined up with the headlights on. It was after dinner. He carried Childress up on his back. It's probably the most remarkable feat I've ever seen accomplished!

I had enough trouble carrying myself up that hill. I can't imagine doing it with another human being on my back. I think I was standing about halfway up. I think most of us started in the middle, and then as they passed us, we all followed them up. There may have been a little money exchanged—some form of wagers—on whether he could do it or not.

When you're running up that hill, you're so tired and bent over, half the time you feel like you're going to crawl up because your hands can reach out and grab the street. It's really steep! It turns your legs into jelly. Coach [Schaly] used to sit at the top of the hill in his pickup truck, smoking a cigarette and drinking his Pepsi, saying, "Come on. Let's go. Move faster!"

Matt DeSalvo is an absolute animal!

Tekulve has plenty of people who agree with him on that assessment of DeSalvo, and it doesn't just pertain to that run up Euclid, one of several regular conditioning tests Marietta College baseball players have been challenged with for years by Schaly and now Brian Brewer. DeSalvo, who's been pitching professionally since 2003, holds Marietta—and NCAA—records for most career wins (fifty-three) and strikeouts (603), as well as the Division III record for strikeouts in a season (205) and the school record for strikeouts in a game (19 twice). He set the career strikeouts record in Schaly's last game.

DeSalvo said:

As a freshman, I didn't drink. I've never been a big drinker. I was at a party—even if you didn't drink, they wanted the freshmen to go and hang out. So I got pushed to go. It was at Timlin [dorm]. We're in the seniors' suite. They were talking about this hill we're going to run. We're in fall baseball when this takes place. They're talking about Euclid hill and how hard it will be and how vertical it seems. I wasn't impressed by what the seniors were talking about.

Dusty [Childress] probably was one of the only guys that befriended me at the time. I was quiet and didn't really talk to anyone. He kind of opened up to me. No one really knew who I was, because I didn't go to parties. I was just the skinny kid on the baseball team. But they're talking about this place, and I had the mentality that I could do whatever I wanted—not in an arrogant way, but to prove myself.

Pitcher Matt DeSalvo performed legendary feats at Marietta, on and off the field—setting the school record for strikeouts in a game and NCAA career records for wins and strikeouts while also leaving teammates and baseball alums awestruck with some of his conditioning accomplishments. *Marietta College Archives.*

They were talking about Euclid, and I was saying, "I can run Euclid." People were like, "You don't even know." I said, "I'll go up Euclid with Dusty on my back." Of course, they weren't going to let me live that down. So the next day, we all went to eat at the dining hall, and it was the big buzz around the table. Everyone was talking about it. Every time someone brought their plate up, they were looking at me and shaking their head like, "I can't believe you're putting yourself through this."

We drive to the base of Euclid hill, and there's probably thirty people at the top of the hill. It looked like everyone was trading currency like they do at a cockfight. They're all at the top of the hill screaming down, and I'm looking at this monster of a hill. It was nearly vertical. It had two grades to it. The last quarter is like climbing up the side of a skyscraper. That's how steep it was. I'm like, "Well, I got myself into this. I can't back down." Dusty jumps on my back, we get our grips right and there I went up the hill.

About halfway up, I'm like, "Dusty, I don't know if we're going to make this." He said, "You better not drop me, and you better keep going." We made it up the hill. My legs burned like hell, but I made it. It was kind of funny because everyone started cheering and laughing.

That's one of the stories that stuck through my career. People remember that for some reason, even though you'd think it would die. People say I'm a legend there. They make me a legend because of the stupid shit I did! When I go back, the younger kids have heard about it.

I wasn't whipped when I got to the top, but I couldn't have done it twice. I grew up wanting to go to the military. If someone told me I couldn't do something, I'd do it. Someone said I couldn't run the mile and a half in under eight minutes, but I did it. If someone told me I couldn't do something, I'd do it. I think that's the reason I'm here today [playing pro ball]. *If no one ever told me I couldn't play Major League Baseball and professional baseball, I'd probably be in an office right now. That's the attitude I had.*

There may have been one person—Mike Hall [pitcher]*—I'm pretty sure he bet for me, because I think he knew my attitude. I was supposed to get some kind of prize, but I never got it. What was I going to do as a freshman? My freshman and sophomore years at Marietta were so much fun. That's when I really began to love the game and love the fraternity of Marietta.*

Here are comments from some other former Marietta players about the Euclid run and what DeSalvo accomplished. The thought of scaling the hill makes them cringe. The thought of DeSalvo doing it with another player on his back literally leaves them in awe.

"I remember Euclid being about a half mile long," said Chris Sidick (2002–5), an all-America outfielder who played for both Schaly and Brewer. "The first half was about forty-five degrees, then a slight flattening of the road at a side street intersection halfway up, and then the second half jumped to sixty degrees. It was brutal!"

"It's steep! I can't give you a grade, but when you're sitting in a car at the top, you're not sure your brakes will stop you going down," said Ryan Eschbaugh, a native of Marietta who was the starting shortstop on the 2006 national championship team. "I've heard about DeSalvo carrying Dusty up on his back. That's a crazy one!"

John Snyder, all-America outfielder on the 2011 national championship team, said, "Euclid is about as close as you can get to running up a cliff without actually running up a cliff!"

"I remember driving up Euclid in my buddy's Ford LTD, and it stalled because it wouldn't make it up the hill," said Mike Brandts, third baseman and MVP of the 1987 national champs.

"I looked at it my freshman year and said, 'We have to run up that?'" said Chris Beatty, a two-time all-region catcher who won the 2010 Way-Weigelt Award for his conduct on and off the field. "The thing about Euclid is that when you got about three-quarters of the way up, you literally could reach out your hand and touch the ground. It's that steep!"

And Jim "J.J." Tracy, an all-America outfielder in 1977, just refused to believe what DeSalvo did.

"It was the most excruciating run I've had in my life…I can't believe anyone could run up Euclid with someone on his back, and unless you have pictures, I don't believe that could possibly occur," Tracy said.

Another witness who "testified" is the player who got the free ride—Childress, who said he was five feet, eight inches, 140 pounds at the time. DeSalvo, by the way, was five feet, nine inches, 150 pounds when he got to Marietta. Childress, an infielder who now runs his own contracting business in Columbus, said:

> There's nothing DeSalvo can't do if he wants to do it. He didn't know physical pain. He's a character. I jumped on his back, and the next thing you know, he's running up Euclid. It's so steep I don't see how it can be legal in the winter.
>
> It was more mind over matter. He just kept pumping those feet. When we got to the top, I jumped off, and I think he might have started dancing around. It was nice to prove he could do it. It's hard enough to make it up the hill on your own.

As legendary as DeSalvo's run up Euclid is, that's really a small part of what makes him one of the most memorable, as well as one of the most accomplished, baseball players in Marietta College history.

And it all began in such a ridiculously subtle way. No one really showed any interest in DeSalvo when he was coming out of New Castle, Pennsylvania. DeSalvo said:

> My mom hired a guy to get me into college somewhere that I could play baseball. I had the grades, a 3.5 or 3.7 in high school. I got flyers from a lot of colleges, but it was academic information. I didn't get any from baseball coaches. I had a good arm, but I wasn't a big kid. I threw hard—eighty-

five to eighty-seven. That's pretty good for high school. I was considered a standout pitcher, but I thought I was a better shortstop, though I don't know if anyone would agree with that.

But the way I got to Marietta is I got a flyer and my mom contacted the school. Then Coach Schaly sent a flyer about the baseball team. I read it and was interested. I had it down to Marietta or Gulf Coast Community College [in Florida]. *My mom said I could only visit one. We didn't have a lot of money. She let me know there wasn't much chance we were going to Florida, so she said to check out Marietta. We went down and sat down with Coach Schaly. He asked, "What other schools are you going to?" I said, "Gulf Coast is the only other one I'm looking at." He said, "Don't be stupid. You're obviously a smart kid. Why would you go to a community college when you can go to a four-year school?"*

My mom really liked him. I just wanted to get out of there as soon as possible, cause I was a shy kid and wasn't even sure I wanted to go to college. I remember leaving and my mom said, "So what do you want to do?" I said, "I guess I'm coming here." I remember thinking Schaly was just like my grandfather. That's why my mom liked him so much. He had that old man look and he smoked and he had that straightforward, "This is what you're going to do, I'm not going to take no for an answer" approach. Really, my mom told me I was going there. I don't think I had a say in it. But I'm glad I went there.

It's pretty safe to say Schaly was glad, too!

"My speech teacher called me 'Doctor DeSalvo,'" he said. "I've always been kind of a free spirit. The first day she said you have to dress up on the day you present. I wore shorts and a T-shirt. She was receptive to that. I think she realized I didn't want to change the way I was."

There were a lot of hitters who discovered who DeSalvo was—and they very much would have preferred not to do that. For his career, the right-hander struck out 603 batters in 395 1/3 innings. Ridiculous! He won fifty-three games and lost just six with a career ERA of 1.80.

"A lot of times in the off-season, DeSalvo would come back for training [when preparing for professional spring training] so he could face live hitters," said Justin Starenka, third baseman on the 2006 national championship team. "I have never been more scared in my life to face somebody. From a skill set, I've never seen anyone else like him. He had five pitches, and every single one of them is devastating."

The Story of the 'Etta Express

Mike Deegan, now Marietta's associate coach, was a sophomore when DeSalvo was a freshman, so he experienced a lot of the making of the "legend"—on and off the field. Deegan said:

DeSalvo is a different guy. I remember after he pitched a fall league game—he was a good freshman pitcher but not a guy you would think would pitch in the big leagues—he'd just pitched six or seven innings in a fall league game, and we get back and look out on the field behind Parsons [dorm], and he's out there throwing weighted balls.

That's Matt in a nutshell. He was a relentless worker. He had in his mind he was going to be an all-American and a professional pitcher. He was different, but what really sticks out is the work ethic and mentality. Most college kids get done with a game and they're thinking about having a good time. He was quirky, but I never saw him get beat in any conditioning or in any sort of mental challenge.

Matt and Schaly had an interesting relationship. Matt was doing fall league stats for him. You couldn't have any mistakes—not one. Schaly would go through them painstakingly, and he would find something. Everything had to be perfect. If he found one mistake, he'd go berserk. "If there's one mistake, there could be one hundred mistakes!" And he'd go on ranting and raving.

So, Matt's compiling these stats, and he's like, "Coach, I can't figure it out..." Coach says, "These better be done by tomorrow morning." Matt's up in Coach's office, and he's got two numbers he can't figure out, so he's going back trying to find whatever it is that's got Coach on the warpath. Coach leaves, and Matt falls asleep in his office. The next morning, Coach walks in and finds DeSalvo asleep. I don't think Matt ever found the answer, but I think that lightened up Coach a bit. Maybe that's when Matt started doing laundry [as a work/study job] *instead of stats.*

I think Coach kind of got a kick out of Matt, and he got a kick out of the fact that he struck out two hundred batters a year, too! Matt was quirky, but he definitely wasn't a prima donna, and no one was going to outwork him. So how mad could you get at the guy? He's going to the beat of his own drummer, but at the end of the day, he's going to be first in every run and so forth.

And about that "laundry" Deegan mentioned. DeSalvo said:

I was the statistician for Coach Schaly for three or four weeks. I didn't like doing it, because I just couldn't get it right. So he turned me into one of the laundry people. It was my junior year, and we were going down to a tournament in Maryland. The bus was leaving at noon, and I was in the laundry room. I was reading Dante's Divine Comedy, *and I fell asleep.*

All the baseball players had to pack their bags and put them on the bus and meet at twelve. I'd been sleeping this whole time, and I remember someone coming in and saying, "Coach wants to know where the jerseys are. Where's the laundry? We're waiting on you." I said, "Oh shit!" I'm in a rush, and I go, "I didn't pack my bag." The guy says, "We packed it for you." So I get on the bus thinking everything's fine.

We go to Maryland, and we're wearing our blues the second game. We win the first game, and there's thirty minutes until the next game. I'm thinking, "Oh, shit." I'm literally going around asking people if I can wear their jersey. Everyone said, "No." Someone finally said, "You have to go to Coach and ask if you can wear his." I went to him and said, "Coach, I didn't bring my blue jersey."

I don't think he really cared, but he started yelling in my face, "I can't believe you forgot your jersey! You knew we were coming down here!" He always wore that pullover, so he said, "Just go on the bus and get my damn jersey." So I had to wear Schaly's No. 50. When they announced it, they said, "Now pitching, No. 50, Don Schaly...what?" The announcer was confused because I was wearing No. 50. I remember looking into the dugout, and Coach Schaly was laughing. I know I brought a lot of happiness to him because I did so much stupid stuff.

"Stupid stuff" like striking out nineteen in a World Series game!

Marietta opened the 2001 World Series against a 31-12 Salisbury State team from Maryland on May 25 in Grand Chute, Wisconsin. In the bottom of the eighth inning, Marietta second baseman Todd Timmer singled in—of all people—Childress with the only run of the game, and DeSalvo struck out a school and Division III World Series record nineteen in a nifty four-hitter. Twelve of the nineteen went down swinging.

Deegan recalled:

Salisbury had the bases loaded and no one out in the first, but I don't think anyone touched the ball after that. He was something else. He was on a whole different level than everybody else. He threw hard—ninety-two, ninety-three, at times ninety-four, ninety-five—that's velocity no

one is going to see at this level. And his slider was nasty. He was really gifted with the baseball, like some people are gifted with a paintbrush. He was a complete warrior, too. He could dominate you, but he could out-will you, too.

DeSalvo saved his best for the big games. His other nineteen-strikeout performance came as a senior in 2003 (he was a medical redshirt in 2002) in the first game of the Ohio Athletic Conference Tournament. He pitched a three-hitter to beat Baldwin-Wallace, 5–1, setting an OAC Tournament record, as well as tying his school record.

That was DeSalvo's final start of his career, but he made one more appearance in relief two days later in the OAC Tournament final against Heidelberg. Marietta lost, 5–2, but DeSalvo faced three batters in the ninth and struck out all three.

If Schaly got a kick out of DeSalvo, it worked the other way, too. DeSalvo said:

I liked watching his leadership. He was trying to get everyone on the same page, and he did that by making everyone hate him during training and during the season to the point that when it really mattered during the playoffs, then he became lovable.

It was weird the way that happened. During [conditioning] runs, you're thinking, "Why am I running seven miles in the snow? I hate everything about Coach right now." And you'd hear the other guys talking about that. But in a way, it was brilliant strategy. If I had to describe him in one word, it would be militant. He was a drill sergeant.

It would be the sixth inning and we'd be winning, 10–0, and I'd strike out the first two batters and then walk two guys. I'd get the next guy out, and then I'd be jogging in and he'd be right in my face, "What the hell are you doing? What's going on?"

It's clear to me now. All I really had to do back then when I was throwing ninety-five in Division III was throw fastballs down the middle and everything would have been fine. I know now he was just trying to make me into the best possible pitcher, but back then as a kid, you don't know that when he's in your face.

DeSalvo signed as a free agent with the Yankees in 2003 and worked his way up through their farm system. In 2005, he was named the Yankees Minor League Pitcher of the Year when he was at Double A Trenton, New

Jersey. He also got an interesting visit that season. Bob Wolfarth, the starting center field on Schaly's first two teams in 1964 and '65, said:

> *I went to the game Trenton was playing in Reading. I asked someone where DeSalvo was, and he told me he would be charting the game. They sit in the stands to do that, not on the bench. So I had on a Marietta College baseball shirt. He was sitting in this little roped-off section. I tapped him on the shoulder, and he turned and saw my shirt and started chuckling.*
>
> *I said, "You captained Don Schaly's last team [2003], and he said, "That's right." I said, "Well, I captained his first team [1964]." I sat and talked with him for about three innings.*

Two years later, DeSalvo made his Major League debut on May 7, 2007, at Yankee Stadium before a crowd of 47,424. It added yet another chapter to his legend, because he pitched seven innings in the House that Ruth Built, giving up just three hits and a run and departed without getting a decision against Seattle. As with just about anything related to DeSalvo, there's more to the story.

"I went out in the dugout, and [comedian] Billy Crystal is standing in the dugout," DeSalvo recalled. "He comes up and says, 'Hey, Matt. How are you doing? Good luck tonight. Congratulations on being called up.' I'm thinking, 'How the hell do you even know my name? I see you on TV, but how do you know who I am?' I didn't say it, but that's what I was thinking."

DeSalvo said he wasn't the least bit nervous during his pre-game routine and warm-ups. That changed quickly when Ichiro Suzuki stepped into the batter's box to start the game. DeSalvo said:

> *When he took his stance, I crapped in my pants right then and there!*
>
> *My first pitch went about fifty feet. The next pitch hit the plate. I'm 2-0 to the best hitter in the league. I'm thinking, "Don't be the guy that walks like three batters because he's so nervous." I tell myself to throw a fastball down the middle. Double down the line! So I'm thinking, "Don't be that guy that gives up seven runs in the first!" I end up getting two outs and have the next guy 0-2, and I'm thinking I'm going to get my first big-league strikeout. They call a backdoor slider and I throw it down the middle and the guy [Raul Ibanez] gets a base hit to left to score Ichiro. But after that, I settled down and threw strikes and got quick outs and pitched seven innings. It was a good game for me.*

Unfortunately, not many good games followed, at least in the Majors. He won his next start, also against Seattle, but that's the only game he's won in the Majors. In 2011, he pitched for the York Revolution of the independent Atlantic League.

True to the "Doctor DeSalvo" nickname hung on him in speech class at Marietta, he's used his downtime in baseball to obtain a master's degree in secondary education, and he says he's contemplating getting a doctorate in psychology. DeSalvo is known as a vociferous reader, and Mike DeMark, a member of Marietta's 2006 national championship team, said, "He's read so many books, he could carry on a conversation with the president or anyone else. He'll be taking over the world someday!"

For all his brilliance, DeSalvo never played on a national championship team. However, that doesn't mean he didn't make a major contribution to one. He was a significant influence in Mike Eisenberg's decision to attend Marietta, and he was a mentor to DeMark, though he refuses to take any credit for that. Eisenberg and DeMark were the aces of the 2006 'Etta Express. Eisenberg, the Division III Pitcher of the Year in 2006, said:

> On my visit, I was sitting in the bleachers with Coach Brewer, and he was telling me about DeSalvo. I'd done tons of research on Marietta. I knew all about DeSalvo. That was at his peak, when I was looking at schools.
>
> It was Community Day when I got there. DeSalvo was shirtless on the [practice or B field] infield, and he's throwing the ball against the backstop and retrieving it. He just kept doing it. This is while the Community Day JV game is happening on the main field. I said, "That's the kind of player I want to be." That might have turned me onto the program more than anything Deegan or Brewer said.
>
> Just the idea of being the "next DeSalvo," coming in when he's leaving, the opportunity to be on a winning team. Brewer tells me, "You've got the body, and if you work hard, you could be in the same rank as DeSalvo and have interest from the Major League people." Whether that's his selling point to a lot of people, it worked on me.

Eisenberg was the winning pitcher when Marietta beat Wheaton, 7–2, for the 2006 national championship. He pitched eight innings, and DeMark worked the ninth. DeMark, who came to Marietta as a middle infielder but switched to pitching when he was told his bat wasn't good enough for a position player, said:

DeSalvo was a fifth-year senior and was breaking all kind of records when I was a freshman [2003]. I pretty much mimicked what he did. I figured if it worked for him, maybe I could try this pitching thing. I videotaped him and copied what he was doing. Sophomore year I was all-America. That was my first year of just pitching.

It was weird how it all started. I just kept working harder and harder. I think I was throwing eighty-six to eighty-eight [miles per hour] at that point. It wasn't until DeSalvo took me under his wing, showing me pointers, that I got better. He's a very humble guy.

DeMark, who originally signed with San Diego, says he again got to work with DeSalvo in 2011 for a short period when they were both with the York Revolution. However, he got picked up by the Arizona Diamondbacks and prospered, going 3-2 with fifteen saves and a 1.85 ERA in thirty-two games for Double A Mobile. DeMark said:

I thought that was great to work with DeSalvo again [at York], but as humble as he is, he didn't want to take credit for that. Actually, he claims he doesn't remember any of that. He was a legend when I was at Marietta. He could have been an ace at a D I school. At Marietta, he was the pinnacle—he was where I wanted to get.

When we went to the World Series in Wisconsin in 2006, they had it on the Jumbotron—"Who holds the single-game strikeout record for the World Series?" Then his name pops up on the board. It was like, "Wow!"

Just like everything else about Matt DeSalvo.

Chapter 16
THE NEXT LEVEL

Terry Mulholland was 30-3 in three seasons with the 'Etta Express. Then the San Francisco Giants made him their first-round draft pick (twenty-fourth overall player taken) in 1984, the same year Mark McGwire was the tenth player taken, leaving Mulholland no practical choice other than to sign.

He is one of forty-five Marietta College players to sign professionally, including Mark Talarico, who played in Italy. Of those forty-five, five—Kent Tekulve, Jim E. Tracy, Duane Theiss, Matt DeSalvo and Mulholland—reached the Major Leagues.

Mulholland had a career-high fourteen wins as a sophomore in 1983 to help Don Schaly win his second national championship. In 1994, the road leading to Pioneer Park was renamed "Mulholland Drive" to honor him for being the lead donor ($250,000) for the lighting system.

He won 124 Major League games, pitched a no-hitter for the Phillies in 1990, was the starting pitcher for the National League in the 1993 All-Star Game and started two World Series games for Philadelphia that year. In salary alone, he made in excess of $26 million in a twenty-year big-league career pitching for eleven teams.

Pretty special guy, right?

To Schaly, all his players were special—but no one was more special than anyone else. Frank Schossler, a member of the college's Board of Trustees who was a teammate of Mulholland's at Marietta, has the story to prove it:

Terry was a good guy, never assumed anything, a hard worker, very much a team player. I played with him for two years before he got drafted. His freshman year, he was 4-0. Sophomore year, which was my freshman year, he won 14 games. I don't remember him having a bad outing. One of his losses was the 1984 national championship game to Ramapo [New Jersey], *5–4.*

His junior year, my sophomore year, he started off on fire again. He only lost one game [12-1, 2.17 ERA]. *He started a game against Otterbein that was the first game of a Saturday double-header. Big conference rival. Terry couldn't throw a strike right from the first inning. He hit a couple of batters. He had a tough couple of innings. It was like 7–0 or 8–0 Otterbein.*

I remember Schaly taking him out, and when Schaly came in from the mound, he walked straight to Mulholland, gets right up in Terry's face, and he says, "Terry, what the hell was that? That's the worst performance by a Marietta College pitcher I've ever seen since I've been here. If you ever throw like that again, you'll never throw for Marietta again. You're starting Monday. You better be ready."

I'm sitting there as a sophomore, thinking, "God, the guy was 14-2 the year before [2.12 ERA]. *It was the only bad outing I ever saw him have." But it didn't matter who you were. Schaly was all over him. He treated everyone the same.*

Talarico, a three-time all-American at Marietta (1981–83), played professionally for seven years in Italy. As a dual citizen, he had an Italian passport and played for Italy in international competition, including the 1984 Olympics in Los Angeles. He was two years ahead of Mulholland, so he saw him his first two years. Talarico said:

Terry was very quiet, really unassuming and worked hard. I still remember playing catch with him the first time. It felt like he was throwing a shot put! Not that he was throwing hard, but it was a "heavy" ball. We weren't throwing the same ball. His weighed like three pounds, and mine weighed five ounces.

My junior year, I played in the Atlantic Collegiate League. Coach Schaly got me an opportunity to go up there. I was playing for Allentown [Pennsylvania]. *A roster spot opened, and we needed a left-handed pitcher. I told the coach, "We've got this guy that's a freshman, and he can play here. He throws hard, and I think he'll fit in with the guys." We called*

Terry, and we ended up winning the league. Our two left-handed starters were him and Jamie Moyer. I think they both played about sixty-two years in the big leagues!

Actually, it was *only* forty-four years—twenty for Mulholland and twenty-four for Moyer, who won 267 games for seven teams.

"We had a pretty good team," Talarico said. "A lot of guys got drafted. Terry was a competitor at all times."

Mulholland, known for having one of the best pickoff moves in the Majors, had an interesting, as well as a long, big-league career. A play he made with the Giants has been shown countless times on TV because he fielded a hard ground ball, and when the ball got stuck in the web of his glove, he tossed the glove to the first baseman to retire the runner. His no-hitter was against the Giants in 1990, and he faced the minimum of twenty-seven hitters. The only man to reach base did so on an error and then was retired on a double play.

He is one of the few pitchers to beat every Major League team at least once. Among other things, he was noted for durability and versatility. With the Cubs in 1998, he sometimes would pitch in relief one day and as a starter the next. In 2004, when he was forty-one years old, his catcher was Pat Borders, also forty-one, making them the oldest battery in big-league history at the time.

In spite of all he accomplished in the Majors, one thing people from Mulholland's Marietta career remember is that he may be the only Schaly player who was ever able to get out of running steps in the field house. Paul "Doc" Spear, Marietta's longtime baseball trainer and retired head of the college's sports medicine program, recalled:

Mulholland was a very, very dedicated athlete. When we had our last game his junior year before he left Marietta, he came and got treatment, even though his career was over. He was very conscientious about treatment.

He had really bad knees. He had a lot of arthritis. I had to do a lot of talking, but I finally convinced Schaly (with a lot of blood, sweat and tears) that instead of Terry running steps at the field house—those horrible steps—to let him ride the stationary bike.

When he got drafted, the pros called me and asked about him riding the stationary bike, and they got one for him so he never had to run in his career. I think he wore out a couple of them here. He's probably the first and only player to get out of running steps. I got him out of it, but it wasn't easy!

Terry Mulholland, who was a first-round draft pick by the San Francisco Giants after his junior year (1984), was 30-3 with a 2.37 ERA at Marietta before going on to a distinguished big-league career that included a no-hitter and starting an All-Star Game and two World Series games. *Marietta College Archives.*

Mulholland's teammates at Marietta undoubtedly envied him for not having to run steps, but they also remember him for his strength and athleticism.

"Terry was a big reason we won the national championship in 1983," said Jim Pancher, who was MVP of that 1983 World Series. "He was only a

sophomore, so people didn't know how good he was, but he ended up being dominating. He would throw consistent speed from the first pitch to the last pitch. He was our ace in the hole. I don't know what he was clocked at, but he got stronger as the game went on."

Duane Theiss, a right-hander who pitched for Marietta from 1973 to 1975 and then for the Atlanta Braves in 1977–78, was an assistant coach for Schaly during Mulholland's career. He said:

> When Mulholland came in as a freshman, he was the biggest, strongest athlete on campus, even including the football players. As a sophomore, he just took off and blossomed. You knew he was going to be a special type of player.
>
> When he was a junior, what really sold the scouts on him—because he kind of came from out of nowhere—was he threw ninety-three, ninety-four [miles per hour] one day in the regional and then came back two days later to start and threw ninety or ninety-one. That's when the scouts said, "Oh my, we've got someone here!" That's when they realized that even though he was big and strong, he was flexible enough to do some things. He was a workhorse.

A Marietta College rarity occurred when Jim Tracy was Mulholland's manager with the Dodgers in the second half of the 2001 season and the first half of 2002 before the left-hander was traded. It was toward the end of Mulholland's career, and he struggled, but the two enjoyed the irony of finding themselves on the same team in the Majors. Tracy said:

> I remember a couple of times when we said to each other, "What the hell would Schaly do?" I'm sure Schaly just relished in seeing the two of us together on the same team, one as a pitcher and the other as the manager. What are the odds of a D III program having a first-round draft pick and having him play in the Majors for a manager from the same program? That's some kind of tradition for a D III program!
>
> Terry was a dandy. He was a guy with a lot of grit. Once he got the ball, he didn't want to give it back to you. He was incredible, and look at what he accomplished! He was such a class act and had such capabilities to bring a staff together. He was versatile. He was special.

Theiss was a twelfth-round draft pick by the Braves in 1975. He steadily worked his way through the Atlanta farm system in rather impressive

fashion, posting records of 8-1 at Class A in 1976, 6-1 at Double A in '77 and 6-2 at Triple A in '78 as a reliever. However, he never got much of a chance in the Majors, appearing in 17 games in 1977 when he was 1-1 and just 3 games the following year, the last big-league action he saw in his career. A shoulder injury forced him to retire after spending 1980 in the minors.

At Marietta, he was 17-4 overall with a 2.04 ERA in three seasons, including 8-2/2.23 with the 1975 team that finished runner-up in the Small College World Series. He had three stints as an assistant for Schaly. Later, Theiss was the pitching coach at Ohio State for several years until a new NCAA restriction required that his position be eliminated.

Theiss said:

> *Playing for Coach Schaly was one thing and coaching for him was an entirely different thing, but still very, very rewarding. I always tell people that when I played at Marietta College, there was a certain amount of intensity, a level of expectation to perform, no matter who you were—freshman, senior. When you crossed the white lines, it was your job to perform.*
>
> *I've been asked how the level of play in pro ball compared to Marietta. I played against some really good athletes, especially at Double A and above. It wasn't until I got to Double A that I felt the pressure and level of expectation to perform that I felt at Marietta. Double A pressure and expectation were very similar to what it was at Marietta, because if you didn't do your job, they'd get someone else in there. Schaly usually had someone on the bench that was ready and capable of playing, and he didn't let you forget that either.*

Theiss, like many players from his era, remembers that Schaly was slow to change from wool uniforms to double-knits, even though everyone else did it.

> *We always said Schaly would call everywhere to find a manufacturer that would still make those uniforms—and the only reason he eventually went to double knit was because he couldn't find anyone to make the wool uniforms anymore!*
>
> *I'll never forget, I was in A ball later on that summer [1975] after we played in the World Series. We picked up a guy from the Mets organization that's a real good friend of mine—Kevin Meistickle. He went to Thiel*

College, where Joe Schaly coaches now. We started talking in the bullpen about where we were from. When I told him Marietta College, he said, "You guys played in the Division II World Series...Marietta College...you guys are the team with the horseshit uniforms. Those are the worst-looking uniforms I've ever seen."

I told him I needed him to talk to Schaly about that! I'll never forget that, because we complained about those uniforms every time we put them on. I was a freshman when we beat Florida State in Tallahassee. They were teasing us about those uniforms, but we were teased everywhere about them, whether it was a Division I team like Florida State or some team we'd beat 20–0. And Schaly loved it!

Of course, he loved short haircuts, too, and long hair was in at that time. I think we beat Florida State, 6–4, and they might have been ranked No. 1 pre-season in Division I.

Not everyone could play for Schaly. You had to have thick skin, and you had to be very focused. He worked so hard at building that community. I didn't realize how hard he worked at it with the alumni newsletter until I went back to coach for him. Sometimes I hear criticism that he over-recruited or something like that, and what I tell people is they don't understand that Don Schaly ran his Division III baseball program like a Division I program. He was way ahead of his time. He was a pioneer at that level.

He believed, I'm sure even before I got there, that they were going to win a national championship. When I would help out before going to spring training and when I went back to coach for him, we'd be deciding on players. We'd have out their files, categorizing them. We'd spread them on the floor—pitchers, catchers. He'd say, "Okay, what guys can help us win a national championship?" And this was before a national championship was in our dreams. He just believed it was going to happen—and it did.

At Marietta, I learned that in a lot of situations you can outwork a problem, just by getting ahold of it and using sheer tenacity and not letting go. And when it comes to crunch time, Schaly used to say, "Dammit, do your job." There are so many times in my life when I came up against a problem, and I'd think back to his words—"You've got a job to do. Get it done."

I don't think people realize unless they went through the program—day in and day out, week by week, month by month—the expectation. I saw him bench seniors, bench all-Americans and put a freshman in. And that guy didn't get his job back until he earned it. He treated us all the same. It was all performance. Maybe at the time, you didn't like that, but it was the best thing.

One of the most successful players in Marietta College history was Joe Thomas, a two-time Division III National Player of the Year in 1996 and 1997. Thomas, a native of Kenmore, New York, spent seven years in pro baseball as a left-handed pitcher but never got above Class A.

As a senior at Marietta, Thomas was 11-1 with a 2.14 ERA and 97 strikeouts in 92 2/3 innings. He also batted .415 with 22 doubles and three home runs. A three-time all-American (1995–97), he shares the school's single-season record for doubles (22) and ranks in the top five in three career categories (second in doubles, 57; third in batting average, .415; and fifth in hits, 240). He also was 20-4 in his career as a pitcher with a 2.66 ERA.

The Red Sox drafted him as a pitcher in the twenty-first round in 1997. He finished his minor league career with a 48-30 record, which included a 26-15 record with affiliated minor league teams and a 22-15 record in independent league play. Pitching for the indy Canton Crocodiles in 2001, he set a Frontier League record for winning percentage with a 9-0 record (1.32 ERA) and also was named to the Frontier League's All-Decade team.

Mike Brandts was drafted in the ninth round by Seattle after the 1986 season, when he set several Marietta College records, including twenty-four home runs, and helped the Pioneers win the national championship. He said:

> *Seattle never had a winning season in the history of their franchise when I got there in 1986. I came from Marietta College, which was the polar opposite. It didn't take long before I was so disappointed. "I came from better than this."*
>
> *Here's an example from a spring training drill. There are three or four coaches in the center. They're spread out a little in a small circle. The players are all in a big circle, jogging, with their gloves, and the coaches are randomly hitting ground balls. So in that drill, I might have gotten one ground ball. There was no conditioning. It's like, "What's the purpose of the drill?" It's not conditioning. It's not skill building.*
>
> *We came from Coach Schaly, where we wore ping-pong paddles and fielded tennis balls to teach us how to give with the ball. It showed me Schaly was world class.*

Chris Sidick, an all-America outfielder for Marietta in 2004 and '05, played his seventh season for the Washington Wild Things of the independent Frontier League in 2011 and holds many of the league's career records.

"After I graduated from Marietta, I signed with the Wild Things, and I've been here ever since, playing center field and batting leadoff," said Sidick, who owns and operates C-Side Sports Academy, a new twenty-seven-thousand-square-foot baseball training facility in Washington, Pennsylvania, about two hours from Marietta.

Sidick went to Marietta as a football player and asked Schaly for a tryout with the baseball team. After first being rebuffed, he got a one-day tryout and turned it into his profession. He played two years for Schaly and two for Brian Brewer and credits them for not only shaping him as a player but also for teaching him many of the drills he now uses as an instructor. He said:

> *I probably play baseball 350 days a year. At some point, I have a ball in my hand, either playing myself, training myself or training someone else.*
>
> *The biggest thing I did at Marietta was to find out what organized baseball is all about. I came from a bad high school program, so it was the first time I got into organized ball with set practices where you actually learn things instead of just showing up and swinging. I learned how much more there was to baseball. I started absorbing all that information. I was like a sponge.*

And Schaly and Brewer provided the ocean of baseball knowledge that he soaked up in four years to become a professional player and coach.

Chapter 17

PASSING THE TORCH

Don Schaly won 1,442 baseball games at Marietta College. There's no telling how many others he's helped win at ballparks and sandlots literally across America. The same, undoubtedly, will be said about Brian Brewer someday.

The impact these coaches had, and continue to have, on those who played and coached under them gets passed on every time one of their alums picks up the coaching torch, which happens dozens of times each season.

"Many of us have gone on to coach, and I know we probably coach pretty similar to how Coach Schaly coached us, because that was a successful way of doing it," said Scott McVicar, starting shortstop on the 1986 national championship 'Etta Express and now associate admissions director at Marietta College.

A native of Marietta, McVicar played for American Legion Post 64 and eventually coached that team of teenagers for five years.

Any time I had any questions in my mind, I'd reflect back to, "How would Coach Schaly do this? How did Coach handle this? What would Coach do?" I often asked myself that on the ball field.

It's like parents. Sometimes you come to respect them even more so later, and that's the case with Coach. As players, we had total confidence in him. But looking back on it now, what really stands out is all the time and effort he must have put into the intricate details to allow us to play on a first-class facility and building that program—the relentless hours he had to put in behind the scenes.

Many former Marietta College players and assistant coaches have gone on to coach at all levels, from Little League to high school and college. Two particularly interesting examples are Tom Galla and Greg Inselmann.

Galla, now an insurance executive, was Schaly's first all–Mideast Region player in 1968 as a sophomore second baseman when he batted .415. Then, as a senior in 1970, he was an all-conference third baseman who hit .393. In 1989, Galla coached Trumbull, Connecticut, to the Little League World Series championship with a 5–2 upset victory over heavily favored Taiwan.

Inselmann was an all-America designated hitter at Marietta in 1978 when he batted .382. He had a great college career and is best remembered for hitting the "Shot Heard 'Round Marietta" to get the Pioneers in the 1977 World Series,

Former Marietta College infielder Tom Galla (1967–70) and his son, Dave (1996), had plenty of reason to celebrate after they and the rest of their Trumbull, Connecticut team upset Taiwan for the 1989 Little League World Series championship. *Tom Galla Collection.*

their first Series berth when hosting the event from 1976 to 1987. Now retired, Inselmann was inducted into the Ohio High School Baseball Coaches Association Hall of Fame in 2006. His career record was a remarkable 505-133 (.792), and he won state championships at two schools where he built programs practically from scratch.

Like most of Schaly's players, Galla admits the coach intimidated him when he was in school, but it was Schaly who he turned to in his time of need. The Little League World Series is a pressure cooker for teams that get that far. Held in Williamsport, Pennsylvania, it attracts big crowds, including forty-thousand-plus for the championship game, and many games are televised nationally.

In 1989, Taiwan was the "Yankees" of Little League baseball. They had won the World Series the previous three years and won the next two years, as well.

Galla said:

I learned a lot playing at Marietta, practicing, how to be organized the way Schaly always was. So I tried to run this Little League team the way Schaly ran our college team. These kids were so good, and they were like sponges. They accepted all of that. We had three coaches, and I was the tough guy...I was the Schaly.

We were very successful early. We hit a lot of home runs, we scored lots of runs. One of my pitchers threw a perfect game in the district tournament. A lot of one-hitters. Everything was rolling along beautifully until we got to Williamsport. When we got there, all of a sudden, we're not hitting the ball, and I couldn't figure it out. The pitching didn't look so much better to me. I figured it had to be just nerves.

We were lucky enough to win the first two games. We beat Iowa, 4–3, and then we beat California, 5–3. But I didn't think we were going to beat Taiwan unless we hit the ball a little bit. So the morning of the game, I called Schaly. He was surprised to hear from me, but happy to hear from me. He said he was following everything on TV.

I can't remember when the last time was that I talked to him before that. I'm certain it was a long time, though. But who else was I going to call? I got him at the field. He knew what I was doing.

I said, "I need your help! These guys were killing the ball all the way until we got to Williamsport. Now all of a sudden we can't seem to get on track. What can I do?"

He said, "Well, at this point, all you can do is try to relax them. Tell 'em you're confident in them, you love them, whatever you want to tell them to try to make them relax." So we had a little huddle before the final game started, and I spoke very softly and told them how proud I was. And we hit the ball a little better that day. We hit the ball at the right moments. We made all the defensive plays.

It was good for me to hear some positive comments about what we might be able to do to let them relax and perform. And they performed like they were playing in front of fifty people instead of forty thousand people. They weren't nervous...though I sure was nervous! It was great. It was good to have someone I could make a phone call to.

Schaly, of course, got a charge out of hearing from a former player he hadn't talked to in years who was calling about an important baseball matter. His wife, Sue, remembers:

When I got to the ball field that day, Don said, "You'll never guess who called me for advice today." I said, "Who?" He said, "Coach Galla wants to know if I can give him some magic formula to make his kids hit the ball."

I asked Don what he told him, and he said, "First of all, you've got to relax, and then tell your kids to relax and then go out there and have fun."

Galla's team certainly did that. It was the first time a team from the United States had won the championship since 1983. What made it even more impressive was that Trumbull had a population of only about thirty thousand and Taiwan had outscored its opponents, 74–5, in its previous eight games.

One of Galla's players was a twelve-year-old named Chris Drury, who would go on to have a solid twelve-year career in the National Hockey League when he was on the Stanley Cup champion Colorado Avalanche in 2001. Drury, who retired from the NHL in 2011, was the winning pitcher against Taiwan and had two hits, driving in the go-ahead runs late in the game.

"Shortly after we returned home from Williamsport, Coach Schaly and I spoke," said Galla. "I thanked him for his great advice and told him I thought it worked. The guys played great, and we got the hits when they were needed."

Galla and his team, which included his son, Dave, who played one year at Marietta (1996), were immediate national celebrities. They appeared on *Good Morning America*, had lunch with Baseball Hall of Famer Mickey Mantle in his restaurant, went to Yankee Stadium, Shea Stadium and Fenway Park, met President George H. Bush in the Rose Garden and went to the World Series in Oakland and to Radio City Music Hall, among many other places.

Galla said he was the starting catcher on Marietta's JV team as a freshman, but he still questioned if he was good enough to play on the varsity.

Schaly intimidated me. I was always afraid to go into that office. But I owe him so much. I tried to quit baseball at the end of my freshman year. I went into his office and told him I was quitting. He said, "Let's talk about this for a while." He wouldn't let me quit. He said, "I'm not going to promise you anything, but you had a great freshman year, even though it was JV. I can see you coming up and helping the varsity." So he talked me into staying. That was great.

Future Little League World Series coach Tom Galla (right) with Marietta College teammates (left to right) Jack Callahan, John Diaddigo and Lonnie Stock pose on campus prior to their senior season (1970). *Marietta College Archives.*

Galla became a varsity starter as a sophomore, but he had to go through a position change to do it.

I got to go on the spring trip as the No. 3 catcher my sophomore year. The team is doing okay, but I'm not playing. About halfway through the trip, Schaly told me I was starting the next game. Guess who's pitching— Tekulve! I had not caught Tekulve once. I'd never even warmed him up. All I knew was all he threw was a fastball, but I had no idea what that fastball did. And it exploded!

It would go right one time, left one time, down one time, up one time. I couldn't catch him! I probably had four passed balls in the first three innings. It was very embarrassing, because I thought I was a good catcher. Luckily for me, I hit four line drives that day—three for hits and one right at the left fielder for an out. Also luckily for me, the two second basemen Schaly brought on the trip didn't hit. So we got back to Marietta, and Schaly calls me into his office.

The Story of the 'Etta Express

Schaly always posted the practice schedule and other information for the team on a little bulletin board outside his office. If he wanted to talk to a player, he'd post an infamous "See me" note that always struck fear into the heart of whoever's name was on it.

Galla said:

> *I got a "See me" on the board. We were afraid we'd get cut or something. But this was a good "See me" because he asked me if I've ever played the infield. I said, "Sure." Well, the last time I played infield, I was ten years old! So I got to start at second base. I played the rest of the season, and it was my most successful season hitting at Marietta.*
>
> *Senior year I got moved to third base. I was horrible in the field. I cringe when I think about it. But luckily I kept hitting, so I stayed in the lineup. I would have been the perfect designated hitter back in those days, but they didn't have it then.*

Fortunately for Inselmann, the DH was adopted at just about the right time for him. Originally a pitcher and outfielder, he had to curtail his throwing early in his career at Marietta, and Schaly was able to use him primarily as the Pioneers' DH. In his junior year, 1978, he was first team all-America DH.

Marietta failed to reach the World Series in 1976 when Inselmann was a freshman and the event was played at Pioneer Park for the first time. That changed in 1977, and the sophomore from Deshler, Ohio, was a major reason for that.

After losing the first game of the conference championship series to Wooster, 6–3, the 'Etta Express fought back to win the next two games, 9–7 and 5–4, to advance to the NCAA Regional. The Pioneers rolled through the first three games to reach the finals against Widener College of Pennsylvania, which was coming out of the losers' bracket. Widener won the first game, 7–1, forcing Marietta into the "if necessary" game, the winner of which would advance to the World Series at Pioneer Park. It turned into a monumental encounter.

"The game didn't finish on the day it was supposed to, because it went extra innings," recalled Inselmann. "So we had to stay around and complete it in the morning. I was the third batter up the next morning with two outs in what was the twelfth inning. I happened to hit it out, and that won the game."

The Pioneers won, 3–2, sending them to their home field for their first ever Division III World Series appearance (1975 was a combined DII/ DIII Series).

Bill Mosca, a junior infielder on that team, said:

> *The newspaper called Inselmann's home run the "Home Run Heard 'Round Marietta." It couldn't have happened to a nicer guy either. He was an even better person than he was a player, and he was a real good player! He hit the home run over the right-center field fence. I'll never forget it. We* didn't do much when we got there [to the Series], *but what a thrill to run out there at your home ballpark.*

Marietta lost the first two games for a quick World Series exit, but the experience no doubt helped the following season, when Schaly's team finished second in the Series to Glassboro State of New Jersey.

Inselmann, who credits Schaly for playing a major role in his success as a high school coach, said:

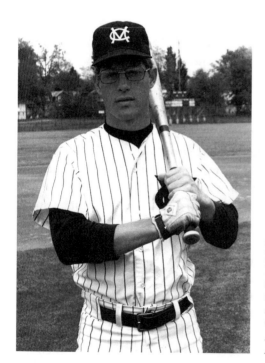

Greg Inselmann hit the "Shot Heard 'Round Marietta" to get the Pioneers into the 1977 World Series and, after graduating, went on to a highly successful career as a high school coach that landed him in the Ohio High School Baseball Coaches Association Hall of Fame in 2006. *Marietta College Archives.*

The Story of the 'Etta Express

To be a part of two World Series, both of them at Marietta, was a really neat thing, even though we came up a little short and finished second in 1978.

Playing under Coach Schaly had a big impact on my career as a coach. As soon as I visited Marietta, I just fell in love with how they conducted business. Our high school program here was more loosely run. At Marietta, there was a friendly atmosphere, but you could tell there was a passion among the players. It was culture shock. I've never worked so hard in my life in terms of a sport, and I played football, basketball and baseball. The discipline, the organization…I've never seen a person more organized than Coach Schaly was—and more demanding, too.

A four-time letterman at Marietta and co-captain as a senior in 1979, Inselmann began his coaching career at Defiance High School in 1979 and became head baseball coach the next season. In eighteen years, his teams were 303-85 (.781) and won the 1992 Division I state championship.

Inselmann then moved to his alma mater, Patrick Henry High in Hamler, where he ran the baseball program for nine years and posted a 202-48 record (.808), winning the Division IV state championship in his last season, 2008.

What makes his accomplishments particularly impressive is that both schools had losing programs before he took over. Of course, Schaly had to start practically from scratch at Marietta, too.

Inselmann said:

I was kind of scratching my head at times as I was going through Schaly's program at Marietta. I was wondering why we were doing some things, to the point where I didn't really care for it. But after I got out, then the light goes on and you start to see how it pays dividends and why they were so consistent year after year.

I took an awful lot from what I learned at Marietta and incorporated it into my personality and style. I think it allowed me to be ahead of the game a little bit as a high school coach. I used a lot of Schaly's techniques. I certainly demanded the discipline that I was a part of at Marietta for four years.

Coach Schaly was tough. When I was going into my senior year, he cut a kid that was our leading hitter for average the year before. I thought, "What in the world?" I remember talking to Bill Mosca [then a student assistant coach], and he said something to the effect that, "If you're not

a team player, it doesn't matter what stats you put up." That says a lot about Schaly—"Nobody's above the team." I tried to emulate that the best I could on the high school front.

And Schaly's organization was second to none. I learned that to be a successful coach, you better be very, very organized. You've got to demand things. The kids want to be pushed. They might not always say that, but they do.

What I liked about it is that I was able to get my high school kids to buy into it and have some pretty quick success. That makes it easier when the kids start to see the fruits of their labor. That first year, we had a twenty-win season, and it just generated a lot of excitement.

The other thing I saw that paid off big-time for me at both schools was I knew there had to be a real culture shock, not only in the attitudes of the kids and that baseball is important, but also in the facilities.

At Marietta College, the facilities in the '70s were just wonderful. When I got there, I remember the players were planting trees outside the home run fence—pine trees. As a team, we had to do that in the fall.

I did the same thing at the two high school programs. I found a lot of local resources and people that were willing to work on it. When the kids were seeing how you were upgrading the facilities, all of a sudden it becomes more important that way, too.

At Defiance, that field had no home run fence. We put up a nice fence. We put nice pine trees back there. The players were involved in that. We did a lot of team building. All of a sudden, players take ownership of the field. It's their baby, and when they hear compliments from players and coaches on other teams coming in, all of a sudden, they stick out their chests a little because they know they had a hand in all that. It's easier then to get them to do more work on the field.

The other thing was the youth program, the lifeblood that would flow toward your high school program. With Coach Schaly, it was his good recruiting at Marietta. But we wanted to make sure we were on par with the youth systems, the feeder systems for the high school team. That was all part of the organization I got from being at Marietta.

In my junior and senior years at Marietta, I also started stockpiling some things and writing down some things. I was getting excited about being a coach and how I could organize on a high school scale. It allowed me to get myself ahead. I'd sit with our hitting coach, Paul Page, on trips and I would pick his brain. We didn't waste much time on the bus. I would just eat up things we would discuss—the pickoff

systems and so forth. Did we ever have a great time with that, because other high schools just weren't ready for those kind of things. We had a wonderful time making them feel a little embarrassed. But there's nothing wrong with that.

To be good at anything, you have to have a passion for it, and to me that's Marietta College baseball. There's a passion there that's second to none.

Chapter 18

EXTRA INNINGS

Marietta College began hosting the NCAA Division III World Series in 1976—the year the event was born. Previously, Division III colleges had to play in the same tournament with Division II schools. It was hardly fair, considering Division II institutions awarded athletic scholarships while Division III schools based financial aid solely on scholarship and need.

In the twelve years the event was played at Pioneer Park, Marietta made the field nine times, winning the Series three times (1981, '83, '86) and finishing second four times ('78, '80, '84, '85), third once ('82) and fourth once ('77).

Of course, it was due mainly to the efforts of Don Schaly that the Division III World Series was first competed at Marietta, but it took thousands of hours each year from the World Series Committee, composed mostly of businesspeople in the town, along with volunteers and college employees, to make it a grand success.

The World Series eventually outgrew the town and the college, causing the NCAA to relocate the tournament. Of course, there might have been some jealousy involved, as well, from some coaches thinking the Pioneers had an unfair home field advantage.

"I know some of them thought that way, but I actually think it was a disadvantage for Marietta," said Gary Frye, a local attorney who served on the World Series Committee for a few years and was its president in 1981 when Marietta won for the first time. "There was so much pressure playing at home. Marietta was expected to win every game."

Schaly believed that getting lights for the field would help get the Series back to Marietta, but that didn't happen, and once the event expanded to eight teams, there was no way for a return since two championship fields were required.

But no one ever questioned the effort or the hospitality extended by the community and the college, right down to the extraordinary measure taken to dry out the field following a heavy rain in 1981. Frye recalled:

> *It stormed Friday after seven innings. It was a river. The wind blew the pipes they wrapped the tarp on all the way to the outfield fence. We left the tarp off at night because it wasn't supposed to rain again. Well, it stormed again at two in the morning. By the time they got the tarp back on, it was too late. We had to completely rebuild between first base and second base. Someone jokingly said we needed helicopters to dry it off.*

That got Jim Meagle, another committee member who's now president of Settlers Bank in Marietta, thinking:

> *I got the name of the colonel that was head of the medevac unit in Parkersburg with the West Virginia Air National Guard. I asked him if they could come in Sunday morning, and he said, "We do need to practice our touch-and-goes." They couldn't sit on the field, but one Huey would hover for a while and then leave and another would come in. They got it dried out, and we played.*

The Series was extended to Monday due to the lost time, but with Marietta College in the championship game, the community turned out in force. The Pioneers did not disappoint, beating Ithaca, 14–12, in twelve innings for Schaly's first national championship.

Through the efforts of the committee, funds were raised to make significant upgrades at Pioneer Park, including the addition of the electronic scoreboard, to make the World Series experience even more special for the participants and fans.

An annual banquet was held that eventually attracted as many as five hundred people to the Lafayette Hotel to see the players and hear speakers that included baseball legends such as Lefty Gomez, Bob Feller, Jim "Mudcat" Grant, Bobby Bragan and "Marvelous" Marv Throneberry.

"Our students were already gone for the summer, but we put one to two thousand people in the stands for every game, and that hasn't

Even though students were out of school, some one to two thousand fans regularly turned out for World Series games at Pioneer Park, and when the 'Etta Express was playing, people often lined the fence all the way around the field. *Marietta College Archives.*

happened since it left Marietta," said Frye. "I don't know of anything I ever worked harder at or had more fun doing in all the community work I did over the years."

John Wharff III is the president of radio station WMOA-AM, which carries Pioneers baseball games. He grew up around the program because his father, the late "Big John" Wharff, was the "voice" of the broadcasts for many years, as well as one of the program's biggest supporters. Wharff said:

I likened those early years of the World Series in Marietta to the old days of baseball when kids would stand outside and peek through the knothole in the fence. It seemed like there were hundreds of kids. If school was going on, I don't know what happened there—that was the pass to be out!

You can't see through the fence now, but back then, it really seemed like there were people along every inch of the fence, and it really was what was going on in Marietta in the late '70s and early '80s. It seemed like that's all there was to do, and no one would have wanted anything else to do.

Tom Carbonar graduated from Marietta College in 1960 and did well enough professionally as an investment banker that he retired at the end of 1989 at age fifty. What did he do to celebrate? Take a cruise or a trip around the world?

Not quite. He returned to Marietta to spend six months as a volunteer assistant baseball coach under Don Schaly.

Though Carbonar and Schaly followed drastically different career paths, they had a unique friendship that began as students. Schaly was a year ahead of Carbonar, but they were on the baseball team together, and Carbonar, an outfielder, was Schaly's "little brother" in Alpha Sigma Phi. When Schaly married Sue Knicely in the summer of '59, he asked Carbonar to be his best man.

Carbonar, who splits his time between homes in Los Angeles and Annapolis, Maryland, said:

Tom Carbonar (kneeling, right), with (clockwise) Joe Schaly, Don Schaly and Bill Mosca, returned to his alma mater in 1989 after retiring from a very successful career in the financial industry to serve as a volunteer assistant coach. *Marietta College Archives.*

Our relationship was very special. I spent six months with him, and it gave us a great chance to reconnect. That shows how I felt about him. Don was a brother to me. We didn't see each other a lot. I was always on Wall Street or overseas.

I had just retired. It was fabulous. I thought I was going to be able to make a contribution to the team, but I think I ended up getting more out of it. I saw the whole program. I went back in the winter, and we began conditioning.

When we were in college, we were all so young and still formulating our character. Most of us played the game back then for fun, but basically when we left the field, that was it and we went back to our studies or whatever. It always stood out to me that Don was so cerebral and analytical in the way he approached the game. He was thinking about the game off the field when the rest of us weren't.

He knew the game and was a very good catcher. He was so smart. I used to kid him about what a slow runner he was. But I always thought he might be a good coach or manager, because he always knew what to tell us to do.

This was in the late '50s. We had a lot of veterans in college on the GI bill. We had quite a few on the baseball team, and of course, they were much senior to us. Don was the catcher, and he was the leader of the team. It was very impressive, because they still looked up to Don even though they were much older. He was very well respected, and you could see he had leadership qualities and a real dedication to the game.

I was on the serious side of things, and Don was, too. He was a real hardworking student. I think the reason we hit it off so well is that he saw the same quality in me. He was extremely goal-oriented, even at that age, and he was tenacious about accomplishing his objectives. I always liked that.

Carbonar was commissioned as a U.S. Marine Corps officer coming out of Marietta and spent three years on active duty. He was in Okinawa and led patrols into Vietnam in the early stages of the conflict. The lessons he learned and experiences he had in the military reminded him a great deal of Schaly.

Don was a perfectionist and very demanding, but I always thought he was very fair. What I saw when I went back for that six months wasn't just that Don was a great baseball coach, which everyone knows he was, but I

saw that he really took an interest in the students. He physically prepared them. He gave them mental toughness. He built their character. When they left that program, they may not have played any more baseball, but most of them were really prepared for the challenges life presents after graduating college. It made me flash back a little to the training marine recruits go through.

Don had character and integrity like no one else I ever met. In a combat situation, I would want Don Schaly to protect my flank. That is the supreme compliment I could give anyone, and that's exactly how I felt about him. I just loved the guy.

<div align="center">*****</div>

Leon "Jack" Jackson is a highly successful South Florida restaurateur who was an outfielder and pitcher for the Pioneers in 1965–66. He never lost his love for baseball, and because of his business, he was able to build friendships and relationships with some of the biggest names in Major League history, including Mickey Mantle. He also was afforded the opportunity for a memorable reunion with Don Schaly in 1997.

Coach Schaly and his wife, Sue, were in Boca Raton to visit their son Jeff, who was working at Lynn University at the time, though he returned to the Marietta College athletic department in the fall of 2011. Two years earlier, Jackson had attended Schaly's induction into the American Baseball Coaches Association Hall of Fame in Chicago, so Schaly called his former player to let him know he was in the area.

"I was very good friends with Wayne Huizenga, owner of the Marlins," said Jackson. "I asked Coach Schaly if he and Sue would like to go to a game. I had real good seats, right behind the dugout, and I sent a limo to pick up Coach. I'm not sure if he'd ever been in a limo in his life."

The game happened to be game five of the National League Championship Series, in which the Marlins beat the Atlanta Braves, 2–1. Jackson recalled:

We all had a ball at the game, and afterward, I took them to my restaurant [Jackson's Steakhouse], and we had a great dinner. It was a thrill to host someone that had been such a significant part of my college experience. We told lots of stories, and I think he especially enjoyed those about the startup of his program. Even though he won national championships and had players make the big leagues, I think that first group was always special.

Jackson also went back to Marietta in 1982 for the baseball alumni game and had an interesting encounter with one of those Pioneers who would make it to the Majors a few years later. Jackson, who also was in the restaurant business for nearly twenty years with actor Burt Reynolds (Burt & Jack's), said:

I was walking around campus soaking up the nostalgia, and I was looking for baseball players. All of a sudden, I see a big guy in the baseball team windbreaker. I asked him if he was in the baseball program, and he said yes. I told him I was one of the alums coming back for the weekend.

I had gotten myself in really good shape, and I was really feeling my oats. Although I hadn't faced any live pitching, I was really excited to be back. The last thing this guy says to me is, "Have a fun weekend and don't get hurt." I was insulted, because I was in such good shape!

We're playing the JV team, and guess who's on the mound in the first inning? It's Terry Mulholland, who was only a freshman and was the guy I ran into! It's my first at-bat against live pitching in many years, and I got a solid single up the middle.

I love to tell the story and don't tell people who it was. Then I say, "A few years later, he was the starting pitcher for the National League in the [1993] All-Star Game!"

Finally, in the interest of full disclosure, I tell them the most they could throw was three-quarters speed and nothing but fastballs. That was the highlight of my retirement!

Jim J. Tracy (1976–79) was known as "J.J." as a player at Marietta because Jim E. Tracy (1975–76) got there a year before him, and Coach Schaly only wanted one "Jim Tracy" on the roster. Schaly summoned Jim J. to his office one day and pronounced him "J.J.," which Tracy said he liked, and he was known by that for four years of baseball.

J.J. was an excellent outfielder who made third team all-America as a sophomore in 1977 and compiled a .330 career batting average as a Pioneer. He jokingly claims to have one unique distinction—other than writing the foreword for this book—among all Marietta players. It's not in the record book, but Tracy says Schaly told him he's the only player ever to lose a game by himself! He recalled:

210

Besides being an all-America outfielder at Marietta College in 1977, writing the foreword for this book and being the director of national sales and business development for Morgan Stanley Smith Barney, Jim "J.J." Tracy may be the only Pioneer to ever "lose" a game by himself! *Marietta College Archives.*

We were winning, 6–4, against Austin Peay. I think it was the bottom of the sixth inning, and they had the bases loaded. A guy got a base hit to left field, and I came rushing in with the full intention of throwing out the tying run at home plate. The ball went under my glove and rolled all the way to the fence. Three runs scored, putting them ahead, 7–6.

In the top of the seventh inning, Abbey Gladstone was on third, and I was on first with two outs. I had the green light for stealing, so I decided to take it upon myself to try to steal second base. I got thrown out. Of course, I never should have tried to steal with the tying run on third and two outs.

So as I'm laying on the ground, Schaly comes running out from the dugout and just tears me a new one. He's yelling and screaming. He said, "Never in the history of Marietta College did one player single-handedly lose a baseball game like you did today." He's literally bending over me, because I'm still on the ground from sliding. I didn't get up, because I knew I was in trouble. All of a sudden when I did look up, his face was about six inches from mine, and he's pointing at my chest. He was a little frustrated!

The good thing about Schaly is that you knew he was mad and you knew you made a mistake, and you knew he didn't mean what he said—although it might have been a fact! But I was in the lineup for the next game. You forgive and forget when you respect someone like him. You can put up with a lot.

Ryan Eschbaugh was the starting shortstop on the 2006 national championship 'Etta Express, but he first suited up in Marietta College pinstripes a decade earlier—at age eleven!

Eschbaugh, now a medical student, grew up in Marietta and was exposed to the baseball team at an early age. His uncle, Mark Eschbaugh, didn't attend Marietta but participated in the same fall league with the college players. He told Coach Schaly that he had a nephew who would enjoy being the batboy, and Schaly suggested bringing him to a game.

Eschbaugh said:

> *My brother* [Nate] *and I were baseball fanatics. Before Marietta College was even in the picture, we would eat, sleep and breathe baseball. We were constantly in the backyard, hitting ground balls to each other, throwing BP to each other, whatever.*
>
> *Coach Schaly told my uncle to bring me to a game, and then he actually did like a little interview with me. I remember him walking me around the field and talking to me about the job, the commitment. He made it a real job. It wasn't just like, "Show up at these games and go get the bats." He made it a big deal, even at that age. Every little detail of that program he wanted a certain way.*
>
> *It worked out, and my mom decided that was something they were willing to do if I wanted to do it. I was at every game. We went to Florida with them on the spring trip and to the World Series. I started in 1996 when I was in fifth grade. I did it from 1996 to 1999. Then my brother stepped in after I was done and did it for three years* [2000–2].
>
> *It was kind of an introduction to what was coming next, I guess! We probably wanted to be a part of Marietta College baseball even more after that. We* [Nate was a Marietta pitcher from 2007 to 2010] *saw what went on at the field and got introduced to a lot of things my mother probably would have preferred we not know!*

<div align="center">*****</div>

Abbey Gladstone was a two-time all-region outfielder who played at Marietta from 1975 to 1978 and still ranks fourth on the college's career stolen bases list with ninety-four. He's gone on to have a very successful career in the financial world, and because of that, he was working directly across the street from the World Trade Center on September 11, 2001.

The Story of the 'Etta Express

Gladstone's whereabouts were not lost on Coach Schaly when he heard the news of the terrorist attack.

Gladstone said:

> *My office was at 1 World Financial Center, which is across the West Side Highway and a little south of the Twin Towers* [of the World Trade Center]. *So when the first building was hit, we heard this giant thud, and the first reports were like they thought it was a Cessna that hit the building. Very quickly, it escalated to where we realized it wasn't that.*
>
> *We were on the twenty-eighth floor across the street, and we could see people that were hanging out the windows and burning and jumping. The emergency broadcast system in our building said, "Everything's fine. Everyone should stay put." When the second plane hit, the glass shattered, debris hit our building and that's when everyone started to evacuate.*
>
> *After about an hour or so down on the ground—I used to drive to work, and my car was parked in our building—no one really knew what was going on. I figured in another hour or so, I'd be able to get my car and drive home. The next thing I know, the building is falling over, and I'm on the esplanade that borders the Hudson River. I pretty much had to hop a fence and put my body up against the apartment buildings that, at that point, I figured was the safest place. I had no way to know if it would work, but I thought that was the safest way to protect myself. It was just crazy, and I wound up being evacuated with the rest of the people.*
>
> *If the buildings had fallen over instead of imploding, I'd be dead. I ended up being evacuated by police boat from the Battery Park Marina over to Liberty State Park in New Jersey. I lived in Long Island, so I went totally the wrong way. Through some friends, I hitched a ride, and I had a brother that lived in northern New Jersey. All the cellphones were down because all the repeaters were on top of the Trade Center. Once the buildings fell, no one knew where I was until I was able to get to my brother's house that night around six o'clock.*
>
> *It took me two days to get home. When I got home, there were a couple of messages on my answering machine. My wife was out of town, and my son was out of the house at that point. A few people called to be sure I was okay, and one of the people who called was Coach Schaly, which was amazing to me. The message was, "Hey, Ab, I'm pretty sure you were working downtown. I just wanted to make sure everything's okay and you're all right. Please give me a call as soon as you can."*

It was late at night, so I called him the next day and spent a few minutes talking. That gives you an idea what kind of guy he was and the kind of family we really had as Marietta College baseball players. When I called him, he had no idea I was right there and went through the whole thing. I kind of described to him exactly what happened and what we went through.

<p style="text-align:center">*****</p>

Jim Katschke won more games (forty-seven) in his career (1983–86) than any other pitcher in Marietta College history except Matt DeSalvo. But, as he admits, he also had a "high anxiety level," something Coach Schaly did not like.

One of the big keys to Marietta winning the national championship in Katschke's senior year (1986) was the addition of left fielder Sean Risley, who transferred from another strong program at Eastern Connecticut. Risley had an amazing season, setting a Marietta and NCAA record for hits in a season (103), but Katschke still managed to find fault with him one day, eventually leading to an amusing story. Katschke said:

Risley always knew when to shine. Whenever he needed to do something, whether it was to foul off pitches, bunt, steal a base or catch a ball in the outfield, he would do it. He's playing outfield in the World Series with an ankle injury. He'd sprained it a couple of days before but said he was ready to go. There's runners on first and second, and we're tied. Fly ball to left, and I figured, "We're good." But he turns around, then turns around the other way, trips and falls, and the ball drops. Now they have a guy at third, and we're down a run.

I was very, very intense. I'm standing on the mound, and I can hear the quiet from everyone, because they're waiting for me to implode. I see Coach Schaly standing in the dugout with his arms crossed, looking at me. I'm looking at him, and I'm thinking, "I can't implode. I've got to maintain."

But the next thing I know, I yell, "Will someone get him a fucking compass?" Coach calls time and comes out to the mound. He calls the infield in and says, "Katschke, that's unacceptable." I said, "I know. I'm sorry. I couldn't help it." He said, "I'm going to leave you in here to get you out of this, and I expect you to strike out this next guy. And I want you to know that compass you're asking about, some of the home runs

you've given up, the compass couldn't find them either." Then he walked off the mound.

Risley and I talked. He said, "I blew it." I said, "No, it's my fault." When I was inducted into the Marietta Hall of Fame, all those guys are cheering for me. It's all good. Frank Schossler is my presenter. At the very end of his speech, he has a box in his hands and says, "Jim, this is from all of us, especially Sean Risley. This is your present from all of us, the f-ing compass you wanted." I've had that with me ever since.

APPENDIX

*Source: Marietta College Baseball Media Guide

FORMER PLAYERS

A

Adams, Dan	1989
Adams, Mike	1987–88
Alazaus, Shawn	1991–92
Alkire, Deron	1990–91
Allen, Dave	1989–92
Allen, Tony	1966
Ambler, John	1964
Andersen, Dave	1966
Anderson, Jim	1985–88
Anderson, Rich	1971
Anderson, Shannon	1992–95
Antill, Frank	1988–91
Applin, Skip	1964
Arkwright, Jim	1991
Asire, Evan	2008
Atha, Kirk	1986
Augustine, Dave	1977
Augustine, Sam	1971
Auricchio, Neil	1970–71

B

Baird, Jess	1992
Baker, Gary	1972–73
Bakos, Bill	2003–5
Banachowski, Tyler	2005
Banton, Rich	1992–93
Barbao, Eric	1980
Barber, George	1989–92
Barber, Scott	1987–90
Barrett, Dave	1976
Barrett, John	1966
Barsky, Bob	1983–86
Barth, Ken	1974
Bartolomeo, Rich	1968–69
Barton, Dave	1977–80
Bartram, Bob	1969
Basic, Mike	2006–7
Bauer, Marty	1973–76
Baumler, Jason	2006–9
Beamer, Bob	1983–86

Beardmore, Mike	1972–73	Brown, Nate	2000–3
Beatty, Chris	2007–10	Bruce, Jim	1964
Becker, Jordan	2006–7	Buchanan, Dave	1990–91
Becker, Kirby	2009–11	Buirley, Kris	1998–2001
Beckman, Steve	1969	Bumbaugh, Jerry	1969, 1971–72
Beebe, Josh	2006	Burchard, Chris	1987–88
Belanger, Ryan	2004–7	Burgbacher, Matt	1996–99
Bell, Dave	1982	Burgess, Terry	1966–68
Bennett, Don	1970–71	Burns, John	1978, 1980–81
Benua, Tom	1964	Bursch, Doug	1964
Bertolino, Dave	1993–96	Burton, Jim	1976–78
Beyerlein, Brandon	2002–3	Bush, Cory	2005
Biddulph, Rich	1978	Bycznski, Brian	1996
Biedenbach, Joe	1994		
Biggers, Andy	1988	**C**	
Bingham, Russ	1965–66	Callaghan, Greg	1988
Bishop, Jerry	1978–81	Callahan, Jack	1967–70
Black, Charlie	1976	Callihan, Mike	1976
Blackwell, Tom	1994–95	Cameron, Kile	1991–93
Blake, Jim	1999–2000	Campbell, Jeff	1978–79
Blaskey, Joel	1964	Campbell, Tim	1978
Blaski, Austin	2009–11	Capitano, Dante	1987–88
Bobo, Al	1970	Capobiance, Rocky	2005–6
Boedeker, Jamie	1998	Capowski, Nick	2004
Bonar, Dave	1972	Carbone, Vince	1969
Bonnette, Dave	1970	Caron, Dan	1995–96
Boyer, Larry	1965–66	Carr, Mike	1974–75
Brackley, Chase	2002	Carr, Rick	1966–68
Bradley, Dave	1996–99	Carr, Steve	1987
Bradley, Richard	1964–65	Caruso, Gary	1968
Brady, Darren	1996	Casto, Shane	1998
Brandts, Mike	1984–86	Cava, Ed	1977–80
Braun, Jeff	1987	Cavallo, Joe	1984–86
Brehm, Andy	1997	Chadwell, Gary	1966–67
Brewer, Brian	1990–93	Chaney, Jeff	1981–84
Briel, Mike	1976	Charter, Mike	1990
Brine, Chris	1993–96	Chartier, Jerry	1987
Brockmeier, Evan	2010–11	Chase, Bob	1975
Brooker, Joe	1979	Chasen, Barry	1966–69
Brooks, Zach	2009	Childress, Dusty	1999–2002
Broun, Josh	2000	Chupek, Bob	1978
Brown, Andrew	2010–11	Ciccone, Mike	1975

Cimino, Cameron 2006–9
Clark, Chris 1996
Clark, Scott 1984–85
Close, Jason 1992
Coakley, Jay 1999–2002
Coble, Andy 2001–4
Cochran, Jon 1984
Coffman, Carson 2003–4
Colegrove, Dale 1992
Collins, Dave 1964–66
Combs, Steve 1975–76
Conley, Adam 1994
Conrath, Jim 1989
Cook, Doug 1988–91
Cook, Jeff 1991
Cook, Roger 1974
Cooksey, Bo 2002–5
Coolidge, Chris 1993
Corbett, Jake 1994
Counts, Nate 1990–93
Cox, Steve 1990
Cox, Tony 1988–90
Crabtree, Aaron 1990
Craddock, Jason 1994–97
Crandall, Karl 1985–86
Crawford, Tim 1979
Cribbins, Brennan 2006–9
Crognale, Corey 1973
Crowley, Greg 1970–73
Cummings, Derek 2004–05, 07
Curtin, Brent 2000–3
Curtis, Steve 1965–68
Czajkowski, Ryan 1996
Czech, Rob 1973–76

D

D'Addio, Joe 1977
Dailey, Jim 1968
Daniels, Mike 1968–69
Darmos, Dan 1974
Dattilio, Terry 1998
Davies, Bob 1996–97

Davies, Dave 1975
Davis, Marty 1988–90
DeAndrea, Ryan 2004
DeAngelis, Tom 2008
Deegan, Mike 1998–2001
DeJeet, Kristian 2007
DelGrippo, Joe 1984–85
DeMark, Mike 2003–6
Demchak, Mike 1968
Dennick, Ryan 2006
Dennis, Jeff 1971–72
Derrick, Sean 1979
DeRubis, Dan 1977
DeSalvo, Larry 1985
DeSalvo, Matt 1999–2003
DeSico, Matt 2007–10
DeToro, Joe 1998
DiCocco, Chad 1992–94
Dietrich, Chris 1995
Dietz, Dana 1985
Ditzeberger, Curt 1987
Doran, Ryan 2006
Doty, Tom 2005–7
Double, Jake 2011
Doughman, Dick 1966–67
Douglass, John 1971
Dowdell, Chris 2008–9
Drake, Jeremiah 1998
Duff, Tom 1985–86
Dulac, Darren 1994
Duncan, Monte 1982–85
Dunlap, Dennis 1981
Dunn, Scott 2006

E

Eddy, Bob 1991–94
Eddy, Jim 1986–89
Eisenberg, Mike 2004–6
Elmer, Matt 1978–79
Elston, Mike 1975–78
Elwell, Dave 1978
Emery, Aaron 1989–91

Emling, Phil	2011		Fuller, Jack	1974
Emmerich, Tom	1964		Fulton, Tom	2010–11
England, Paul	1974			
Engstrom, Ken	1982		**G**	
Enz, Mike	1989		Gagner, Don	1964
Epling, Dane	1993		Gahan, Brian	1981
Ervin, Rick	1972–73		Galla, Dave	1996
Eschbaugh, Nate	2007–10		Galla, Tom	1967–70
Eschbaugh, Ryan	2004–7		Gammiere, Tom	1979–82
Esler, Dick	1966–67		Gandee, Jason	1992–95
Esposito, Dustin	2002–4		Garmong, Josh	1996
Evans, Brian	1995		Gasser, Brian	2009–11
Evers, Jack	1974		Gerken, Tim	1977–78
Eyler, Bob	1985		Gerkin, Steve	1985–88
			Geudtner, Dan	1997–2000
F			Gibson, Barry	1986
Falconer, Rick	1987–88		Giddings, Mike	2000
Falvey, Joe	1979		Gilkey, Izzy	1993
Fama, Ron	1981–84		Gioioso, Mike	2004
Faria, Gregg	1967		Gish, Charlie	1967–68
Farmer, Chad	1992–95		Gladstone, Abbey	1975–78
Farnham, Dan	1995–98		Glazier, Andy	2005–6
Fatzinger, Darrell	1991–94		Glenney, Brian	1969
Fauquher, Gabe	1995		Goldbach, Bryce	2008–9
Feazell, Kent	1987		Goldberg, Bob	1966
Feigel, Jeff	2005		Golubchik, Dave	1965
Feist, Dan	1966–69		Gorba, Bernie	1982
Fiermonte, Jeff	1995		Gornik, Brad	1997–99
Filkovski, John	1983		Grabko, Nick	1969–71
Finke, Gerry	1985–86		Graham, Adam	2002
Finke, Jon	1982–85		Graham, Henry	1970
Fischer, Jason	2003		Grant, Kim	1971
Fisher, Roy	1969–72		Graziano, Lou	1968
Forosisky, Bob	1982		Greathouse, Damon	1993
Fortuna, Eric	2000		Greenawalt, Jim	1969
Frafjord, Brent	1991–94		Gregorich, Bryan	2010–11
Fredo, Chris	1975		Grilliot, Jordan	2010–11
Freidhoff, Skip	1964–65		Gronwall, Marc	1989–92
Freshour, Shane	1996–99		Gruenberg, Steve	2006–7
Frost, Ryan	2007		Guerrera, Lee	2003–6
Fryfogle, Jim	1970–73			
Fullen, Bill	2009			

H

Habrum, Don	1969
Hall, Mike	1997–2000
Hamborsky, John	1983–86
Hampton, Doug	1994–96
Hancock, Rick	1968
Handschumacher, Dustin	1998–99
Hanolt, Brian	2003–5
Harless, Jack	1995
Harold, Jim	1965
Harold, Tim	1966–68
Harrington, Kyle	1971–72
Harris, Mark	1974–75
Hart, Ed	1964-65
Hart, Roger	1981–83
Hartman, Craig	1975
Hartman, Jeff	1970–72
Haskin, Tyler	2010–11
Hasselo, Bob	1966
Hauptmann, Bob	1967–69
Haverlack, Frank	2010
Hefner, John	1982–85
Heller, Brandan	1991–94
Hendricks, Chris	2003–6
Hendricks, Matt	1995
Henry, Bill	1980–81
Henry, Gary	1971
Henson, Rod	1986
Herbert, Dave	1996–97
Herman, Leo	1965
Hesson, Brian	2007–9
Hill, Tom	1984–85
Hill, Tyson	1998–2000
Hillman, Chuck	1986–87
Hlabse, Paul	1972
Hlabse, Phil	1972
Hoane, Jason	1994–97
Hockenberry, Larry	1974–76
Hodgdon, Brett	2002
Hodinka, Rick	1973–74
Hoepfinger, Bob	1969–71

Hofmeister, Shawn	1994–97
Holland, Jamie	1991–94
Hollen, Randy	1980–81
Hollinger, Scott	1976–79
Hollrah, Adam	1997–2000
Hollrah, Brandon	1997–98
Holmes, Bill	1986–89
Holt, Les	1970
Hoover, Maury	1975
Hopper, Aaron	2010–11
Horne, Pat	1979–82
Horner, Frank	1980
Howard, Chuck	1977
Howard, Jeff	1973
Howell, Jim	1973
Hoyt, Jeff	1996
Hudock, Chris	1992
Huffman, Bob	1964–65
Huffman, Doug	1990–92
Hughes, Andy	1998
Hughes, Rob	1990
Humphrey, Tony	1997
Hunt, Steve	1977–78
Huntington, Tom	1969, 1971–72
Hupp, Ben	2009–10
Hurey, Jon	1987
Hurley, Paul	1966
Hurst, Dale	1979–82
Hyde, John	1970
Hydro, Randy	1994–97

I

Inselmann, Greg	1976–79
Isak, Barry	1965
Israel, John	1993
Ivan, Andy	1964–66
Ivin, Richard	1964

J

Jackson, Leon "Jack"	1965–66
Jackson, Mark	2007–8
Jacquet, Tom	1966–68

Janosko, Mike	1987	Koloskie, Jerry	1976
Jarrett, Mike	1989	Kotowski, Tom	1974–75
Jessup, Ben	2001, 2003–4	Kovacevich, Tom	1971
Jewell, Jeremy	2007	Kovalchuk, John	1982–83
Johanns, Tom	1970–71	Kovar, Steve	1977–80
Johnson, Mark	1992–95	Kraker, Travis	2005
Johnson, Pete	1964–65	Kraker, Tyler	2007
Jones, Bob	1977	Kramer, Kevin	1988
Jones, Dan	2007–10	Kramer, Mike	1985–88
Jones, Ron	1964	Krzywicki, Jim	1990
Jordan, Rob	1988	Kubera, Jeff	1980
Joy, Shawn	1990, 1992	Kuhn, Andy	2002–3
Julian, Mark	1981–82		
Jurena, Blake	2006	**L**	
Justus, Greg	1976–78	Lacy, Chris	2006
		Lafferty, Mike	2008
K		LaHood, Vic	1969
Kalland, Paul	1979	Laird, Tom	1969
Karney, Eric	1988–91	Lakas, Mark	2007
Katschke, Jim	1983–86	Lamb, Trey	1999, 2001–3
Kelley, Bob	1989	Langdon, Luke	2010–11
Kelley, Jeff	1982	Lansinger, Gary	1965–66
Kelly, Pete	1977–80	Laslo, Joel	1997
Kemp, Jonathan	2005	Latos, Gary	1969–72
Kennedy, Jim	1981–84	Laveck, Ken	1972–75
Kenney, Bill	1970	Leatherberry, Russ	1974
Kenyon, Ozzie	1969–70,	Lee, Brian	1977–80
	1972–73	Lehman, Joe	1983–84
Kerr, Dave	1986	Leibman, Paul	1967
Kerr, Tom	2003	Leiendecker, John	1968
Kerze, Al	1965	Lemmon, Bill	1991–92
Kessler, Steve	2011	Leoni, Dean	1989–91
Kiefer, Matt	1988–89	Levins, Casey	2008–11
Klaczak, Paul	1983	Lewis, Logan	2009–11
Klahr, Ben	2000	Lewis, Scott	1986–89
Klaus, Matt	1999–2000	Lindquist, Kyle	2009–11
Klausman, Jarrod	2004–6	Lingerfeldt, Paul	1966
Klempay, Ray	1983	Linhart, Bob	1971–72
Klug, Tim	1992	Liput, John	1976
Kmiecik, Kellen	2005	Lisko, Ken	1979–82
Knowlton, T.J.	2006–9	Litke, Derek	2003–4
Kohls, Gary	1981–83	Litke, Joe	2004–7

Lochbihler, John	1984–85	May, Kevin	2000–3
Lockwood, Scott	1978	Mazza, Rocky	1997
Logan, Pat	2006–7	McCarroll, Mike	1988–91
Long, John	1994	McCarthy, Brian	1980
Long, Johnathan	2010	McConnell, Tim	1990–91
Lonsinger, Gary	1965	McCullough, Larry	1985, 1990–91
Lonsway, Joe	1971–72, 1974	McCullough, Mike	1964
Losey, John	1971	McElroy, Craig	1998
Lowden, Bob	1978	McFadden, Conor	2006
Loy, Brian	1998–99	McGee, Craig	2008
Lubinski, Dale	1969–70	McGoun, Bryan	1973
Lucas, Howie	2011	McKeon, Rich	1976
Lucot, Kyle	2008	McKeown, Brian	1975–78
Luginbuhl, Tim	1970	McKinney, Ben	2002
Luiso, Chris	1993–94	McLean, Pat	1986
Lyles, Andy	1976	McLuckey, Matt	2001–3
		McManus, Matt	2002

M

		McMillan, Kevin	2007
Machusick, Rich	1965–66	McMillin, Terry	1973–76
Maenpaa, Keith	1989–91	McVicar, Scott	1983–86
Mahaffey, Mike	2010–11	Meador, Britt	2008–11
Mahley, Sean	2008	Meadows, Jay	2001
Mahoney, Keith	1978	Medaglio, Joe	1985
Maier, Jordan	2009	Menke, Mike	1997–99, 2001
Malario, Matt	1987–90	Menke, Rob	1995–98
Malavite, Terry	1970–73	Merryman, Justin	2006–9
Malpica, Jose	1995	Merten, Evan	2007
Mancini, Tony	1971	Messerschmidt, Roger	
Mann, Brett	1994–97		1992–93
Marbaugh, Jeff	1985–87	Mettler, Eric	1991–95
Marcil, Jim	1977	Middleton, Will	2009
Marshall, Mike	1998	Migliore, Dan	1965–66
Martin, Mike	1970–71	Miller, Eric	1996
Mason, Don	1965	Miller, Roger	1966–68
Massey, Aaron	2000–1	Miller, Rusty	1996–97
Mast, Brady	1992	Milowicki, Chris	1984
Mastronicolas, John	2010	Minerva, Dave	2001–2
Matchan, Scott	1984	Mininberg, Dave	1989
Mateczun, Jon	1992–93	Misinec, Marc	1991
Mathis, Erik	2007	Moavero, Marc	1983
May, Dan	2000–3	Moehring, Mike	1989–92
May, Joe	1966–69	Mohl, Tom	1979–82

Mollica, Tony	1971	**P**	
Montgomery, Chad	1995	Pace, Darrell	1971
Mooney, Mike	2002–5	Padgett, Ron	1973
Moormeier, Matt	2011	Palidar, Jake	2010
Moran, Tom	1976	Palmer, Geoff	1981
Morford, Ryan	2009	Pancher, Jim	1980–83
Morman, Steve	1978–81	Pangle, Jack	1973–75
Morrissey, Kevin	1995–98	Papania, Justin	2002–5
Mosca, Bill	1975–78	Parhamovich, Andre	1970–73
Mott, Chris	1991–94	Park, Braden	2010–11
Mroczkowski, Dave	1971	Parsley, Neal	1972–75
Muckle, Ken	1975	Paskoski, Joe	1992–94
Mulholland, Terry	1982–84	Passerelle, Dan	1976
Mulvey, Mike	2010–11	Paugh, Jamie	1988
Munday, Dan	1977–78, 1981	Pauley, Derek	2001–4
		Payne, Ted	1980–82, 1984
Murray, Bill	1980–81	Pearson, John	1967–69
Murray, John	1982–83	Pegram, Mike	1994–96
Musgrave, Kaid	2005	Pekol, Mark	1986
Myles, John	2000, 2003	Pendry, Dave	1973
		Penwell, Tyler	2007–9
N		Perkins, Bret	1989–90
Nachreiner, Chuck	1976–79	Perryman, Jeff	1986
Napierkowski, Dave	1985	Petrick, Tom	1968
Natale, Mike	2011	Pettry, Joe	1988
Nau, Dustin	2000	Petty, Tim	2008
Neeb, Bill	1964–65	Phalin, Jeremy	1995–96
Negron, Mingo	1997	Piconke, Tony	2005–8
Nelson, Blaine	1978	Pisha, Rob	2001
Nelson, Bob	1968	Pitrone, Joe	2007–8
Nida, Dwight	1991	Planisek, Jeff	2005
Nieman, Sean	2004	Podkul, Mark	1989–92
		Poholsky, Bob	1965–66
O		Polen, Chris	1988
Oberhaus, Mike	1995–97	Pope, Mike	1975
Oberhelman, Steve	1985–88	Potochnik, Len	1981
O'Connor, Tom	1995–96	Potter, Jim	1968–69
Olchon, Tom	1966	Preston, Ed	1971–74
Ollish, Ken	1976	Prezioso, Frank	1972–73
Opsitnik, Denny	1991–92	Price, Larry	1966–69
Ott, Ray	1967	Prish, Al	1967–70
Ottoson, Eric	1968	Puffer, Brett	1988

Pugliese, Don	2006–7
Puhala, Craig	1989–90

Q

Quigley, Pat	1983

R

Radvansky, Michael	2010–11
Rainey, Sean	2007
Ramthum, Mike	2005
Randle, Patrick	2005
Rankin, Carl	1973
Rapp, Cody	2001
Rayburn, Josh	2000
Reams, Vern	1999
Recchia, Lou	1968
Reese Jeremy	2007
Reynolds, Sam	1976–78
Reynolds, Scott	1987
Rich, Mike	1980
Richard, Jeremy	2002
Ricke, Rod	1977
Ridgeway, John	1978
Rieger, Ken	1977
Ries, Rich	1975
Riley, Lee	1972
Riley, Steve	1980–83
Ringhiser, Troy	1993–95
Ripoly, Rome	1986
Risley, Chris	1979–82
Risley, Sean	1986
Roath, Steve	1980
Robe, Ed	1988
Rober, Dan	1996–98
Roberts, Kevin	1989–90
Roberts, Larry	1987
Robinson, Chris	2001
Robinson, Chuck	1972–75
Rode, Scott	1986
Rodgers, Brandon	2000
Rodriquez, Aurelio	1987–88
Roman, Clay	2011

Romp, Todd	1979
Rose, Mike	1996–98
Roth, Jayson	2006–7
Roush, Rob	1994
Rover, Gerry	1966, 1968
Rowland, Garry	1973–76
Roy, Jon	1999–2000
Roy, Matt	2002
Rubbo, Jerry	1966–68
Runkel, Scott	1973–73
Russo, Frank	2002–4
Rutter, Randy	1970
Ryan, Mike	2005–6
Ryne, Shawn	1987

S

Sanders, Jim	1988
Sanger, Jim	1988–89
Satterfield, Jason	1993–95
Saunders, Tim	2009–11
Savel, Jim	1980
Sayre, Dave	1994
Sberna, Marty	1980–83
Scepaniak, Bob	1967–68
Schaffner, Rick	1970
Schaly, Joe	1985–86
Schaly, John	1979–82
Scheffel, Dan	1976–79
Scholl, Chris	1988–90
Schossler, Frank	1983–86
Schultz, Steve	1967
Schumm, Mike	1974
Schwendeman, Greg	1984–85
Sciullo, John	2004–5
Sedam, Alex	2006
Sekley, Bob	1983–84
Selock, Tom	1971
Sette, Brian	2000–1
Settles, Dan	1973–76
Shafer, Eric	1999
Shamblin, Toby	1992–95
Shapaka, Tylar	2010–11

Sharp, Jim	2000–2	Steranka, Justin	2003–6
Sharpe, Justin	1996	Stewart, Chris	2008–9
Shepherd, Jay	1998–2000	Stiffler, Dave	1975–78
Sherk, Dick	1967	Stock, Lonnie	1967–70
Sherman, Mike	1989–92	Stocker, Scott	2001–4
Shoup, Eric	1985–86	Stovall, Dave	1980–82
Shrimpton, Mike	2001–4	Stratman, Todd	1997–99
Shufelt, Scott	1993	Streit, Josh	1996–99
Shuler, Jon	1980–83	Strouse, Bob	1966
Sidick, Chris	2002–5	Sturm, Denny	1982
Simmons, Dick	1968–69	Sudges, John	1986–87
Simpson, Todd	1974	Sullivan, Kevin	1998
Sipple, John	1964	Sullivan, Shawn	1987
Slesh, Derek	1985	Surace, Joe	1980
Slevin, Mike	1971, 1974	Suranie, Derek	1989
Slivinski, Frank	1974–75	Svoboda, Mike	1972
Smith, Barry	1986	Swarney, Randy	1981
Smith, Bob	1966	Szafraniec, Andy	2004
Smith, Ed	1979	Szafraniec, Ron	1975–78
Smith, Mark	1965	Szafraniec, Scott	1998–99
Smith, Neal	2009	Szeman, Steve	1982
Smith, Norm	1967		
Smith, Sam	1983–84	**T**	
Snyder, Jeff	1981	Talarico, Mark	1980–83
Snyder, John	2008–11	Tanis, Jim	1964
Soohey, Mike	1975	Tarpoff, Nick	1977
Spanich, Steve	1966	Taylor, Bill	1976
Sparks, Marty	1997	Taylor, Brian	2004
Speaks, Steve	1964	Teaman, Jon	1989
Spicer, Josh	2006–9	Tekulve, Brian	2004
Spiegel, Jim	2001	Tekulve, Chris	1997–2000
Spitzer, Darren	1986–89	Tekulve, Jerry	1968–71
Springer, Nick	2007–8	Tekulve, Kent	1966–69
Springer, Rob	1989–91	Tepley, Paul	1999
Springhetti, Bob	1983	Tharp, Ken	1993
Stabile, Ed	1978	Theiss, Duane	1973–75
Stanbery, Kim	1972–75	Thibaudeau, Brian	1990
Stanislav, Niko	2009–11	Thibodeau, Jim	1987–90
Stanley, Jim	1984	Thomas, Cort	2010–11
Staton, Casey	1993	Thomas, Dave	1981–84
Steffan, Paul	1982	Thomas, Joe	1994–97
Stegman, Larry	1969	Thomas, Shawn	1985–88

Thomas, Steve	1999–2001	**W**	
Thomas, Tad	2006	Walker, Eric	1995
Thompson, Jordan	2009	Wandryk, Frank	1984
Thompson, Roger	1984–87	Ward, Devan	2005–6
Thrash, Joel	1999–2001	Ward, Sam	2010–11
Timko, Gary	1967	Ward, Tim	2000
Timmer, Todd	1998–2001	Warden, Matt	1990–93
Tirlia, Paul	1972	Warluft, Dylan	2010
Tornes, Scott	1994	Warner, Harry	1977–80
Toth, Alex	2010–11	Warthen, Chuck	1965
Toth, Drew	2002	Watson, Mason	2004
Townsend, Dick	1968	Watterson, Jeff	1966
Tracy, Doug	1976	Waugh, Dave	1968–70
Tracy, Jim E.	1975–76	Way, Henry	1978
Tracy, Jim J.	1976–79	Wear, Bill	1994
Trammel, Kirk	1984	Weaver, Kean	1981–83
Traylor, Kurt	1973	Weaver, Reggie	2001–2
Treftz, Dustin	1999	Weber, Tom	1981–82
Tuck, Gary	1974	Weeter, Hal	1964
Turecki, Jeff	1964–65	Wegner, Rick	1966
Turkall, Joe	2001	Weidig, Chuck	1979
		Weiermiller, Mike	1979–80
U		Weigle, Greg	1981
Ulle, Mike	2001–4	Weiss, Mel	1976
Umholtz, Matt	2004	Welch, Jeff	1974
Unger, Jeff	1984	Welch, Ty	2010
Ungerbuehler, Josh	2011	Welch, Zack	2005–6
		Wells, Adam	1986
V		Wert, Tom	1979
Vales, Bob	1975	Westfall, Larry	1972
Valvo, John	1969	Whetzel, Matt	1993–95
VanDerslice, Tim	1964	White, Ken	1974–75
Van Voorhees, Dave	2007–9	Widder, Bruce	1970–72
Varley, Bill	1982–85	Widlund, Bob	1966
Vavro, Tony	1999	Wiktorski, Jeff	1982–85
Vavruska, Mark	1972–73	Wilcoxen, Dave	1964–66
Vazquez, Carl	1977–80	Wiley, Sam	1964
Vincell, Shelba	1969	Williams, Joe	2008
Vogt, Joe	1973–76	Williams, Mark	2008–11
Vondrak, Marty	1971	Williams, Roy	1966
Voss, Bob	1978	Williams, Ryan	1996–98
		Wilmot, Nate	2001–2

Winkler, Gary	1970–73
Winstel, Ryan	1993
Winters, Dominick	2005–8
Winters, Mike	1985
Wirsul, Bob	1976–77
Wise, Brad	1987
Witmer, Al	1970–73
Witmer, Jordan	2009
Witouski, Drew	1985–88
Wolfarth, Bob	1964–65
Wolfe, Bryan	2007
Wright, Mike	1964–65
Wylie, Travis	1997–98
Wyman, Don	1972–74

Y

Yager, Justin	2006
Yarnell, Tom	1973
Yazombek, Joe	1973–76
Yoder, Todd	1999–2002
York, Bill	2001
Young, Max	2001
Youngblut, Carl	1965
Yurchak, Steve	1979–82

Z

Zallenick, Jim	1981
Zelenka, Tony	1972
Zentek, Ted	1979
Zimmerman, Joe	2005
Zink, Todd	1992–93
Zoller, Tim	1980–81
Zuke, Zach	2006

ALL-AMERICAN

YEAR	NAME	POSITION	TEAM
1972	Jerry Bumbaugh	OF	Second Team
1973	Ozzie Kenyon	OF	First Team
1975	Ken Laveck	SS	First Team
	Kim Stanbery	P	First Team
	Joe Yazombek	C	Third Team
1976	Jim E. Tracy	OF	First Team
	Chuck Nachreiner	3B	Second Team
1977	Mike Elston	P	Third Team
	Jim J. Tracy	OF	Third Team
1978	Jim Burton	2B	First Team
	Greg Inselmann	DH	First Team
	Ed Cava	SS	Second Team
1979	Brian Lee	1B	First Team
	Chuck Nachreiner	3B	Second Team
	Carl Vazquez	OF	Second Team
1980	Dave Barton	P	First Team
	Carl Vazquez	OF	First Team
	Brian Lee	1B	Second Team
1981	Dan Munday	DH	First Team
	Ken Lisko	3B	First Team
		2B	Second Team
	Mark Talarico	OF	Second Team
	Dale Hurst	P	Third Team

Year	Name	Position	Team
1982	Tom Mohl	C	First Team
	John Schaly	2B	First Team
	Ken Lisko	3B	First Team
	Mark Talarico	OF	First Team
	Dale Hurst	P	First Team
1983	Mark Talarico	OF	First Team
	Terry Mulholland	P	First Team
	Jim Pancher	2B	Second Team
1984	Jim Kennedy	P	First Team
	Terry Mulholland	P	First Team
	Jeff Chaney	C	Second Team
	Jeff Wiktorski	SS	Third Team
	Dave Thomas	OF	Third Team
	Jim Katschke	P	Third Team
1985	Jon Finke	DH	First Team
	John Hefner	1B	First Team
	Monte Duncan	SS	First Team
	Jim Katschke	P	First Team
1986	Mike Brandts	3B	First Team
		OF	Second Team
	Jim Katschke	P	Third Team
1987	Roger Thompson	OF	First Team
	Steve Oberhelman	P	Second Team
	John Sudges	1B	Third Team

Year	Name	Position	Team
1988	Drew Witouski	C	First Team
	Darrin Spitzer	SS	Second Team
	Jim Sanger	OF	Second Team
	Bill Holmes	DH	Second Team
	Jim Anderson	P	Second Team
	Mike Adams	2B	Third Team
1989	Bill Holmes	1B	First Team
	Scott Barber	DH	First Team
	Jim Eddy	P	First Team
	Doug Cook	P	Second Team
	Matt Malario	UTL	Third Team
	Jim Sanger	OF	Third Team
1990	Scott Barber	1B	First Team
	Jim Thibodeau	OF	First Team
	Matt Malario	3B	Second Team
1991	Tim McConnell	3B	First Team
	Doug Cook	P	First Team
	Doug Huffman	OF	Second Team
	Aaron Emery	P	Second Team
	Mike McCarroll	UTL	Third Team
1992	Doug Huffman	UTL	First Team
	Brent Frafjord	P	Second Team
	P Eric Mettler	P	Second Team
	Brian Brewer	DH	Third Team
1993	Bob Eddy	SS	First Team
	Darrell Fatzinger	DH	Second Team
	Mark Johnson	2B	Third Team

Year	Name	Position	Team
1994	Bob Eddy	SS	First Team
	Brent Frafjord	P	First Team
	Darrell Fatzinger	1B	Second Team
	Jamie Holland	OF	Second Team
1995	Mark Johnson	2B	First Team
	Toby Shamblin	OF	First Team
	Joe Thomas	1B	Second Team
	Chad Farmer	P	Second Team
	Jack Harless	OF	Third Team
1996	Joe Thomas	UTL	First Team
	Bob Davies	P	First Team
1997	Joe Thomas	UTL	First Team
	Bob Davies	P	Second Team
1998	Dave Bradley	P	First Team
	Josh Streit	C	First Team
	Dan Farnham	UTL	Third Team
1999	Dave Bradley	P	First Team
	Josh Streit	C	First Team
	Dan Geudtner	DH	Second Team
	Todd Timmer	2B	Third Team
2000	Matt DeSalvo	P	First Team
	Jay Coakley	C	First Team
	Adam Hollrah	OF	First Team
2001	Matt DeSalvo	P	First Team
	Jay Coakley	C	First Team
2002	Jay Coakley	C	First Team
2003	Matt DeSalvo	P	First Team
2004	Mike DeMark	P	Second Team
	Chris Sidick	OF	Second Team

Year	Name	Position	Team
2005	Chris Sidick	OF	Third Team
2006	Mike Eisenberg	P	First Team
	Jarrod Klausman	OF	Third Team
2009	Cameron Cimino	3B	First Team
2010	Chris Beatty	DH	Third Team
2011	Brian Gasser	P	First Team
	Tim Saunders	SS	First Team
	John Snyder	OF	First Team
	Austin Blaski	P	Second Team
	Mark Williams	P	Second Team

In the Pros

Name	Signed	Original Club
Bob Wolfarth	1965	Tigers
Kent Tekulve	1969	Pirates
Rob Nelson	1971	Yankees
Chuck Robinson	1975	Pirates
Duane Theiss	1976	Braves
Gary Tuck	1976	Expos
Jim E. Tracy	1978	Cubs
Jim Burton	1979	Dodgers
Dave Barton	1980	Mets
Carl Vazquez	1980	Pirates
Dale Hurst	1982	Indians
Tom Mohl	1982	Pirates
Mike Weiermiller	1982	Twins
Steve Roath	1983	Cardinals
Mark Talarico	1983	Italy
Terry Mulholland	1985	Giants
Jim Katschke	1986	Rangers
Mike Brandts	1987	Mariners
Eric Shoup	1988	Tigers
Jim Eddy	1989	Expos
Bill Holmes	1989	Pirates
Doug Cook	1991	Braves
Marty Davis	1991	Rangers
Tim McConnell	1991	Tigers
Brian Brewer	1993	Redcoats
Matt Warden	1993	Redcoats
Bob Eddy	1994	Redcoats

NAME	SIGNED	ORIGINAL CLUB
Darrell Fatzinger	1994	Redcoats
Brent Frafjord	1994	Redcoats
Chad Farmer	1995	Newark
Mark Johnson	1995	Newark
Toby Shamblin	1995	Newark
Bob Davies	1997	Twins
Joe Thomas	1997	Red Sox
Dave Bradley	1999	Reds
Josh Streit	1999	Chillicothe
Kris Buirley	2001	Chillicothe
Jay Coakley	2002	Washington, PA
Matt DeSalvo	2003	Yankees
Chris Sidick	2005	Washington, PA
Mike DeMark	2006	Florence, KY
Mike Eisenberg	2006	Indians
Jarrod Klausman	2006	Washington, PA
Chris Stewart	2009	Marion, IL
Mark Williams	2011	Washington, PA

COACHES' RECORDS

Don Schaly

1964	14-4	1984	53-7
1965	21-4	1985	46-11
1966	10-9	1986	48-13
1967	16-5	1987	38-14
1968	16-7	1988	44-9
1969	12-8	1989	36-9
1970	11-7	1990	39-7
1971	27-7	1991	43-6
1972	22-7	1992	43-8
1973	31-6	1993	35-7
1974	22-12	1994	39-4
1975	44-6	1995	46-9
1976	29-12	1996	43-13
1977	36-13	1997	43-7
1978	38-7	1998	40-10
1979	40-6	1999	50-8
1980	43-4	2000	44-7
1981	59-5	2001	48-9
1982	53-11	2002	41-9
1983	49-9	2003	30-13

Brian Brewer

2004	33-11
2005	32-10
2006	43-11
2007	32-17
2008	23-20
2009	32-17
2010	36-13
2011	47-4

POST-SEASON

Ohio Athletic Conference

Year	Place	Year	Place	Year	Place
1954	3rd	1974	3rd	1994	1st
1955	10th	1975	1st	1995	1st
1956	1st	1976	2nd	1996	1st
1957	7th	1977	1st	1997	1st
1958	7th	1978	1st	1998	1st
1959	5th	1979	1st	1999	1st
1960	8th	1980	1st	2000	1st
1961	12th	1981	1st	2001	1st
1962	10th	1982	3rd	2002	1st
1963	8th	1983	3rd	2003	3rd
1964	2nd	1984	1st	2004	2nd
1965	5th	1985	2nd	2005	2nd
1966	5th	1986	1st	2006	2nd
1967	9th	1987	1st	2007	4th
1968	5th	1988	1st	2008	2nd
1969	2nd	1989	2nd	2009	2nd
1970	1st	1990	1st	2010	2nd
1971	1st	1991	1st	2011	1st
1972	1st	1992	1st		
1973	1st	1993	1st		

Regional

Year	Place	Year	Place	Year	Place
1971	5th	1984	1st	1996	1st
1972	3rd	1985	1st	1997	4th
1973	2nd	1986	1st	1998	4th
1975	1st	1987	3rd	1999	1st
1976	5th	1988	1st	2000	4th
1977	1st	1989	2nd	2001	1st
1978	1st	1990	2nd	2002	1st
1979	4th	1991	1st	2006	1st
1980	1st	1992	1st	2007	1st
1981	1st	1993	3rd	2009	2nd
1982	1st	1994	4th	2010	2nd
1983	1st	1995	1st	2011	1st

World Series

1975	2nd		1985	2nd		2001	2nd
1977	4th		1986	1st		2002	2nd
1978	2nd		1988	3rd		2006	1st
1980	2nd		1991	5th		2007	7th
1981	1st		1992	5th		2011	1st
1982	3rd		1995	5th			
1983	1st		1996	7th			
1984	2nd		1999	5th			

NO-HITTERS

DATE	PITCHER	OPPONENT	SCORE	IP	SO	BB
4/4/64	Mike Wright	Morris Harvey	4–0	7	8	1
5/9/64	Andy Ivan	Otterbein	1–0	7	7	1
4/13/68	Lonnie Stock	WV Wesleyan	10–2	7	8	6
3/16/71	Gary Latos*	Oglethorpe	3–0	7	12	0
3/16/71	Craig Hartman	Oglethorpe	4–1	7	13	3
4/7/73	Neal Parsley	Capital	5–0	5	10	4
4/29/80	Mike Weiermiller	Glenville State	9–0	7	6	2
3/20/82	Roger Hart	West Virginia	3–1	7	3	4
3/12/83	Roger Hart	Missouri Rolla	5–0	7	3	3
3/15/97	Joe Thomas	Beloit	10–0	4	6	1
	Dave Herbert			1	0	1
3/6/98	Dan Farnham	Huron	10–0	4	6	1
	Mike Hall			1	1	0
	Tyson Hill			1	1	0
5/8/99	David Bradley	Otterbein	13–0	7	9	0
3/11/00	Joel Thrash	Dana	6–0	7	4	5
3/12/00	Matt DeSalvo	WI–Platteville	14–1	5	8	3
3/9/01	Trey Lamb	Northern State	6–0	5	4	0
5/5/01	Matt DeSalvo	Ohio Northern	2–0	7	14	1
4/10/02	Mike Mooney	Mount Union	6–0	7	6	4
3/20/04	Mike Mooney	Ohio Wesleyan	5–0	9	6	2
3/21/04	Mike DeMark	Thiel	13–0	9	9	7
4/7/11	Brian Gasser	Baldwin-Wallace	7–1	7	7	2

* perfect game

ABOUT THE AUTHOR

Gary Caruso is a graduate of Marietta College and is a product of its baseball program, where he lettered twice as a student assistant coach under the legendary Don Schaly. He also is the co-author of *Behind the Plate*, the autobiography of former Atlanta Braves catcher Javy Lopez, released by Triumph Books in spring 2012.

Caruso is the best-known and most accomplished of modern Atlanta Braves historians. A career sports journalist, he is the author of *The Braves Encyclopedia* (Temple University Press, 1995) and *Turner Field: Rarest of Diamonds* (Longstreet Press, 1997). Editor of numerous Braves publications for the last twenty years, he has the unique distinction of having delivered the eulogies for two of the greatest pitchers in history—Warren Spahn and Lou Burdette. He also conceived and raised the funds for the Warren Spahn statue that stands in front of Turner Field in Atlanta, and he designed and scripted the popular Atlanta-Fulton County Stadium Mural at the Braves' home ballpark.

Caruso lives in suburban San Diego with his wife, Lane, and their Boston terrier, Pumpkin.